Queen Victoria and Thomas Sully

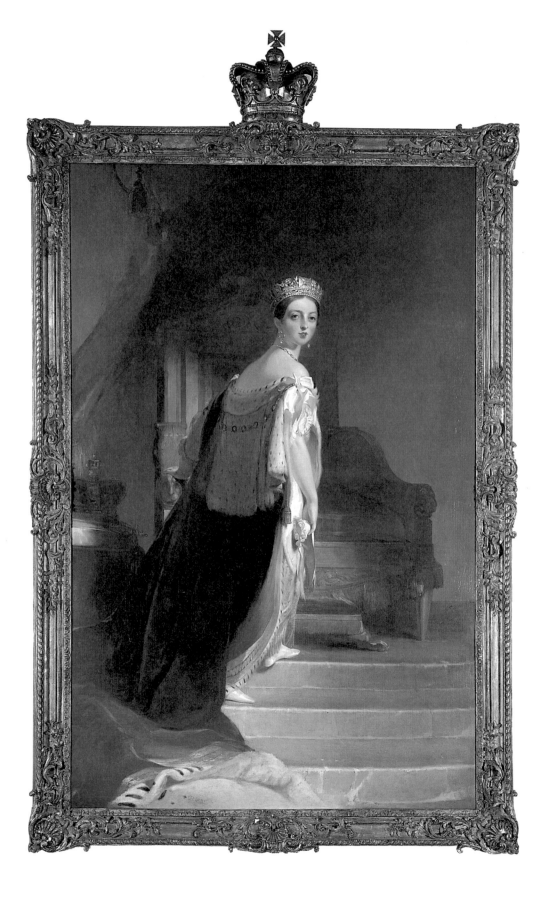

Queen Victoria and Thomas Sully

Carrie Rebora Barratt

PRINCETON UNIVERSITY PRESS IN ASSOCIATION WITH
THE METROPOLITAN MUSEUM OF ART

Published on the occasion of the exhibition
Queen Victoria and Thomas Sully

The Metropolitan Museum of Art, New York
September 19–December 31, 2000

The Wallace Collection, London
January 22–April 29, 2001

At the Metropolitan, the exhibition was made
possible by The Crown Equipment Corporation.
The publication was made possible in part by a sub-
vention from The William Cullen Bryant Fellows.

Published by Princeton University Press in
association with The Metropolitan Museum of Art

Princeton University Press
41 William Street
Princeton, New Jersey 08540

In the United Kingdom:
Princeton University Press
3 Market Place
Woodstock, Oxfordshire OX20 1SY

The Metropolitan Museum of Art
1000 Fifth Avenue
New York, New York 10028

Frontispiece: Thomas Sully, *Queen Victoria*, 1838.
Oil on canvas, 94 x 58 in. (238.8 x 147.4 cm).
Collection of Mrs. Arthur A. Houghton, Jr.

Binding and endpapers: Details of Thomas
Sully's Journal, 1792–1846. Historical Society of
Pennsylvania, Philadelphia

Printed and bound in Spain (D.L.TO: 752-2000)

10 9 8 7 6 5 4 3 2 1

Library of Congress Cataloging-in-Publication Data

Barratt, Carrie Rebora.
 Queen Victoria and Thomas Sully / Carrie Rebora
Barratt.
 p. cm.
 Published on the occasion of an exhibition held at
the Metropolitan Museum of Art, New York, Sept. 19–
Dec. 31, 2000 and the Wallace Collection, London,
Jan. 22–Apr. 29, 2001.
 Includes bibliographical references and index.
 ISBN 0-691-07034-2 (alk. paper)
 1. Sully, Thomas, 1783–1872—Criticism and inter-
pretation. 2. Victoria, Queen of Great Britain,
1819–1901—Portraits. 3. Sully, Thomas, 1783–1872—
Diaries. I. Metropolitan Museum of Art (New York,
N.Y.) II. Wallace Collection (London, England)
III. Title.
 ND1329.S84 B37 2000
 759.13—dc21

 00-041675

Contents

Foreword

*T*his volume represents a collaboration between Princeton University Press and The Metropolitan Museum of Art, where the exhibition *Queen Victoria and Thomas Sully* will be on view during Fall 2000. Scholarship is often facilitated and enhanced by partnerships, and we are grateful for the vision and expertise our colleagues at Princeton have brought to the presentation of this subject matter. The book and exhibition offer new research on Sully, one of nineteenth-century America's most talented portraitists, by opening up the case study of his monumental coronation year portrait of Queen Victoria. This episode involves the complex protocol of portrait making in the royal court, the determination and personality of the young queen, and the ingenuity and perception of the painter. Sully's own London journal, published here for the first time, richly augments the art history with his personal narratives of visits to galleries, museums, and private collections. This fascinating information extends far beyond the commission at hand to reveal the life of a gregarious and intelligent artist in a bustling city at an important time. As Sully comes in touch with the world of art as seen in London and, briefly, in Paris, so does this book cover a wide range of subjects and circumstances that will engage various readers.

Research on Sully's likeness of Queen Victoria began nearly five years ago, after the full-length portrait came to the Metropolitan on long-term loan. In our galleries, the painting hangs alongside the artist's preliminary oil study for the picture, and this juxtaposition provoked the notion of broadening the two-painting display into a dossier exhibition that would further illuminate these special works of art. We are most grateful to Mrs. Arthur A. Houghton, Jr.

for entrusting her portrait of the queen to our care and thus inspiring this scholarly enterprise.

We are grateful to the collectors and institutions that have graciously loaned works to the exhibition. At the Metropolitan, the exhibition was made possible by Crown Equipment Corporation, a company that may have found certain resonance in their name and the subject matter, but offered their sponsorship in the altruistic spirit of promoting new scholarship. We also express thanks to the William Cullen Bryant Fellows of the Metropolitan for their contribution to the publication costs.

We would particularly like to acknowledge the excellent work of Carrie Rebora Barratt, Associate Curator of American Paintings and Sculpture and Manager of The Henry R. Luce Center for the Study of American Art, who planned the exhibition and is the author of the catalogue.

Philippe de Montebello
Director
The Metropolitan Museum of Art

Preface

This book is published in conjunction with the exhibition of the same title at The Metropolitan Museum of Art. Mounted in commemoration of the centenary of Queen Victoria's death in January 2001, this project marks the occasion by recognizing the significant achievement of an American artist who demonstrated talent, integrity, and ingenuity in a competitive situation. My research began several years ago, shortly after the arrival of Sully's full-length portrait of the queen on loan to the Metropolitan from Mrs. Arthur A. Houghton, Jr. It is to Mrs. Houghton, whose kind friendship and unstinting generosity have made this project possible, that this volume is dedicated.

The defining moment in the conception of the book and exhibition was the shifting of Sully's journal from private hands to a public collection. His journal has long been known and studied in typescript form at the New York Public Library (and on microfilm at the Archives of American Art), but as any scholar will freely admit, access to the original document enhances research tenfold. I owe thanks to Stuart P. Feld of Hirschl & Adler Galleries for giving me permission to pore over the journal, as though his office were my own private reading room. The journal was acquired by the Historical Society of Pennsylvania, where I continued my research. At the Historical Society, I wish to particularly name Lee Arnold for his assistance, and extend my gratitude to that institution at large for granting permission to have such a large part of the journal edited and published.

Early on, it was decided that the editorial strategy for the journal would be to identify people, places, and works of art. For finding hundreds of people, the

easy-to-find lords and ladies and the obscure dentists and merchants, I give my heartfelt thanks to Elizabeth Lamb Clark, the best biographical researcher I know, a fine scholar, and a true friend. Her painstaking work on Sully's journal required a rare combination of cleverness, intelligence, logic, and persistence. Elizabeth could find a needle in a haystack. Caroline Doswell Smith found present locations and correct titles for many of the paintings Sully mentioned and described, and Elizabeth Barry concentrated on Sully's side-trip to France. I thank both of them most kindly.

The editing of the journal involved research in London, Philadelphia, New York, and Winterthur, Delaware. In London, I spent many hours in the Heinz Archive of the National Portrait Gallery, and I thank the reference staff there for their assistance. At the Royal Collection Trust, research was aided considerably by Christopher Lloyd, Oliver Everett, Hugh Roberts, and Jane Roberts. I was welcomed to the Guildhall Art Gallery by Jeremy Johnson and Jackie Lea. Their colleagues at the Guildhall Library helped narrow the search for Sully's British acquaintances. Many of the people he met in London were listed in standard sources, such as *Burke's Peerage* and the *Dictionary of National Biography*. Some of the harder-to-find individuals appeared in pertinent volumes of *The Royal Kalender: And Court and City Register, for England, Scotland, Ireland, and the Colonies* and in F. Kelly's *The Post-Office London Directory*. For place names and events, *A Visit to London, or the Stranger's Guide to Every Interesting Object in the Metropolis and its Environs* (London, 1837) proved invaluable. In Philadelphia, where Sully papers abound in numerous repositories, research was conducted at the American Philosophical Society, the Historical Society, the Library Company of Philadelphia, and the Pennsylvania Academy of the Fine Arts. Robert D. Schwarz and David Cassedy of Schwarz Gallery gave expert advice. The manuscripts division of the Winterthur Library is a treasure trove of Sully documents. Secondary source research was conducted at the New York Public Library and at the Thomas J. Watson Library here at the Metropolitan Museum.

In the course of research, many individuals kindly abetted our efforts: Michael N. Altman put a face to Blanch Sully by finding her portrait and making sure it ended up in a public collection; Francis Lowell Coolidge provided information for the journal; Susan Eible graciously introduced me to the extended family of Sully descendants; William H. Gerdts introduced me to grand manner portraiture and provided encouragement; Robin Hamlyn at Tate Britain walked the streets of London with me on a few occasions, searching out Sully's service flat and so many other arcane addresses; Reynolds scholar David Mannings

generously made his research available to me; Belinda and Jeremy Morse have enhanced each of my trips to London; Richard Stone has taught me amazing things about portraiture and the life of a royal portraitist; Thomas Sully III brought his ancestor to life for me in magical ways; and Paul Worman made certain I knew of every pertinent, if obscure, reference to the subject at hand.

Perhaps the best part of this project was having an excuse to learn more about Queen Victoria. The list of biographies consulted for this project is quite long, but I wish to mention my conversations with the Victoria scholars Deirdre Shearman and Adrienne Munich, both of whom contributed greatly to my work. I continue to learn fascinating bits about the British royal family from my friend Elle Shushan, who can recognize by face and tell a story about every monarch back to Alfred the Great.

I thank the fates who introduced me to Paul Staiti at the perfect time and place several years ago. His reading of the manuscript was helpful, critical, and inspiring. David Meschutt gave crucial comments on the journal of the sort that only he, a scholar of portraits and a diehard, erudite anglophile, could provide.

Work with Princeton University Press has been nothing short of delightful, and I thank Patricia Fidler for agreeing to take on this publication and for putting my work into the hands of her excellent staff. Curtis Scott deftly shepherded the book through all stages of editing and production. Barbara Einzig copyedited the manuscript with care and fervor for the subject. Diane Gottardi designed the book in perfect sympathy for the subject. Ken Wong and Sarah Henry insured that the printing and reproductions were of the highest quality. Kate Zanzucchi made all things possible by bringing the sundry components of the publication together. Kathleen Friello prepared the index.

At the Metropolitan, one is surrounded at every turn by helpful experts in myriad fields. I thank the Director, Philippe de Montebello, whose general wisdom and specific counsel informs every aspect of this project. In the Editorial Department, John P. O'Neill was enthusiastic about the book from the outset, and Susan Chun guided the manuscript to Princeton and beyond. I owe thanks to Katherine Baetjer and Walter Liedtke, colleagues in the Department of European Paintings, for their help. In the Departments of American Art, I thank John K. Howat, who cherishes a good, beautiful book. My friends and mentors H. Barbara Weinberg and Amelia Peck have given all manner of advice, for which I am extremely grateful. Morrison H. Heckscher and Peter M. Kenny were helpful, as always. Catherine Scandalis undertook much of the day-to-day work required by such an enterprise, and Dana Pilson assisted on many occasions.

As this publication serves as an exhibition catalogue, I wish to thank Rosalind Savill and Stephen Duffy at the Wallace Collection, London, the second venue for the show. It has been a pleasure to work with them and an honor to bring them their very first loan show. In honor of this occasion, which is a part of the Wallace's grand centenary building project, Michele Beiny Harkins established the American Friends of the Wallace Collection, and she deserves great thanks for that gesture. The exhibition includes pieces from many generous lenders, who have also allowed their art to be illustrated in the book: Arizona State University, Tempe; the British Museum, London; the Brooklyn Museum of Art; Crowns and Regalia, Ltd., London; Mrs. Arthur A. Houghton, Jr.; Otto von Mitzlaff, Frankfurt; the Pennsylvania Academy of the Fine Arts, Philadelphia; the National Portrait Gallery, London; the New Britain Museum of American Art; the Royal Collection, London; Schwarz Gallery, Philadelphia; the Victoria and Albert Museum, London; the Winterthur Museum and Library, Delaware; and Yale University, Beinecke Library. I also thank the private collectors who wish to remain anonymous.

This publication is supported, in part, by a grant from the William Cullen Bryant Fellows of The Metropolitan Museum of Art. The exhibition is sponsored by Crown Equipment Corporation, a concern guided by an exceptional gentleman, James F. Dicke II.

Queen Victoria
and Thomas Sully

FIG. 1. HENRY INMAN (AMERICAN, 1801–1846), THOMAS SULLY, 1837.
OIL ON ACADEMY BOARD, 23 15/16 X 19 13/16 IN. (60.7 X 50.3 CM).
PENNSYLVANIA ACADEMY OF THE FINE ARTS, PHILADELPHIA. GIFT OF BLANCH SULLY

On October 9, 1837, the day before his decided date of departure from Philadelphia to London, the portraitist Thomas Sully (fig. 1) received a missive from the local chapter of the Society of the Sons of Saint George, a benevolent association devoted to supporting indigent English emigrants and their families. The gentlemen prevailed upon the artist to paint for their meeting room a full-length portrait of Queen Victoria, who had ascended to the throne just months before. Sully had by that time packed for a three-month study trip, intended as a refresher course in British painting; for his daughter Blanch, who was to travel along as his companion, it was anticipated as an exploration of English manners, dress, and society. They had neither bargained nor, it seems, wished for a royal encounter. Sully's inevitable acceptance of the commission propelled him into an intricate realm of propriety and protocol that extended his trip and changed his life. Because of the work, he was, in his own modest words of astonishment, "introduced to distinguished people, and kind friends, enabled to converse familiarly with the Sovereign of the present greatest empire in the world."[1] The youthful Victoria, for her part, was a keen portrait sitter, eager to dispatch her image to all foreign ports and tickled by the notion of being painted by an American: "Am I in the position you require Mr. Sully?" she asked during their first session in March 1838, indulging the Yankee with the privilege of posing the royal body according to his preferred design.[2] This is their story.

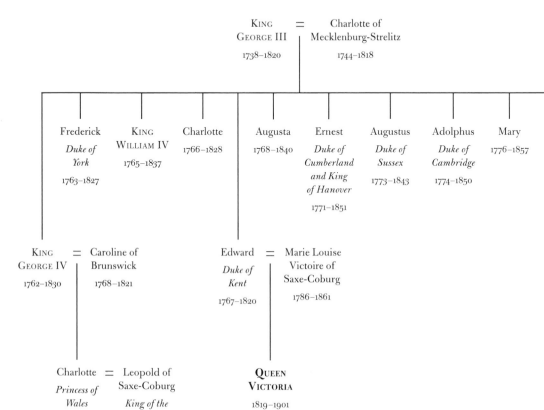

KING
GEORGE III
1738–1820

=

Charlotte of
Mecklenburg-Strelitz
1744–1818

Frederick
*Duke of
York*
1763–1827

KING
WILLIAM IV
1765–1837

Charlotte
1766–1828

Augusta
1768–1840

Ernest
*Duke of
Cumberland
and King
of Hanover*
1771–1851

Augustus
*Duke of
Sussex*
1773–1843

Adolphus
*Duke of
Cambridge*
1774–1850

Mary
1776–1857

Sophia
1777–1848

KING
GEORGE IV
1762–1830

=

Caroline of
Brunswick
1768–1821

Edward
*Duke of
Kent*
1767–1820

=

Marie Louise
Victoire of
Saxe-Coburg
1786–1861

Charlotte
*Princess of
Wales*
1796–1817

=

Leopold of
Saxe-Coburg
*King of the
Belgians*
1790–1865

**QUEEN
VICTORIA**
1819–1901

Queen Victoria: Her Life in Pictures

*I have just returned from the Academy, where I think we shall have
an amusing exhibition. There are Queens of all sorts and sizes, as you may
suppose, good, bad, and indifferent.*

Charles Robert Leslie to his sister Anne, April 30, 1838

On June 24, 1837, four days after the death of her uncle William IV, Queen Victoria named Sir George Hayter her Painter of History and Portrait.[3] The ambitious artist was well known to the royal family—he had painted portraits of Victoria, her mother, her dog, and her favorite uncle, Leopold, King of the Belgians—and they seem to have excused his obsequiousness in favor of his ability to paint a perfectly princely portrait. There can be no doubt of their regard for Hayter's properly grandiloquent tableaux, yet he persistently hounded members of the royal household, constantly visiting, repeatedly signing his name in the young Heir Presumptive's book of callers, and sending Victoria birthday gifts every year. As queen, she promptly chose him as a matter of course, as a matter of duty, as a matter of fact: no time was lost in futile deliberation over who should make the official portrait of the new sovereign, a clever girl who understood from the start that her public image would mean everything to her reign.

Hayter's appointment occurred without slight to the venerable Sir David Wilkie, who would continue to hold the higher post of Principal Painter in Ordinary, as he had for George IV and William IV, Victoria's "uncle kings," as she called them. On the road to becoming the most portrayed monarch in British history, she would have two court portraitists. She would also employ numerous copyists to reproduce official paintings—most often in the form of watercolor on ivory or enamel miniatures—and entertain petitions from all comers who wished to take her likeness. She turned her Buckingham Palace closet into a sitting room, complete with a painting chair, footstool, draperies, cushions, and various

other desirable accoutrements. According to rule, her lord chamberlain, the Marquis Conyngham, vetted the portraitist applicants, but Victoria also accepted painters recommended by her devoted prime minister, Lord Melbourne; she relied upon her governess, the Baroness Louise Lehzen, to keep her sitting schedule. Victoria sat for at least fifteen artists over the ensuing coronation year, day after day, occasionally twice a day and two at a time. Painters, sculptors, engravers, and miniaturists produced full-length canvases, cabinet-size watercolors, bronze medals, marble busts, cameos, ivory miniatures, Wedgwood adornments, and engravings for newspapers, documents, and postage stamps. The painter Benjamin Robert Haydon, himself a supplicant for a royal preferment, surveyed the parade of painters in October 1837: "Yesterday Her Majesty sat to Sir David Wilkie for her state portrait. Today her Majesty sat to Mr. Hayter. On Friday Her Majesty sat to Pistrucci. On Saturday Her Majesty knighted Mr. Newton, Miniature Painter. On Sunday Her Majesty went to Church with Sir Augustus Calcott, the Landscape Painter. On Monday Her Majesty sat to Mr. Tomkins, the Black Chalk drawer. On Tuesday, Her Majesty sat to Jenkins, the lead pencil outline designer. On Wednesday, Her Majesty knighted Smith, Tomkins, and Jenkins."[4]

Victoria was an experienced sitter, trained from infancy to esteem portraiture and the means by which it was accomplished. She and every member of her extended family—and their pets—sat on a fairly regular basis, always for special occasions, but more often as a simple fact of royal life. Portraits were suitable gifts, properly intimate tokens between family members and close friends—just the thing for someone who had nearly everything—and Victoria grew up giving and receiving portraits with remarkable frequency. On her eighteenth birthday, May 24, 1837, she received portraits of her mother, her half brother, and his son; that August her mother found four portraits, including one of Victoria, among her own birthday gifts.[5] The private exchange of portraits reinforced (or forced, as the case may be) bonds of kinship and loyalty between members of the royal family.

Among princely skills, a talent for sitting, which involves patience, fortitude, and a certain degree of self-possession, was no small accomplishment, and Victoria perfected the art early on. The biography of her youth, or at least a version of it, may be read in the chronicle of portraits for which she sat: the darling picture painted by Stephen Poyntz Denning in 1823 of the four-year-old princess bundled in velvet coat, feathers, and furs (fig. 2); the various watercolor renderings and oil paintings executed by Richard Westall even while he offered the adolescent Alexandrina Victoria lessons in drawing (fig. 3); William Behnes's cherubic marble bust (The Royal Collection, London); Richard James Lane's

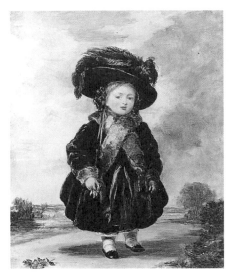

FIG. 2. STEPHEN POYNTZ DENNING (ENGLISH, 1795–1864), QUEEN VICTORIA, AGE FOUR, 1823. OIL ON PANEL, 11 X 8 7/8 IN. (27.9 X 22.7 CM). DULWICH PICTURE GALLERY, LONDON

FIG. 3. RICHARD WESTALL (ENGLISH, 1765/66–1836), PRINCESS VICTORIA SKETCHING WITH HER DOG, 1830. OIL ON CANVAS, 57 X 44 3/4 IN. (144.8 X 113.7 CM). THE ROYAL COLLECTION, LONDON

drawings of the teenage princess (The Royal Collection, London), among many others.[6] Without exception, the portraits convey an impression of Victoria as a delightful, gentle child, with a pretty face that glowed for each of her myriad painters.

She appears especially sweet in the double portraits of her and Marie Louise Victoire, Duchess of Kent, the domineering stage mother in the drama that was Victoria's childhood. The duchess, who controlled every aspect of her daughter's daily life, was responsible for virtually all of her portrait commissions and sittings. In the double portrait by Sir William Beechey (fig. 4), a tiny, angelic Victoria holds a miniature of her late lamented father, Edward Augustus, Duke of Kent, and snuggles against her ornately dressed and bejeweled mother. A later double portrait by Hayter (The Royal Collection, London) lovingly links mother and daughter; this time, the duchess gazes contentedly at her adolescent princess. An otherwise handsome and poised woman, the duchess desperately— some would say pathetically—clung to Victoria as her lifeline. The duke's unfortunate death on January 23, 1820, when the baby had not reached her first birthday, had left the duchess alone, insolvent, and held in contempt by most members of her royal family-in-law for many reasons, not the least of which was

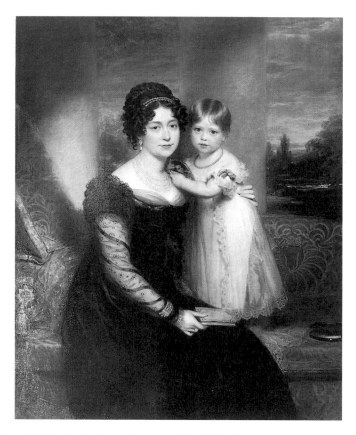

FIG. 4. SIR WILLIAM BEECHEY (ENGLISH, 1753–1839), VICTORIA, DUCHESS OF KENT,
WITH PRINCESS VICTORIA, 1823. OIL ON CANVAS, 57 X 44 1/2 IN. (144.8 X 113 CM).
THE ROYAL COLLECTION, LONDON

her relatively humble German heritage. Her daughter's birthright was her prized possession, her only undeniable claim to privilege.

Due to what must have seemed a bizarre twist of fate, at the time of her birth in 1819 Victoria was sixth in line of succession to the throne, number fifty-seven of George III's grandchildren, fifty-six of whom were illegitimate. Eleven of George III's children survived to adulthood, but few survived their hearty, albeit ultimately insane, father. A swift process of elimination cast Victoria's royal fate: George III died in 1820, just a week after the death of the Duke of Kent, leaving the Prince of Wales to assume the throne as George IV, with the Dukes of York and Clarence next in line. The Duke of York's death in 1827 promoted Victoria to second in line, and with this the Duchess of Kent began possessively guarding the child who would one day be queen and shower her mother with riches, favors, and all manner of parliamentary concessions. Still more auspicious for the

doting duchess was the possibility that Victoria's turn would come before she reached the age of eighteen, in which case her mother would rule England as regent, the ultimate vindictive triumph for the downtrodden German matron.

The Duchess of Kent, with the strong-armed counsel of her household comptroller and intimate confidant, the insidious and predatory Captain Sir John Conroy, adopted what has been termed "the Kensington System" to prepare and protect her progeny.[7] At Kensington Palace, where the Duke of Kent's family remained after his demise, Victoria slept in her mother's room and was never left unattended. Her governess or another member of the household staff remained with the princess on the rare occasions when she had visitors. She had over 130 dolls but no companions her own age, except for Conroy's daughter, Victoire, whom Victoria rejected, despite the isolation that ensued. She might have found some alleviation of loneliness in the company of her half sister Princess Feodora of Leiningen, the duchess's daughter from her first marriage, but Feodora was several years Victoria's senior and often traveling, presumably so that their mother could nurture her more royal daughter according to method without interruption. Victoria was defiant and willful, a headstrong girl whose temperament was further ingrained as a result of the constraints put upon her, for she was grievously punished for her perceived misbehavior, occasionally placed in a secluded stairwell with her hands shackled with ropes.

Portrait sittings and drawing lessons were integral parts of Victoria's highly managed upbringing, but surely ones that offered diversion in the princess's tight schedule of essential and obligatory lessons and meager entertainments. Very few people outside of the palace walls had any idea of what the princess looked like or how she acted; the duchess orchestrated donkey rides and games for Victoria in Kensington Gardens, or served her breakfast there, so that some of her future subjects might catch a favorable glimpse of her from the public pathways. In the same way, she allowed only the most satisfactory portraits—especially those double portraits that invoked her image in connection with Victoria's, thus insinuating herself in the regime of future power—to be published or engraved for broad dissemination. For the duchess, Victoria's girlhood portraits would disclose only her pleasant countenance and charming personage.

Victoria thwarted her mother's well-laid plans and selfish ambitions by coming of age just three weeks before William IV's death. (Some would say the king exerted his will to live in this regard, as he despised the duchess and adored Victoria.) On the very night of her ascension, she moved into her own quarters, and when she soon thereafter moved from Kensington she designated apartments for her mother distant from her own in Buckingham Palace and Windsor

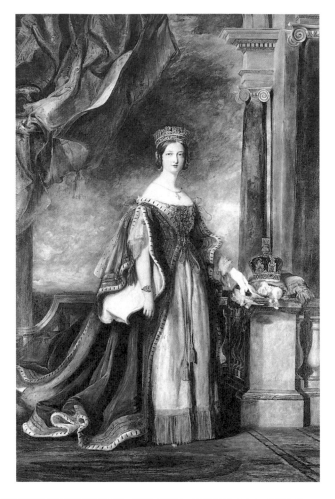

Castle. They barely spoke, except on public occasions when Victoria deemed it judicious for her to be perceived as a loving daughter. The girl who had rarely appeared before anyone now presented herself to court and nation—to people of all walks of life. Many of them remembered—how could they forget—her daft and depraved grandfather, and had uniformly disdained George IV for his extravagant personal habits and corrupt politics, just as they made the best of the gruff and bawdy, but kind William IV. The queen recognized the challenge before her: to dispel worries that she too would exhibit eccentric family traits. She rose to the challenge by displaying shrewdness and intelligence in her rule and a composite image of princely majesty and common decency in her portraits.

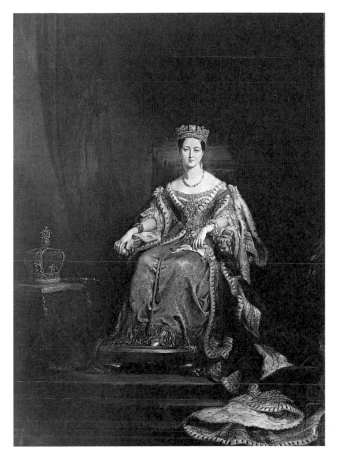

The nature of Victoria's specific involvement in the promulgation of her portraits can be gauged to some extent by how frequently and willingly she sat for painters of myriad interests and talents. As a matter of international diplomacy, the reigning monarch sent her image not only to British embassies, colonies, and outposts, but also to the rulers of other nations. Victoria unstintingly created and monitored what amounted to a portrait factory, staffed by a varied and productive team of painters dedicated to producing the best possible portraits that they could. Rather than telling them precisely what she wanted, the queen seems to have allowed her painters some degree of freedom. She knew many of the portraitists either personally or by reputation and scrutinized letters of introduction for those of whom she had neither met nor heard. It would be an exaggeration to say that the queen had an exacting plan of what her image should

be—how she would look, where the portraits would appear, and so forth—for the girl whose childhood had been so carefully scripted now indulged in a bit more flexibility as an adult.

Victoria knew for a certainty that Hayter would produce an official portrait worthy of any king. She could also reasonably expect that Wilkie would execute a highly respectable image. With these reliable fellows at hand, Victoria fulfilled her responsibility to sit for artists knowledgeable of the archaic conventions necessary for the traditional and hieratic portrayal of an absolute monarch. The other painters, from hither and yon, would be granted permission to describe her on their own terms. Surrounded by ancestral portraits in her various homes, the queen would have been well acquainted with the complex nature of royal portraiture, the informal and the formal, the official and the unofficial, the respectful and the satirical, all of which were highly charged. By the time of her reign, it was incumbent upon the ruler to accept and promote the idea that her person, her very body, represented her dominion. Simon Schama has explained that "the ideal sovereign was one who understood that the body natural became, in effect, a department of state, so that its dress, deportment, and ritualized display functioned as a symbol of the condition of the body politic. It also required the majesty to negotiate artfully between the remote and the familiar, the magical and the commonplace, so that the king or queen could be seen to be both 'one of us' and utterly unlike us."[8] Moreover, because the relatively undistinguished reigns of George IV and William IV had been characterized by diminished ritual and ceremony, Victoria inherited a situation in which the monarch was infrequently seen in person and conveyed an image through portraiture.[9]

The actual purpose of the "state portrait" had changed dramatically in the years between Victoria's birth and her ascension.[10] Historically, the king or queen had sat to the Principal Painter for a portrait that would be replicated and copied for use in the British embassies. As such, it was just one element of the ceremonial paraphernalia sent along to an ambassador as a means of conveying the enigmatic idea that a privileged connection existed between him and the monarch. But an 1822 ruling by Britain's Foreign Secretary effectively limited the number of portraits required in the embassies. William IV sat for his state portrait but sent no copies to the embassies. Victoria embraced the previous tradition and would send her portrait far and wide.

Those interested in the intricacies of royal protocol have debated over whether Victoria's state portrait was Wilkie's or Hayter's (figs. 5, 6).[11] Wilkie followed the historical prototype to the mark. Here is the canonical image of the *divinas majestas*, in force since the reign of Elizabeth I: the sovereign stands,

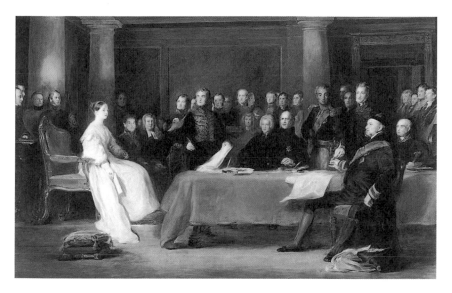

FIG. 7. SIR DAVID WILKIE, **THE FIRST COUNCIL OF QUEEN VICTORIA**, 1837. OIL ON CANVAS, 59 3/4 X 94 IN. (151.8 X 238.8 CM). THE ROYAL COLLECTION, LONDON

wearing the Dalmatic robes but without the crown, which is off to the side with the orb and scepter. Hayter's composition was not far off that mark but his seated queen presented a rare aberration with most recent precedent in Sir Joshua Reynolds's state portrait of George III (1779–80; The Royal Academy of Arts, London). Before that, no monarch had sat, as it were, for his portrait since Charles II. Wilkie's portrait of Victoria ought to have been her state portrait, since it strictly honored traditional iconography and had been painted by the Principal Painter. But Victoria rejected it. She did not record her reasons, but it has been logically surmised that she did not think it a faithful likeness, nor was she particularly charmed by the unkempt and nervous Wilkie, with his tangled wig and awful teeth.[12] Moreover, by the time Wilkie got around to painting her portrait in mid-1838, she had already grown accustomed to Hayter's more ingratiating portrait, which he had promptly executed during the fall of 1837 on commission from the Corporation of London—making it perhaps a city portrait rather than a state portrait.[13] Wilkie had spent the same fall preparing a narrative scene of the queen with her first council, an elaborate tableau that would involve portraits of many of the most important figures in court (fig. 7). Victoria liked Wilkie's council picture, but still favored Hayter's portrait, at least to the extent that she never spoke against it. Hayter himself found that most viewers deemed it a grim likeness; some in the queen's immediate circle thought "that it was too serious, even melancholy."[14] Part of the difficulty for Hayter, as for others, stemmed

from Victoria's gender and youth. Painters accustomed to working with aging men faced the problem of making the new queen look serious but not dour, youthful but not naive.

The negative comments on Hayter's portrait were outranked by the "great praise" it received from palace insiders, including Lord Melbourne, who "strenuously defended [the expression] as historical, for that particular situation on the Throne."[15] The painting had its debut in February at a levee at Saint James Palace and then entertained a packed house at the Colnaghi Gallery, where it was sent for a brief showing. The queen allowed Hayter to display the portrait at the Royal Academy's exhibition of spring 1838, proof enough that she thought highly of it. Her sanction surely got him through the spate of criticism on the picture during the show. It seems to have helped matters that Wilkie's council picture fared no better: Hayter gloated that "Wilkie's picture of the Queen at her first Council [is] well composed and badly painted, negligently got up for Exhibn."[16] He owned up to his own shortcomings by beginning a new portrait of Victoria that would be softer in expression, and by admitting on one occasion that the gravely solemn aspect of his portrait for the city was forced by his position, and not representative of his true artistic abilities.[17]

Victoria dutifully offered her imperial body for portrayal to numerous other artists, some known to her, others complete strangers with good recommendations; she thereby set herself up for likenesses advantageous and ruinous. An easy portrait sitter, she may not have fretted much, but in any event could rest assured that her advisors would insulate her from potential debacle by turning away any portraitist who might be expected to produce a wholly unflattering or condemnatory likeness. If the Marquis Conyngham, Lord Melbourne, and Baroness Lehzen somehow failed to ferret out those with hurtful intentions, she could rely upon the sheer power of the monarchy for protection. For those painters who were actually received by the queen in her closet—as opposed to the countless artists who drew her portrait without royal authorization from secondary sources and presumably had less at risk for not having had an audience with her—displeasing the sovereign was tantamount to professional suicide. Even with Hayter and Wilkie in place, many painters still sought royal preferments, appointments, and commissions. In most instances, the queen and the painter shared a mutual wish for a highly successful portrait. The British public as well demanded flattering images of Victoria, commensurate with their hopeful expectations for her success: "her commonest phrase is quoted as a *bon mot*. If she rides out, the newspapers are in raptures as to her grace. If she laughs, it is a gracious smile of condescension. If she blush, it is an expression of gratified delight."[18]

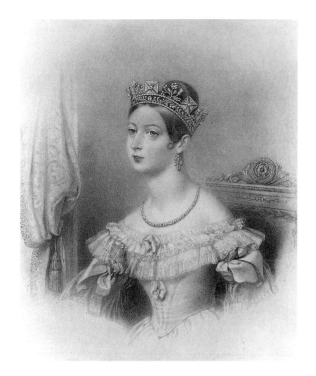

FIG. 8. RICHARD JAMES LANE (ENGLISH, 1800–1872),
QUEEN VICTORIA, 1837. GRAPHITE ON PAPER.
ROSENBACH LIBRARY, PHILADELPHIA

While her royal predecessors had attempted a careful balance between their official and unofficial images, Victoria tipped the scales on the popular side, outnumbering Hayter's and Wilkie's portraits with the work of other portraitists by five to one. The first painter to visit her after her ascension was Richard James Lane, who had drawn her a number of times before.[19] Of Lane's several highly finished and informally posed drawings of Victoria, the best known depicts her in her opera box (fig. 8). Lane's exacting technique and artistic disposition resulted in by far the prettiest images of the young queen; she is a vision of loveliness blessed with soft hair, perfect skin, and a fine figure adorned with lace and ribbons. Only the diadem betrays her station as a great ruler. Lane drew for the purposes of engraving, the prints of which were popular during the early years of Victoria's reign. The prints were probably the source for Edmond T. Parris's portraits, which portray Victoria as a modern beauty with few if any references to her princely occupation. Parris apparently failed to receive approval to paint the queen from life, and joined the ranks of those who simply worked off of others' images to devise his own interpretation.

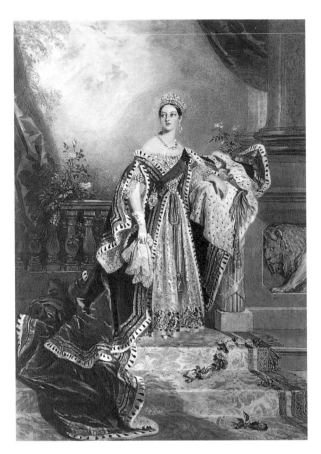

FIG. 9. ALFRED EDWARD CHALON (ENGLISH, 1780–1860),
QUEEN VICTORIA, 1837. WATERCOLOR ON PAPER.
ROYAL COLLECTION OF BELGIUM, BRUSSELS

Victoria also knew Alfred Edward Chalon, for whom she sat four times in July and August 1837 and then periodically throughout the year. Chalon worked in watercolor and produced a work (fig. 9) so successful to Victoria's eye that she purchased it from the artist as a gift for her beloved Uncle Leopold and commissioned it to be engraved. The portrait takes a traditional state image and softens the overall expression. Victoria wears the abundant robes of state and stands against a balustrade, looking off to the distance. She is framed by a romantic pink sky and vines of roses, those growing up from behind the railing and those strewn on the carpeted steps before her, tokens from her admirers. A formal image by almost any standard, the picture diverged from the specified tradition of state portraiture in the queen's animated pose and the fanciful setting. She described it as "very like and beautifully done."[20]

Victoria sat for at least two medallists during her coronation year, beginning with William Wyon on August 25 and Benedetto Pistrucci on September 27.[21] These profiles became ubiquitous fixtures in newspapers, broadsides, Wedgwood pieces, postage stamps, and of course medals, which were struck to be given as gifts for dignitaries. The images follow the imperial Roman prototype: usually just head and neck in profile, with Victoria's hair swept up in a high chignon.[22] Variations appeared in bust length, jewelry, and the neckline of her gown. The two sculptors to model busts of Victoria in her first months as queen, Henry Weekes and Sir John Steell (fig. 10), worked up likenesses similar to the medals and would have their work replicated in large and small, in marble and parian, so that before long Victoria sat on pedestals throughout her kingdom.

Queen Victoria thought William Charles Ross "a very silly man and very tedious to sit to," but nonetheless consented to pose for him every day, save one, in the last week of November 1837 for her portrait in miniature.[23] For her trouble, she had in hand by week's end a tiny portrait, which she recognized as "very like and very well painted" and would subsequently send far and wide. Victoria did not often describe the goings-on in her portrait studio and sat for artists regard-

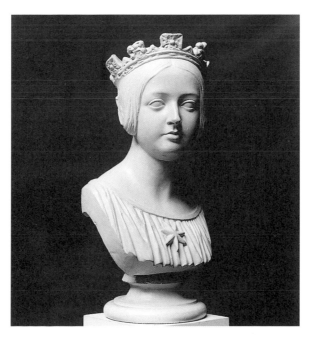

FIG. 10. SIR JOHN STEELL (SCOTTISH, 1804–1891), QUEEN VICTORIA, 1837. MARBLE, HEIGHT 22 1/8 IN. (56.2 CM). SCOTTISH NATIONAL PORTRAIT GALLERY, EDINBURGH

less of their personality, but clearly preferred sittings that were amusing and with an interesting or handsome portraitist. Early in the fall, she described accompanying her Aunt Louise, wife of Uncle Leopold, to her sitting with Lane, which was enjoyable; two weeks later, Aunt Louise chatted with Victoria while she sat to the medallist Wyon.[24] The sittings were social affairs and the queen, who had been without companionship for so long, looked forward to spending time with her painters, except perhaps for the tedious Ross, the scruffy Wilkie, and the boring Hayter, for whom she sat fifteen times between October 9 and December 23, 1837: "Sat to Hayter in my robes till ½ past 1," she wrote in her diary, "*Quel ennui!*"[25] The animal painter Edwin Landseer was a particular favorite, from the moment he was introduced to her by her lord chamberlain in late November: "he is an unassuming, pleasing and very young looking man, with fair hair."[26] Landseer, who became a frequent visitor to the palace, immediately received a commission to paint portraits of two of Victoria's dogs, Hector and Dash, and would eventually take a respite from his usual canine and equine sitters to paint a number of portraits of the queen.

Queen Victoria sat seventy-two times between her ascension in June 1837 and her coronation on June 28, 1838, but did not by any means sit for all of the artists who would have wished to paint her portrait. She refused, for example, to "sit to that painter [*sic*], for that Institution at Belfast; for that he was not a person of sufficient merit."[27] In this regard, as in nearly all matters, she deferred to Lord Melbourne for advice. Those who passed muster to reach her sitting room had a certain something to recommend them, and that something may have been different every time. Some made it on skill alone, others on professional reputation or personal manner. Sully, one of the last portraitists for whom she sat before her coronation—his was her sixty-first sitting of the coronation year—made it into the sitting chamber on his impeccable references, but the queen regarded him as a useful foreigner. On March 22, 1838, she recorded in her diary: "I sat to a Mr. Sully, a painter who is come from America to paint me."[28] For a sovereign eager to spread her image across the globe, perhaps especially to former colonies, there could have been few more agreeable portrait opportunities.

Thomas Sully: Hints from an Old Painter

One month to-day since our arrival in London—I wish it were the last month
of our stay—yet, had I the power, I would not break off until
my task is finished. It would be said why undertake more than you have the
courage to perform?

Thomas Sully, Journal, December 3, 1837

The Philadelphia publisher Edward Carey sustained the panic of 1837 well enough to assist his friend Sully, whose financial portfolio looked bleak. Just about every type of business in America suffered that year, not least the business of portrait painting, which flagged under the weight of economic strife and personal insecurity. Portraiture thrives under circumstances of affluence and self-interest, attributes that had defined Philadelphians for decades, until the mid-1830s. For Sully, the current state of affairs—few commissions and delinquent payment for those he had—sent him on the road, along with others like him with mouths to feed at home. During the early 1830s, he took to Baltimore, Washington, D.C., Boston, West Point, New York, Providence, and Annapolis, seeking work. For over a decade he had contemplated a trip to his native England, but it took Carey's encouragement and money to get him on the boat.

The publisher offered the artist a one-hundred-dollar advance on subject pictures that he would paint in London; he would also pay Sully's wife Sarah one hundred dollars each month, up to one thousand dollars, to help her with expenses in his absence.[29] Within a week, the artist had similar orders, minus the household stipend, from four other Philadelphia collectors, had been presented with a traveling purse by a committee of thirty-eight gentlemen, and purchased tickets for passage to London for himself and his twenty-one-year-old daughter

Blanch.[30] They sailed on October 10, 1838, but not before the artist had received yet another commission—this one for a life-size portrait of the new queen of England to adorn the boardroom of the Philadelphia chapter of the Society of the Sons of Saint George—for one thousand dollars, the artist's newly raised fee for a full-length.[31] He stuck their letter in his luggage and settled in for the three-week Atlantic crossing. Blanch was seasick the entire voyage.

One conceivable version of this story might continue with the portraitist rushing ashore to execute the most prestigious commission of his career. But the fifty-four-year-old Sully, who already had some thirteen hundred portraits to his credit—more than a few of distinguished personages—bid his captain goodbye and took his hungry daughter to dine on turtle soup. A week later, an unexpected sighting of the queen in the lord mayor's parade thrilled the artist, his daughter, and some friends, but did not spark a fire beneath his feet to get going on the commission; nor did a private viewing of his friend Wilkie's sketch for his painting of the queen at her first council. Sully was more concerned about making arrangements to land his paintings from America, which he had sent ahead to hang in his rooms as enticing examples of his work for potential patrons. On that score, he called on the American minister, Andrew Stevenson; while on the subject of navigating London's bureaucratic systems, he ventured to ask what to do with the Saint George Society's letter, which beseeched the queen to sit for their designated artist. The minister would get back to him. Sully played the waiting game with characteristic aplomb and a healthy degree of impatience. Never before had he made application to paint a queen, but he had spent a lifetime negotiating sittings with subjects from all walks of life.

The son of the actors Matthew Sully and Sarah Chester, Sully was born at Horncastle, England, in 1783. The family immigrated to Richmond, Virginia, in 1792 and two years later settled in Charleston, South Carolina, where young Thomas and his siblings often took part in stage performances with their father. Sully was a schoolmate of Charles Fraser, who went on to become a celebrated miniature painter, and Sully seems to have had this same ambition early on. But where Fraser and Sully's older brother Lawrence found satisfaction in painting tiny portraits, Sully found the work taxing and met with limited success. He fared far better at oil portraiture and opened his own studio in Richmond in 1804. That very year Lawrence died and Thomas assumed responsibility for his widowed sister-in-law and her three daughters. He took the familial obligation so seriously and presumably got to know Sarah Annis Sully so well that within two years he married her and took his brother's family for his own.

A shrewd entrepreneur and meticulous technician always looking to im-

prove his methods in business and art, Sully kept a daybook in which he recorded each of his paintings—the date on which it was begun, the size, the subject, the price, an explanatory note, and the date of completion. By the end of 1807, when the Sullys were living in Philadelphia, he had painted at least seventy portraits. He made a reasonably good living for his growing family—the Sullys raised four daughters and two sons of their own, in addition to Lawrence's brood—and he traveled often to New York and Boston seeking the advice of skilled painters, including Gilbert Stuart, and hoping to see fine paintings on exhibition. Sully diligently recorded advice received and techniques observed in one or another of his various memorandum books.

After meeting Stuart, Sully realized that it was imperative for a painter to study abroad. In July 1809 he sailed for his native England and entered the studio of Benjamin West, the American painter who had settled in London decades before. By this time, West was president of England's Royal Academy and never failed to welcome his compatriot colleagues with open arms. Sully benefited from West's instruction but more importantly gained access to the studios of the best English painters. Sully found his polestar in Sir Thomas Lawrence, with whom he became friendly, learning to emulate his fashionable, fluidly painted portraits. After only a year, Sully's level of painterly accomplishment had grown tenfold; back home he was recognized as the "American Lawrence," the finest portraitist in Philadelphia and one of the best in the country.

Sully's daybook overflowed with citations naming commissions from the elite of Pennsylvania and Maryland society, and the affable and levelheaded artist managed his affairs in a manner worthy of a successful portraitist: he was both a competent businessman and an adroit "people person." For many years, he supplemented his income by running a gallery with the framemaker James S. Earle; Sully managed the creative side of things—arranging exhibitions, retouching paintings the gallery offered for sale—while Earle ran the business. His theater connections won him prized commissions to paint several actors in character, a genre at which he excelled. His brilliant portraits of *William Burke Wood as Charles de Moor* (The Corcoran Gallery of Art, Washington, D.C.) and *George Frederick Cooke in the Role of Richard III* (fig. 11) brought him acclaim nearly commensurate with that of his celebrity subjects. That Cooke fell ill and died in November 1812, shortly after Sully had finished the portrait, redoubled the attention paid to the image; the grand likeness hung in the Chestnut Street Theatre in homage to the great actor and, as it turned out, in compliment to the fine painter.

Sully created a vogue for full-length portraiture in Philadelphia, and his career soared on an upward trajectory that had him painting celebrated public fig-

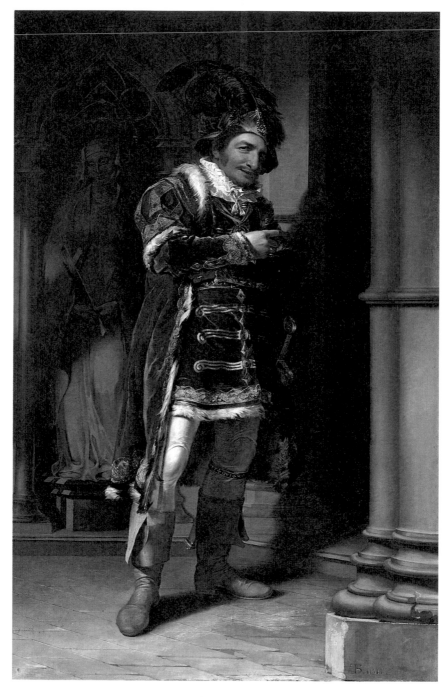

FIG. 11. THOMAS SULLY, GEORGE FREDERICK COOKE IN THE ROLE OF RICHARD III,
1812. OIL ON CANVAS, 92 1/8 X 58 1/2 IN. (234 X 148.6 CM).
PENNSYLVANIA ACADEMY OF THE FINE ARTS, PHILADELPHIA.
GIFT OF FRIENDS AND ADMIRERS OF THE ARTIST

ures and the most eminent and fashionable private citizens in the vicinity. He won highly sought-after commissions: the Pennsylvania Hospital commissioned a likeness of their president, Samuel Coates (Pennsylvania Hospital, Philadelphia) and the United States Military Academy at West Point requested a portrait of its founding superintendent, Jonathan Williams. Sully painted Andrew Jackson when the general made a triumphal tour through Philadelphia in 1819; he captured the elegant Marquis de Lafayette as he paused in the midst of the grand parade that welcomed him to the city in 1826 (fig. 12).

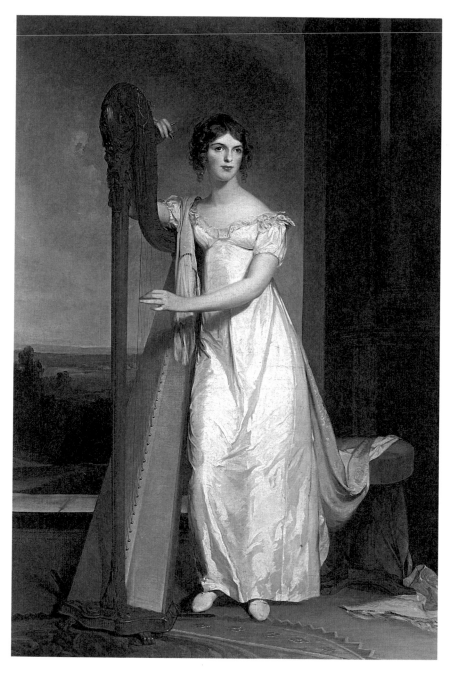

FIG. 13. THOMAS SULLY, **LADY WITH A HARP**, 1818. OIL ON CANVAS, 84 3/8 X 56 1/8 IN.
(214.3 X 142.6 CM). NATIONAL GALLERY OF ART, WASHINGTON, D.C.
GIFT OF MAUDE MONELL VETLESEN

FIG. 14. THOMAS SULLY, **SARAH REEVE LADSON GILMOR**, 1823. OIL ON CANVAS,
36 1/8 X 28 1/8 IN. (91.8 X 71.3 CM). GIBBES MUSEUM OF ART, CAROLINA ART
ASSOCIATION, CHARLESTON, SOUTH CAROLINA

Even as his name was invoked as America's best painter of distinguished and grand men, Sully became still better known for his enchanting portraits of women. The rich, painterly style he had learned from Lawrence is shown to full effect in his much touted *Lady with a Harp* (fig. 13), a work that positioned a Baltimore girl of privilege, Eliza Ridgely, as the icon of ideal refinement and femininity.[32] He was equally capable of bringing his considerable talents to bear in less conspicuous portraits, such as that of Sarah Reeve Ladson Gilmor (fig. 14), a tour de force of brushwork and masterful color, and an insightful portrayal of a woman of grace and sophistication.

Unlike so many of his colleagues—frustrated portraitists who would rather be history painters—Sully took sittings with enthusiasm. He continually developed new techniques and often invigorated his works with elements of narrative structure and allegory. His occasional misunderstandings of female anatomy are countered by his feats of colorism and overall fluidity of composition and form.

In Sully's best work the sense of immediacy and speedy execution belies the significant amount of study necessary to his accomplishments. He was indeed a learned student of art history and was nineteenth-century America's most knowledgeable paint technician. He filled his journals with hints, tips, and methods for mixing colors, applying paint, and achieving desired effects.

By the mid-1820s, Sully had set his sights on returning to London to freshen his skills by studying anew the Old Masters and investigating the work of living artists. The works he agreed to create in 1837 for Carey and other patrons were to be subject paintings rather than portraits and would be inspired by images seen in British museums, galleries, and private collections. These experimental canvases would challenge his hand and eye. Upon arrival in London on November 4, 1837, this was the work to be done, the purpose for the trip. With the help of his good friend, the painter Charles Robert Leslie, Sully and his daughter settled into a modest boardinghouse in Howland Street, Fitzroy Square, near the Tottenham Court Road, the Bloomsbury neighborhood of his compatriot colleagues G. P. A. Healy and Thomas Doughty. Within two days Sully began a round of social calls that were typical for the time, but that nevertheless defined him as astoundingly social, gregarious, and self-confident.

The Audubons—John James, his wife, and their son Victor—were then in London, and with the help of their close friendship as well as Leslie's, Sully skillfully rekindled acquaintances from his previous visit, although twenty-seven years had passed. The domino effect of social connections—Sully knew so-and-so who introduced him to a friend, who invited him to tea and introduced him to others, who invited him to dinner, and so on—was astonishing. He became a player in the complex London art scene with grace, candor, and remarkable speed. His only handicap, it seems, was his unfashionable address. In mid-November, the American banker Joshua Bates, who had engaged Sully to paint a portrait of his daughter Elizabeth, advised the artist that he lived too far west and "that the *Nobility* would not be driven there for anything."[33] Within a week, the Sullys improved their lot with slightly bigger rooms in a better part of town. Their three-room apartment—a bed chamber for Blanch, a smaller room for her father, and a front parlor that doubled as his studio during the day—at 46 Great Marlborough Street in Soho gave them a cozy home base.[34] Sully drew a floor plan and watercolor for his wife (figs. 15, 16) and Blanch wrote her a detailed description: "Here we are snugly fixed in our new lodgings. The situation first rate being an avenue to Regent and Oxford St. through the Pantheon which is directly opposite to us—our rooms all on one floor—the drawing room all *red*—the windows—casements, of course open to the floor on an iron balcony—I have

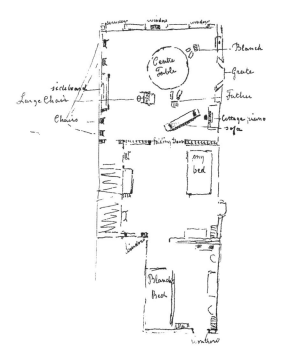

FIG. 15. THOMAS SULLY, **PLAN OF ROOMS AT 46 GREAT MARLBOROUGH STREET**, LONDON, 1838. INK ON PAPER. THE HENRY FRANCIS DU PONT WINTERTHUR LIBRARY, WINTERTHUR, DELAWARE. JOSEPH DOWNS COLLECTION OF MANUSCRIPTS AND PRINTED EPHEMERA

arranged all my goods and chattels—but father being a little more *particular* is still busy at it."[35] Sully and his daughter enjoyed the immediate excitement of Oxford and Piccadilly, found easy access to many other city pleasures, and, as Bates had suggested, found themselves regularly in the company of distinguished visitors, some of them sitters and others simply eager for Sully's company.

He visited every exhibition and museum, from the Royal Academy just a few blocks from his rooms and the British Institution slightly farther out on Pall Mall, to the Dulwich Picture Gallery and the National Gallery, from Sir John Soane's Museum and the Garrick Club to Buckingham Palace, where he was privileged to see a number of private chambers, as well as the grand picture gallery. He studied nearly all private collections of note, making his way via the agency of friends and by his own good graces and charming inquiries. He developed a friendship with the poet and collector Samuel Rogers, whom he visited many times over the course of the year. Alexander Baring, Lord Ashburton, welcomed Sully into his home and showed him his fine collection of Dutch and

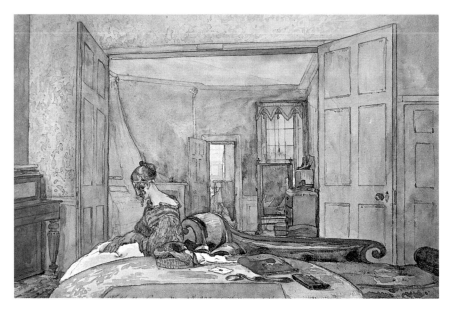

Flemish pictures, including Gerard ter Borch's *A Woman Playing a Theorbo to Two Men* (c. 1668; National Gallery, London) and Jan Steen's *Skittle Players Outside of an Inn* (c. 1660–65; National Gallery, London). Sully saw Rembrandts, Titians, Van Dycks, and Rubenses in the collections of Lord Lansdowne, Sir Henry Hope, Sir Robert Peel, and Lord Egerton. Many of these collectors not only gave Sully access to their treasures but also invited him back to suppers and soirees. "How strange," he wrote to his wife, "that I should leave my quiet, humble circle at home, to visit London and mix with the elite of the Court—for these were only next in rank to the Queen herself!!!"[36] So rich was Sully's experience that he took to keeping two journals to record his observations: one more or less a diary that he wrote in each evening as a continuous missive to his wife, the other a memorandum book that he carried with him specifically for his comments on works of art. During the evening, he would cross reference his entries. He also kept up his daybook or register of pictures, although he barely had time to work between social calls. "Only think," he wrote to his wife on November 22, "I have not touched a brush yet."[37]

When the light was good in the parlor of his apartment, he spent his mornings working on various portrait commissions from people he met in London and on subject pictures for his Philadelphia patrons. By December he was in-

creasingly conscious that he must somehow gain access to the queen. It was all a matter, it seemed, of getting his letter of commission in the right hands. He knew that she was sitting for Hayter; Stevenson seems to have given this as the supposed reason for his difficulty in getting the artist into the palace.[38] Sully, however, certainly knew that the queen was not entirely devoted to sitting for Hayter. Even his daughter Blanch knew of the young monarch's sitting schedule and sympathized: "Poor little thing, she has already sat twenty seven times—she must be quite tired of it."[39] Wilkie had shared with Sully his stories of sittings at the palace, as did Alfred Chalon, who encouraged Sully by saying that he would find her "an excellent sitter."[40]

While Stevenson did what little he could to help Sully fulfill the Saint George Society's commission, the artist would not have gotten anywhere near the palace sitting room by the minister's efforts alone. His path from the docks in Philadelphia to Buckingham Palace was anything but clear-cut; Sully worked his way through a veritable maze, guided by casual advice, friendly strangers, and his own good instincts. At times, the means of getting to the queen became ends in themselves.

With portraitists all about London scrambling to present themselves as desirous of a sitting with Her Majesty, the gossip—who was close to getting in, who was out—traveled swiftly. Sully's name reached the grapevine sometime toward the end of December, after Stevenson had received a letter from Lord Melbourne granting Sully a sitting in February.[41] Demonstrating both excessive helpfulness and his own proprietary interests, Wilkie responded to the news by offering Sully elaborate hints on protocol—"Never turn your back. Dress, as though going to a party" and more.[42] Others cautioned him about Wilkie's absurd advice, "as he is noted for a nervous man."[43] At a gathering hosted by the collector John W. Brett, guests quizzed Sully about his plans for his portrait of the queen, "so that I find the fact of her going to sit to me is generally known."[44] He was shocked one evening to overhear one gentleman explain to another "that one of the States had sent me over the Atlantic to execute the portrait—by and by we shall find that I am sent by Congress or [President] Van Buren, as he is a single man."[45] The word-of-mouth made Sully impatient, especially after February came and went. His wish to be "relieved of the uncertainty" was only exacerbated by news from the nosy Mrs. Joshua Bates, whose husband had recommended the Sullys' move, that the queen's physician had declared that she could see no more painters on the basis that so many sittings were detrimental to her health.[46]

When pressed by Sully, Stevenson offered to try Melbourne again, but came back with the answer that it would be better to talk to Lord Lansdowne,

Lord President of the Queen's Council. Sully had already met Lansdowne at a dinner party in his home on February 25 and had queried him about sitting for the queen. Lansdowne apologetically declined to intercede, not wishing to interfere with Lord Chamberlain Conyngham's sitting schedule for her, but his party provided Sully with such magnificent food, conversation, and companionship that his dilemma over the queen was banished from his thoughts, at least for a time. This had become the pattern of Sully's existence, in which the sheer exhilaration of day after splendid day of looking at paintings and spending time with noble ladies and gentlemen was dampened only by the nagging reminder that he had still not reached the queen's sitting room. "Had I been able to have guessed that it would have caused me so much delay and bother," Sully confessed to his wife, "I would not have hampered myself with the commission. The money to be paid for it will be but a scant allowance for the trouble."[47]

Stevenson wrote a letter to the Marquis Conyngham, which Sully himself delivered on March 1. By mid-month, with no news from the palace, Sully listened impatiently to more gossip concerning his quest for a sitting. Brett had heard from Henry Pickersgill, yet another painter attempting to take Her Majesty's portrait (so perhaps an unreliable source, or at least a jealous one), that "there were many persons, who would rather I should not paint the portrait."[48] Brett encouraged Stevenson to have Sully presented at court, but the invariably sensible artist refused: "I thought that would not at all matter, and perhaps give me an erroneous notion of the Queen's manner."[49] John James Audubon ventured the opinion that "from what had passed in negotiations with our minister, that [the queen] would not be painted by me."[50] But lo and behold, when all hope seemed lost, on March 21 Sully received his summons to the palace: after waiting five months for a sitting, he received notice on a Wednesday night for a sitting the very next morning. For this he could thank Stevenson, Conyngham, Melbourne, and, as it turned out, Lord Francis Egerton, whose servant, carrying the momentous royal note in hand, searched the town for Sully that evening before finally slipping it under his door. Sully had no doubt that he had been selected on the basis of his own accomplishments, which were by then well known throughout town, but even the finest painter required pull to get in. In Sully's case, there was another individual whose influence had expedited his connections to everyone else; her name, linked with his, gained him social entrée in the broadest possible sense.

Fanny Kemble Butler: The Muse

Her warmest friends and admirers, are amongst the best and most influential.

Thomas Sully, Journal, February 18, 1838

That Sully painted thirteen portraits of the British actress Fanny Kemble Butler and only eleven of his wife should never impugn the artist's marital fidelity. That both of the paintings that he took with him to London in 1837 to hang in his studio—works that would advertise his talents to prospective clients—portrayed Mrs. Butler presumably indicates that they were the best available works he had for transport. Indeed, several of the thirteen portraits, including the two in question—*Beatrice* and *Isabella* (figs. 17, 18)—are among the artist's most inspired works. That her name comes up frequently in his travel journal, even though she was not in London at the time, is easily explained: she was a much-admired celebrity, and people often talked to him about her. Yet when taken together, these facts define a person dear to Sully, someone he thought of frequently, someone with whom he was, in a word, smitten. It is especially telling that he painted most of her portraits from memory, although he knew her quite well and saw her fairly often when she lived in Philadelphia. She was his muse.

Sully's preoccupation with Mrs. Butler did not reach the intensity of his mentor Lawrence's obsession with Fanny's grandmother, the illustrious Sarah Kemble Siddons, which devolved into scandal and disaster.[51] The personalities and circumstances defined that particular situation, and Sully's scrupulous fascination with a somewhat reluctant actress never matched Lawrence's ardor for the impassioned Mrs. Siddons. The basic parallel between the two artists and their respective fixations on the Kemble actresses, however, is drawn from each portraitist's pleasure at finding a winsome and chameleonic subject. Sully's accomplishments as a theatrical portraitist naturally extended from his family life—the son of actors had friendly attachments to thespians and pursued commissions

FIG. 17. THOMAS SULLY, **FANNY KEMBLE AS BEATRICE**, 1833. OIL ON CANVAS,
30 x 25 IN. (76.2 x 63.5 CM). PENNSYLVANIA ACADEMY OF THE FINE ARTS,
PHILADELPHIA. BEQUEST OF HENRY C. CAREY (THE CAREY COLLECTION)

from them and their agents. He excelled at painting staged portraits, as it were, likenesses that emphasized the idea that every portrait is a performance.[52] Sully gravitated to Fanny Kemble the moment he saw her.

Like Sully, the child of actors, Fanny made her debut in the role of Juliet in 1829 at Covent Garden at the behest of her father, Charles Kemble, who managed the nearly bankrupt theater. Her critically acclaimed performance saved her family from financial ruin and she remained on the stage, however dispassionately at first, in London and other cities, where she toured with her father. In 1832 they embarked on an American tour that began in New York and included stops in many major cities. Fanny reprised her famed rendition of Juliet in Philadelphia in October and Sully, who was in the audience one evening, sketched her portrait. She visited his studio on November 8, after which he painted an oil sketch that he sold to the local lithographer, Cephas Childs. Sully and his wife struck up a friendship with the Kembles and the actress inspired many portraits from the

FIG. 18. THOMAS SULLY, **FANNY KEMBLE AS ISABELLA**, 1836. OIL ON CANVAS, 36 1/4 X 28 3/8 IN. (92.1 X 72.1 CM). PENNSYLVANIA ACADEMY OF THE FINE ARTS, PHILADELPHIA. BEQUEST OF HENRY C. CAREY (THE CAREY COLLECTION)

painter. Within the next year, even while Fanny was touring other cities, Sully painted portraits of her as Bianca in *The Taming of the Shrew*, as Julia in the *Hunchback of Notre Dame*, as *Lady MacBeth*, and as Beatrice in *Much Ado About Nothing*. She halted her tour in 1834 when she consented to marry Pierce Butler of Philadelphia and Butler's Island, Georgia, who had reportedly followed the actress from theater to theater in an effort to woo her. For Butler, who was Sully's cousin, the artist painted two identical portraits, one for him and one to send to her family in England (fig. 19). Neither Fanny nor her family appreciated the exquisitely inspired composition, which they thought failed to capture the boisterous and impulsive young woman they knew so well. Said Fanny: "I do not feel very sanguine about it for Sully's characteristic is delicacy rather than power, and mine may not be power, but it is certainly not delicacy."[53]

Sully's penchant for idealizing women—soft focus, perfect skin, glossy hair, pretty face, and enchanting facial expression—was magnified in his portraits of

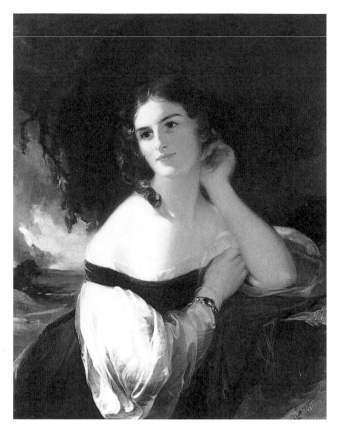

Fanny, whose sauciness impressed him as sheer vitality. The life of the party
wherever she went, Fanny captivated the company in her midst, whether men or
women. Before coming to America, her fame provided entrée into the upper eche-
lons of London society, where she was respected and admired not merely for her
acting but primarily for her engaging personality and swarthy good looks. It may
have been impossible for any portraitist to convey the fully dimensional Fanny
Kemble, but Sully succeeded in evoking the extraordinary sensuous charisma
that captivated her public audiences and private dinner partners alike.

 After her marriage, Mrs. Butler lived in Philadelphia, with seasonal trips to
Butler's Island, and the Sullys saw her frequently. But she was nowhere more
constantly in the artist's thoughts than when he was in London. Sully visited fre-
quently with Charles Kemble and his family, in whose home were portraits of
Fanny and also the lively presence of her sister Adelaide, an opera singer whose

voice and gestures reminded him of the absent actress.[54] Mrs. Butler was a spectral presence at virtually every aristocratic gathering to which Sully had been invited. Lord and Lady Lansdowne welcomed him into their home again and again after first receiving a letter of introduction for the artist from his friend, Mrs. Butler. Samuel Rogers, the Egertons, the Dacres, the Fitzhughs, the Jamesons, and so many other members of polite and noble society extended their kindness to Sully on the basis of their mutual friendship with the actress.

In this company, the absent Fanny Kemble Butler often assumed the largest presence. "Lady L[ansdowne]," Sully wrote, "is not old, nor remarkably handsome, but you soon forget every want in her pleasant manner and sweet voice, that put me in mind of dear Fanny Butler—by the way I sat next to a clergyman at dinner who asked me if I knew and loved her as he did."[55] Sully and Francis Egerton visited regularly to discuss three topics of apparently equal importance to them: "the arts, America, and Mrs. Butler."[56] Like her husband, Lady Egerton wanted nothing more than to talk about Mrs. Butler, to the extent that Sully "quite neglected dining" one evening in favor of sharing Fanny stories.[57] At home in his modest rooms, Sully could count on his daughter for more mentions of the actress, for she saw on her walks about London visions of Mrs. Butler at every turn.[58] Upon catching sight of the queen at the opera, Blanch decided that she, too, looked like the actress.

Sully eventually made his way to the queen's sitting room through the aegis of Lord Melbourne, and even he was not without connection to Mrs. Butler. He knew her quite well and although he seems not to have been previously aware of her friendship with Sully, he recognized the fact at the crucial moment. Indeed, Sully might not have ever reached the queen without Fanny. Even before Stevenson had begun courting the necessary powers, it seems to no use, Mrs. Butler had written to Lord Egerton, who prevailed upon Melbourne and effectively gained Sully his sitting. Some weeks before, Egerton had found his way to Sully's apartment in Great Marlborough Street at Mrs. Butler's recommendation. Much to the artist's amazement—and to his daughter's pleasure at the sight of their extremely handsome and noble visitor—Egerton offered the assurance that "my name should always be a passport."[59] And so it was that Fanny paved the road to the queen's closet, and, for that matter, beyond. When poised to approach Her Majesty with some degree of trepidation, Sully was stopped short when the queen too wished to talk about the actress: "She is not so pretty as her sister, I believe," said Victoria. "I think Miss Kemble is rather thin."[60] The plump queen may never have imagined that her American painter would inflect her royal image with shades of Fanny.

Queen Victoria by Thomas Sully

In Beatrice, high intellect and high animal spirits meet, and excite each other like fire and air. . . . She has not only an exuberance of wit and gaiety, but of heart, and soul, and energy of spirit.

Mrs. Jameson, *Characteristics of Women*

While Fanny Kemble Butler dutifully remained in the states by the side of her husband, her painted surrogate in the guise of Shakespeare's Beatrice arrived in London just before Christmas 1837. Sully had struggled through the fall to get through customs the painting and its companion, the portrait of Fanny in the role of Isabella (see figs. 17 and 18). When his travails with the duty office had finally been resolved, he was devastated to discover that "they had knocked a hole in the picture of Beatrice, and much injured the frames."[61] He sent the painting to the Bond Street art dealers John M. and Samuel Smith, who repaired the damage in time for the annual exhibition at the British Institution, so that, in fact, the paintings did not hang in his rooms for all to see during the winter, as he had intended. On varnishing day at the British Institution, February 5, 1838, while other painters retouched their work, Sully wandered about observing with some measure of astonishment the major alterations invoked by the artists—especially J. M. W. Turner, who completely changed the appearance of his seascape with a last-minute wash of brown watercolor over the oil paint—and upbraided himself over his submissions to the show: "My own works, I see, are on too low a scale of color, and my usual fault of weakness of effect is *very* apparent here."[62] Yet he neither touched up *Beatrice* and *Isabella*, nor withdrew them from the show. On the contrary, by boosting the color scale and strengthening the overall effect, he would make the queen his Beatrice.

Perhaps it was Blanch's influence that fused Mrs. Butler and Queen Victoria in Sully's mind, but he found similarities of his own. For both Sullys, it was a matter of carriage and attitude rather than physical semblance. Blanch thought

the queen "a good-natured, fat face, ugly likeness of Mrs. P. Butler," and Thomas saw "a mixture of character in [her] personage resembling Fanny Kemble—she calls Lord Melbourne 'Mel' and the Duke of Wellington "Well'."[63] Before Sully met the queen, he had heard from others, including artists for whom she had sat, bits and pieces about her feisty disposition and lively personality, characteristics that would have reminded him of Mrs. Butler. He would have read some of the scores of articles and essays in the daily press speculating about her personality and nature, which would also have linked her temperament with that of the actress. "We may hope," reported one source, "that England will experience the advantage, for the first time, of having a queen brought up in a mother's arms, and in a manner at once feminine and wise. We may, in that case, look to see womanhood on the throne in its best character; and such as may give life and advancement to what is best and manliest in the hopes of the world."[64]

Sully approached his commission to paint the queen intending to produce a work of great beauty and strength. If he suffered any uneasiness at the prospect of conveying the queen's character or appearance he did not mention it in his journal or letters home. His task, to paint a portrait for a meeting room in Philadelphia, differed from that of the English painters who aimed to make a name for themselves in noble circles. Indeed, Sully seems to have understood that his position outside of the fray gave him the opportunity to remedy the flaws he recognized in the portraits he had seen while waiting his turn, particularly the one by Hayter. He had seen Hayter's portrait on view at Colnaghi's in February: "I think the picture a failing, both as a work of art and portrait. It is too old, too large, and too cross looking."[65] These defects must have been all the more glaring after Sully finally met the queen. "I should be gratified," he wrote after his first sitting, "if I were able to give an idea of the sweet tone of voice, and gentle manner of Queen Victoria! It was impressive of dignity and mildness, and at the same time I felt quite at my ease, as tho in company with merely a well bred lady."[66]

Sully's sense of ease translated into an image that took remarkable liberty in both his portrayal of the queen and his interpretation of state portraiture. It seems that he contemplated portraying Her Majesty in plain clothes, a notion his son, the portraitist Thomas Sully, Jr., urged him to strike from his thoughts: "Robes again I say," he urged his father, and on another occasion, "I hope you will paint the Queen . . . *in her robes, of course*, for it will do for a portrait of anybody without them, and we are not used to seeing such things here."[67] Sully may have taken his son's advice to heart, but it was Hayter's painting that convinced him of what he must do. He set out to better Hayter's egregiously orthodox composition by setting it to memory and then transforming it into an image suited to

his particular vision. Sully joined the coronation-year game of one-upmanship by going so far as to use the valuable parts of the competition's work for his own purposes. He sketched the queen's robes as delineated by both Hayter and Chalon "as memorandums of the dress" and visited the House of Lords to take careful sketches of her throne (fig. 20) and footstool, but never with the slightest idea that he would follow their conventional approaches to portraying the monarch.[68] Quite the contrary, Sully learned the local vocabulary but inflected it in a much different pattern. It was the same queen in precisely the same robes and jewelry in exactly the same setting, but now portrayed on Sully's terms: young, petite, and enchanting rather than old, large, and cross.

For Sully, Fanny Kemble Butler epitomized enchantment, and *Beatrice*, the picture that was on his mind during much of his first few months abroad, became the logical point of departure for his image of the queen. Sully's bust-length oil study (fig. 21), executed over the course of four sittings at Buckingham Palace, is the implicit sister image to *Beatrice*. If Fanny Kemble Butler and the queen shared fundamental traits—gentle women streaked with impertinence and vivacity—

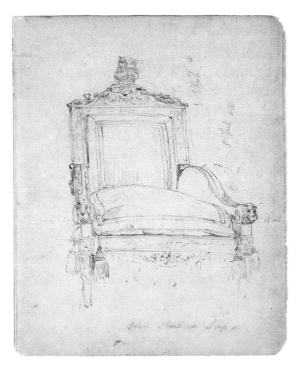

FIG. 20. THOMAS SULLY, **STUDY OF THE THRONE IN THE HOUSE OF LORDS**, 1838. GRAPHITE ON PAPER, 11 3/4 X 18 3/4 IN. (29.8 X 47.6 CM). COLLECTION OF MRS. ARTHUR A. HOUGHTON, JR.

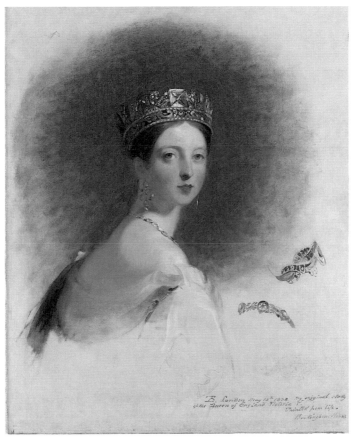

FIG. 21. THOMAS SULLY, **QUEEN VICTORIA**, 1838. OIL ON CANVAS, 36 X 28 3/8 IN.
(91.4 X 72.1 CM). THE METROPOLITAN MUSEUM OF ART, NEW YORK.
BEQUEST OF FRANCIS T. S. DARLEY, 1914

then either of them could figure as Beatrice, a character whose essence is her per-
fectly honed femininity laced with an intelligent wit, a strong temper, and an
overriding degree of sensibility. As painted by Sully with a bare back and come-
hither gaze, Mrs. Butler is the modern personification of one of Shakespeare's
most compelling female characters. The portrait of *Beatrice* served as the perfect
prototype for Victoria's portrait, both in concept and form: the role suited the
young queen's personality, and Sully's composition flattered her physical appear-
ance. Sully wrote a fairly precise description of Victoria's appearance in his
journal, noting that she was "of good form, particularly the neck and bosom."[69]
While propriety forbade him from calling attention to her décolletage, he felt free
to feature the lovely expanse of her back that no other portraitist would dare
commit to canvas.

FIG. 22. THOMAS SULLY, MUSIDORA, 1813–35. OIL ON PANEL,
28 1/8 X 22 1/2 IN. (71.4 X 57.2 CM). THE METROPOLITAN MUSEUM OF ART, NEW YORK.
GIFT OF LOUIS ALLSTON GILLET, IN MEMORY OF HIS UNCLES,
SULLY GILLET AND LORENZO M. GILLET, 1921

The greatest license Sully took in portraying Victoria as a lovely young woman was to express her sensuality. This comes across in the oil study, in which he described her neck and shoulders in the succulent, painterly style that characterizes his best work. The attentive brushwork matches that lavished on the portrait of Fanny Kemble Butler and provokes the idea, which holds true in Sully's oeuvre, that a portraitist's most beautiful works are those involving a captivating sitter. This was certainly so of Sully's portraits of Mrs. Butler and Queen Victoria, who inspired the artist's finest technique. It was also true of another subject that had distracted him for decades: *Musidora* (fig. 22). Between 1813 and 1835, Sully worked on this picture, his only nude and, as reward for twenty-five years of effort, arguably the most beautiful nude painted in America in the early nineteenth century.

The painting depicts an episode from James Thomson's poem *Summer* from his opus *The Seasons*. Sully's choice of subject was inspired by Leslie's *Musidora Bathing* (1812; location unknown), which that artist had copied from West's *Arethusa* (c. 1802; location unknown), a scene derived from the fifth book of Ovid's *Metamorphoses*.[70] The climactic moment in the story of the maiden Musidora, as in the tale of the nymph Arethusa, occurs when her lover comes upon her bathing in a forest stream. His gentlemanly understanding of her modesty and concern for her virtue so impresses her that she confesses her love for him. In Sully's version of the tale, there is no lover peering through the trees, only Musidora looking over her shoulder into the forest, as if hearing the rustle of footsteps. The beauty of Sully's conception comes in its lack of narrative device and the sheer expressive power of the unclothed female figure. Musidora's anatomy is carefully guarded, so that her legs, abdomen, and back become provocatively sensual, a vision both chaste and erotic. Musidora is not a courtesan, but simply a young woman caught unawares while bathing. By extension, Queen Victoria, her bare back exposed to her audience, is caught unawares in a moment before she is seated.

Sully's pose for Victoria, on approach to her throne rather than seated in it, was key to his interpretation. Although he would not paint his full-length portrait until he returned to Philadelphia in the autumn of 1838, he clearly conceived his composition from the start. Each of Sully's various sketches of the robes and body positions (figs. 23–28) describes the queen from the back, rather than the front. Much later in life, Sully would explain that because of her height "had she been seated, the draperies would have spoiled the whole effect."[71] In response to her question of his preferred pose at the first sitting, he asked "that her Majesty would indulge me by turning her head in another position."[72] It can only be pre-

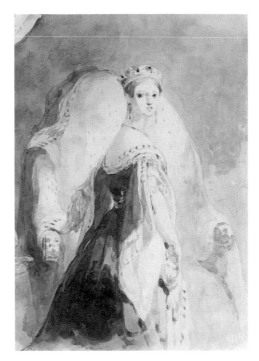

FIG. 23. THOMAS SULLY, STUDY FOR QUEEN VICTORIA, 1838.
BLACK INK ON PAPER, 9 X 6 3/8 IN. (22.9 X 16.2 CM).
COLLECTION OF MRS. ARTHUR A. HOUGHTON, JR.

FIG. 24. THOMAS SULLY, STUDY OF QUEEN VICTORIA'S NECKLINE, 1838.
GRAPHITE ON PAPER, 7 1/16 X 10 5/8 IN. (18 X 27 CM).
COLLECTION OF MRS. ARTHUR A. HOUGHTON, JR.

FIG. 25. THOMAS SULLY, **STUDY OF QUEEN VICTORIA'S ROBES**, 1838.
GRAPHITE ON PAPER, 9 1/16 X 7 3/8 IN. (23 X 18.8 CM).
COLLECTION OF MRS. ARTHUR A. HOUGHTON, JR.

FIG. 26. THOMAS SULLY, **STUDY OF QUEEN VICTORIA'S ROBES**, 1838.
GRAPHITE ON PAPER, 9 X 7 3/8 IN. (22.8 X 18.8 CM).
COLLECTION OF MRS. ARTHUR A. HOUGHTON, JR.

FIG. 27. THOMAS SULLY, **STUDY OF QUEEN VICTORIA'S TRAIN**, 1838.
GRAPHITE ON PAPER, 7 3/8 X 9 IN. (18.8 X 22.8 CM).
COLLECTION OF MRS. ARTHUR A. HOUGHTON, JR.

FIG. 28. THOMAS SULLY, **STUDY OF THE QUEEN'S TRAIN**, 1838.
GRAPHITE ON PAPER, 9 1/16 X 14 3/4 IN. (23 X 37.5 CM).
COLLECTION OF MRS. ARTHUR A. HOUGHTON, JR.

sumed that she had sat down to face Sully, as would have been the usual course for a sitting, and that he turned her around. The pose matched Victoria with Fanny as Beatrice, and both by extension with Musidora, but it also derived from an image he had recorded in one of his sketchbooks at an earlier date as an idea of a highly flattering posture for a young woman (fig. 29). This sketch is not connected to any other painting by Sully and so can justifiably be considered a study for his portrait of Queen Victoria, although it may very well have been inspired by his encounter with the figure of Lady Mary Villiers in Anthony Van Dyck's portrait of Philip Herbert, fourth Earl of Pembroke, and his family (fig. 30), which Sully could have seen at Wilton House on his first trip to London or, more likely, in a print. In Van Dyck's highly theatrical composition, he gives center stage to the woman whose marriage enhanced the Pembroke family's economic and political influence; she is shown, to use the words of Christopher Brown, "as a great prize intrigued for and won."[73] The device of Lady Mary's position in front of a semicircle of her new family suggests a secular version of a traditional religious presentation. Sully cleverly used the pose to portray Victoria as the subject of a presentation who would, when she reached the top of the stairs, become the divine ruler to whom all others would thereafter be presented. In a brilliantly innovative take on state portraiture, Sully chose the moment of Victoria's literal and physical ascendance in order to convey her dignity and humanity, her femininity and strength.

Ironically, Victoria could not gracefully climb stairs. Sully noted this after his first sitting: "It gives her pain to ascend or descend steps—this does not proceed from any defect in the foot or ankle, but I fear from something wrong in the knee. And perhaps this may take somewhat from grace and ease in her walking."[74] He sympathetically described the help she required in order to get into and out of the sitting chair, and then generously allowed her to move in her portrait in the agile and flowing manner of which she was physically incapable. His pose also made her appear taller than her actual sixty-one inches, the fact of which he was well aware as she gave him a ribbon cut to her exact height (fig. 31). "If you show this measurement when you return to America," Victoria predicted, "they will say, what a little Queen the English have got."[75]

The sheer magnificence of Buckingham Palace and prominence of Queen Victoria was not lost on Sully, who after one of his sittings searched for any sort of item that he could spirit away as a souvenir and ended up lifting a piece of fluff from her footstool and on another occasion gratefully accepted her autograph (fig. 32) "as a remembrance." But he seems never to have forgotten that she was first and foremost a girl.[76] This fact impressed him at each of the sittings, which

FIG. 29. THOMAS SULLY, **STUDY, POSSIBLY FOR QUEEN VICTORIA**, 1838.
IRON GALL INK AND WATERCOLOR ON PAPER, 18 13/16 X 11 1/2 IN. (47.9 X 29.2 CM).
THE BROOKLYN MUSEUM OF ART, NEW YORK.
GIFT OF THE AMERICAN ART COUNCIL

FIG. 30. ANTHONY VAN DYCK (FLEMISH, 1599–1641), **PHILIP HERBERT, FOURTH EARL OF
PEMBROKE, AND HIS FAMILY**, C. 1635. OIL ON CANVAS, 130 X 200 3/4 IN. (330 X 510 CM).
COLLECTION OF THE EARL OF PEMBROKE, WILTON HOUSE, SALISBURY

FIG. 31. TAPE MEASURING THE HEIGHT OF QUEEN VICTORIA, PRESENTED TO THOMAS SULLY, 1838.
COTTON TWILL, 61 1/4 X 1/2 IN. (155.6 X 1.27 CM). COLLECTION OF MRS. ARTHUR A. HOUGHTON, JR.

FIG. 32. QUEEN VICTORIA'S AUTOGRAPH, PRESENTED TO THOMAS SULLY, 1838. INK ON PAPER,
7 1/8 X 4 5/8 IN. (18.1 X 11.7 CM). THE METROPOLITAN MUSEUM OF ART, NEW YORK

were enlivened by giggly ladies-in-waiting and spunky pets. At one sitting, Sully mentioned that the ladies "greatly aided me by keeping up a lively conversation; it was of advantage as the Queen could throw aside constraint and laugh and talk freely like a happy innocent girl, of eighteen—Long may she feel so light of heart!"[77] If there was ever any doubt of the true nature of a girl the queen's age, Sully would have been reminded of it every day by his own twenty-one-year-old daughter (fig. 33), who shared everything with him during their year abroad together. A man surrounded by many children in his bustling Philadelphia home, Sully had only Blanch to concern him in London, and while he devotedly wrote to the others, he minded Blanch's every need, from new clothes to cologne at Christmas to proper medicines when she felt poorly to the modest meals they enjoyed together. The two of them lived in three rooms for ten months, a situation that acquainted Sully with nearly all of the habits of a young woman.

Blanch became intimately entwined with what she called "this Queen's business" by sitting in Victoria's stead on a number of occasions.[78] On May 15, 1838, Blanch wore the George IV diadem that appears in the portrait, making her the only American ever to have worn the British crown. She agreed to help her father on the promise that the queen would not see her in the crown, but when Victoria appeared and was amused by the sight of Blanch in her jewels, the two girls chatted and laughed. Blanch spent two days with her father at the royal

FIG. 33. THOMAS SULLY, **BLANCH SULLY**, 1839. OIL ON CANVAS,
27 1/8 X 22 1/8 IN. (68.9 x 56.2 CM). TERRA MUSEUM OF AMERICAN ART, CHICAGO

dressmakers. She donned the complete state robes and struck the pose in the interest of helping him get it right. Her favor in this enterprise was granted in the form of extra sittings, but her more vital contribution was in bringing her youthful presence to bear on her father's work. As his helpmate and his model, his breakfast companion and substitute queen, Blanch kept his production in check by reminding him every day that their ultimate goal was to arrive back home as soon as possible, queen or not.

The Lawsuit and the Legacy

We have been induced thus to petition your Majesty in consequence of the contemplated departure of Thomas Sully, Esq., for England, whom we beg leave to recommend to your Majesty as the most finished artist in portraits in America, who would do ample justice to your picture, and who combines in himself the various recommendations of being an Englishman by birth, an accomplished artist and a gentleman.

*The Society of the Sons of Saint George, Philadelphia, to Queen Victoria, October 9, 1837**

In England, only those who lived to see the queen's Golden Jubilee of 1888 would have a chance to view Sully's finished picture (frontispiece), although the artist left behind ample clues as to its appearance when he sailed from London in early August 1838. Before his departure, he asked the British portraitist John Wood, whose manner of painting was similar to Sully's, to paint a copy of his oil study (fig. 34) for safekeeping, perhaps fearing that his original study might suffer the same damage in transit as did *Beatrice*. He had also painted a large engraver's version of the portrait: Her Majesty's designated print-sellers, the firm of Hodgson and Greaves, kept track of Victoria's sittings to various artists, and as early as April 9 called on Sully. They invited him to dinner at their Pall Mall gallery on May 2, and two weeks later visited the artist at home and "bespoke a half length portrait of the Queen," for which they would pay two hundred pounds.[79] Anxious to return home but in need of money, Sully reluctantly accepted the commission and swiftly completed the picture, at least to

* The complete memorial to Queen Victoria, signed by the president and vice-president of the Society of the Sons of Saint George, is transcribed in *A History of the Society of the Sons of Saint George* (Philadelphia: Theodore C. Knauff, 1923), 97.

FIG. 34. JOHN WOOD (ENGLISH, 1801–1870), AFTER THOMAS SULLY,
QUEEN VICTORIA, 1838. OIL ON CANVAS, 30 X 25 IN. (76.2 X 63.5 CM).
PRIVATE COLLECTION

his own liking, by early June (fig. 35). The artist, whose only difficulty with the queen was in arranging sitting times, and who enjoyed complete independence as to his manner of portrayal, found the royal print-sellers "too much disposed to cavil and find fault."[80] He listened to their "hypercriticism" but refused to alter the painting to suit them or their engraver, Charles Wagstaff: "I am displeased with the pretense of this Hodgson, he grants that all are pleased with the picture, the subscription large, the Queen's name at the top of the list—and yet he wants more done. But I decidedly refused to be imposed upon."[81] Sully was vindicated in his refusal to make alterations by Victoria's good word. Hodgson wrote Sully in July, just before the painter was to leave for a trip to Paris before going home, that the queen liked the painting so much that she "expected to have seen you again before you left England," and encouraged him to postpone his departure and pay her a visit while the portrait was at Buckingham Palace for her approval.[82] A man in firm possession of his priorities, Sully left for France as scheduled.

He also received high praise when the print (fig. 36) appeared in London in early April 1839—"it is by far the most striking likeness, and the most agree-

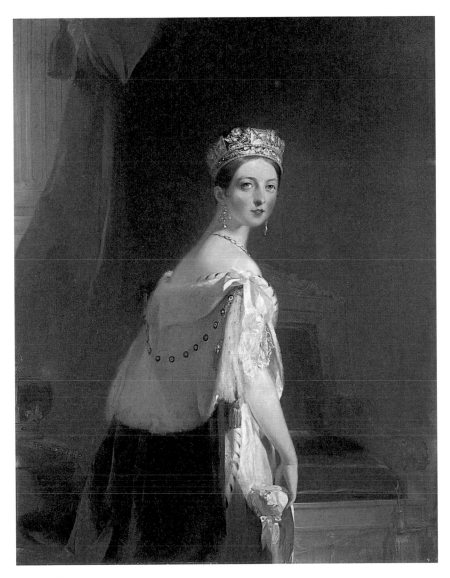

FIG. 35. THOMAS SULLY, **QUEEN VICTORIA**, 1838. OIL ON CANVAS,
56 1/8 X 44 1/4 IN. (142.5 X 112.5 CM). THE WALLACE COLLECTION, LONDON

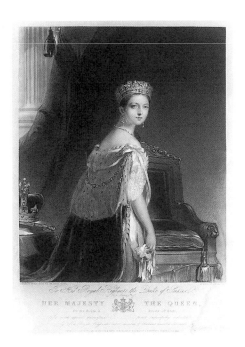

FIG. 36. CHARLES EDWARD WAGSTAFF (ENGLISH, BORN 1808),
AFTER THOMAS SULLY, **QUEEN VICTORIA**, 1838. MEZZOTINT.
PUBLISHED BY HODGSON AND GREAVES, 1839.
NATIONAL PORTRAIT GALLERY, LONDON

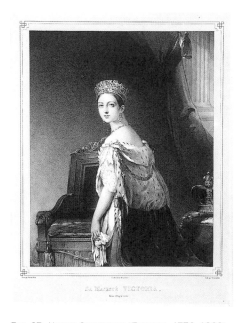

FIG. 37. HENRI GREVEDON (FRENCH, 1776–1860),
AFTER THOMAS SULLY, **QUEEN VICTORIA**, C. 1839. LITHOGRAPH.
BRITISH MUSEUM, LONDON (1870/7/9/680)

able portrait, of her who rules over the destiny of Great Britain, that has yet appeared"—and then was subsequently published in France (fig. 37) and in Germany (fig. 38).[83] The print and the half-length pulled Sully into the fray of coronation-year portraiture competition and kept his image of the queen alive in England for more than a decade. His portrait was the favorite of *The Art-Union* editors—"it is likely to throw all others into the shade"—and in due course inspired copies by a number of artists, including Denning and William Warman, among others (figs. 39–41).[84] In January 1839, Lord Lansdowne confided to Mrs. Butler in a letter that "all the portraits hitherto painted of her Majesty have been comparatively a failure, except Mr. Sully's who had . . . caught an expression which was peculiar and very favourable."[85] By the spring, the word on the streets of London, at least as it was reported to America, was that Sully's portrait "is generally acknowledged by London connoisseurs to convey the best likeness of her majesty that has yet been offered to the publick."[86] A writer for the *London Examiner* reported that "it is quite understood to be the prevailing opinion of the Court circle that the American artist has succeeded in rendering the best and the most graceful likeness of our youthful Queen," and further congratulated

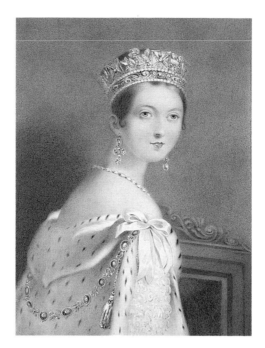

FIG. 39. W. WARMAN, AFTER THOMAS SULLY, **QUEEN VICTORIA**, AFTER 1838. WATERCOLOR ON BOARD, 13 3/4 X 12 IN. (35 X 30.5 CM). NATIONAL PORTRAIT GALLERY, LONDON

FIG. 40. STEPHEN POYNTZ DENNING, AFTER THOMAS SULLY, **QUEEN VICTORIA**, C. 1840. WATERCOLOR AND GOUACHE WITH GUM VARNISH ON PAPER, 15 3/8 X 13 3/4 IN. (39.1 X 35 CM). THE WALLACE COLLECTION, LONDON

FIG. 41. UNIDENTIFIED ARTIST, AFTER THOMAS SULLY,
QUEEN VICTORIA, N.D. OIL ON CANVAS, 15 X 11 1/4 IN. (38.1 X 28.6 CM).
ARIZONA STATE UNIVERSITY ART MUSEUM, TEMPE

Sully "upon having had the opportunity of transmitting such an original to his own country; for we have a strong notion that the opulent and moral descendants of William Penn would not have sent him over to furnish them with 'a counterfeit presentment' of any bloated debauchee, or vulgar old sailor, who might have filled a very high office with us. The idea of a gifted and a virtuous young female's sway will not be repulsive to the sternest republican."[87]

Later that year, Sully copied the image in bust-length (fig. 42) as a gift for his friend Samuel Rogers, who had shown him such great kindness during his year abroad. While this beautiful, reduced image was seen by visitors to Rogers's home, the half-length made its public debut at the annual exhibition of 1840 at the Royal Academy, where Hodgson and Greaves sold it to an English gentleman, Charles Meigh of Grove House, Shelton, who no doubt enjoyed his private audience with Sully's graceful queen. The portrait enjoyed a brief revival at the Crystal Palace Exhibition of 1851, where it was reincarnated as a bejeweled brooch (fig. 43) and highly embellished cabinet door (fig. 44), coupled with another artist's rendition of Victoria's husband, Prince Albert. In subsequent years, Sully's image was copied by a number of artists working in London: in miniature by D. G. Lamont and by George Freeman as a gift to Sarah Coles Stevenson—

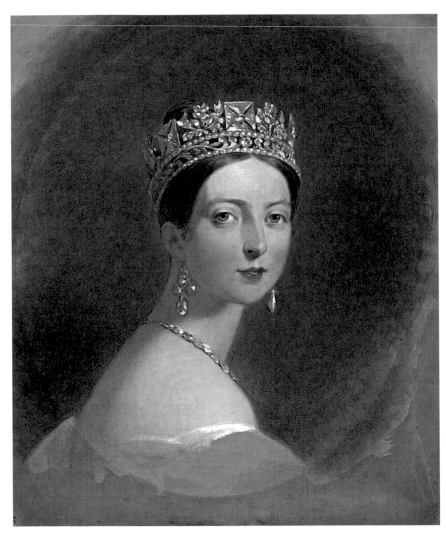

FIG. 42. THOMAS SULLY, QUEEN VICTORIA, 1839. OIL ON CANVAS,
24 1/8 X 20 1/8 IN. (61.3 X 51.1 CM). THE ROYAL COLLECTION, LONDON

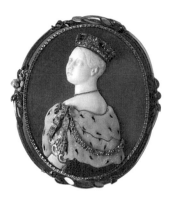

FIG. 43. FELIX DAFRIQUE AND PAUL LEBAS (FRENCH), AFTER THOMAS SULLY, QUEEN VICTORIA,
1851. SHELL CAMEO, MOUNTED WITH GOLD, ENAMELED AND SET WITH TABLE-CUT
AND CABACHON EMERALDS AND ROSE-CUT DIAMONDS; GOLD FRAME WITH ENAMELED ROSES,
HEIGHT 2 IN. (5.1 CM). VICTORIA AND ALBERT MUSEUM, LONDON

FIG. 44. CABINET ON STAND (WITH PORTRAIT OF QUEEN VICTORIA AFTER THOMAS SULLY
ON CABINET DOOR), C. 1848. MADE BY MCCULLUM & HODSON (BIRMINGHAM).
PAPIER-MÂCHÉ, WITH OTHER MATERIALS, 52 3/4 X 26 3/8 X 23 5/8 IN. (134 X 67 X 60 CM).
COLLECTION OF OTTO VON MITZLAFF, FRANKFURT

wife of the American minister—and in oil by Charles Cohill, Richard Rothwell, and Daniel Maclise.

Meanwhile back in America, Sully received more notoriety for his portrait of Victoria than he might have ever imagined, although he anticipated enough fanfare to convince him to paint two portraits instead of one. On September 30, 1838, he began the full-length portrait for the Sons of Saint George, and three days later set up a canvas of equal size for another painting that he would send on tour.[88] Sully did not realize that the Society had the same thing in mind, perhaps because even before the queen had sat for him, he had secured the Society's permission to have his portrait engraved and exhibited in London, if such opportunities arose.[89] "I am quite astonished," he wrote after a committee of Society members visited him on November 25 to check his progress and deliver an advance of five hundred dollars, "to find that they expect to exhibit this picture for cash on their own account—by which I should lose all the profits I have looked to as a return for the extraordinary trouble I have had."[90]

The committee members were equally astonished by the sight of two identical pictures where they thought there would be one. Within a fortnight, the Society sued the artist for taking liberties with what it considered to be its exclusive property. Salt on the wound for Sully came in the form of an offer of eight thousand dollars from a Mr. Mitchell of New Haven for one of the portraits, which he could not accept because of a Supreme Court injunction. Sully retained as his counsel John Kintzing Kane, one of the gentlemen who had funded his trip to London, but the initial negotiations failed to bring the matter to an amicable conclusion. After months of out-of-court bargaining—during which time Sully went so far as to contemplate surreptitiously sending his painting to London and the Society proposed the outlandish idea that Sully should pay them for the second portrait—the Society and the artist brought their cases before a committee of arbitration from the Bar Association of Philadelphia. The decision named Sully the author of the image and proclaimed that while the Society owned the painting, it did not have propriety over "the design or invention."[91] It was a Pyrrhic victory for Sully, who retained the right to paint and exhibit a second, identical portrait of the queen, but could not prohibit the Society from exhibiting their painting for their own benefit. The ruling set him up as his own competition. As that was the case, he trounced himself by valuing his picture at two thousand dollars, twice that of the Saint George version.[92] He also fastidiously recorded the palette he used for the portrait, in case he should ever care to paint yet another version of it (fig. 45).

If any good resulted from the debacle it was in the form of heightened at-

FIG. 45. THOMAS SULLY, **DIAGRAM OF COLORS USED TO PAINT QUEEN VICTORIA**, 1838.
OIL AND INK ON PAPER, 4 7/8 X 7 11/16 IN. (12.4 X 19.5 CM).
COLLECTION OF MRS. ARTHUR A. HOUGHTON, JR.

tention paid to Sully not only by his fellow artists, including John Neagle, Rembrandt Peale, Henry Inman, and others who drew up petitions in his support, but also by a sympathetic press. The Philadelphia papers, which were coincidentally edited by members and friends of the Society, lauded Sully's painting while keeping silent on the issue, except to discreetly mention that "it is only necessary to announce to the public that the difficulties have been reconciled."[93] The New York press alleged that the Society's commission to Sully "was not an impulse of loyalty, which induced her liege subjects, in Philadelphia, to beg her gracious permission to sit to Sully, but a motive of speculation, a huckstering desire for gain."[94] The same papers redoubled their support for Sully by anticipating that the finished portrait would brilliantly manifest his "gifted and glowing pencil" and "add to the fame of the estimable and modest artist and will be visited by thousands."[95]

Sully fulfilled every expectation of the portrait's quality and beauty when he showed his version in New York, Boston, and Washington, and the Saint George Society showed theirs in Philadelphia and Quebec during the summer and autumn of 1839.[96] The tours inspired a number of copies, including one so faithful as to have been attributed to Sully well into the twentieth century (fig. 46). In Quebec, the portraitist and landscape painter Joseph Légaré, who was

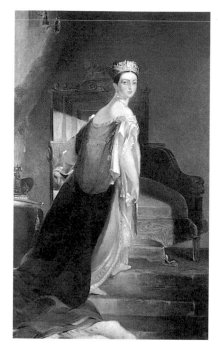
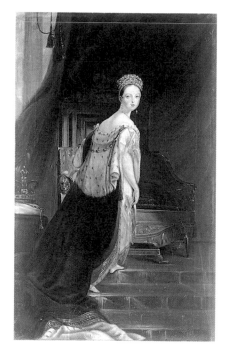

FIG. 46. UNIDENTIFIED ARTIST, AFTER THOMAS SULLY, QUEEN VICTORIA, N.D.
OIL ON CANVAS, 94 X 58 IN. (238.8 X 147.4 CM). BELMONT MANSION, NASHVILLE, TENNESSEE

FIG. 47. JOSEPH LÉGARÉ (CANADIAN, 1789–1855), AFTER THOMAS SULLY, QUEEN VICTORIA,
1839. OIL ON CANVAS, 41 7/16 X 26 IN. (105.2 X 66 CM).
MUSÉE DE LA CIVILISATION, DÉPÔT DU SÉMINAIRE DE QUÉBEC, CANADA

also the proprietor of the gallery that displayed Sully's painting, copied the picture twice, once as a small full-length (fig. 47) and the other on an actual-size canvas (fig. 48).[97] The artist sent his portrait south in 1845 as a gift to the Saint Andrew's Society of Charleston, South Carolina, a group that had expressed interest in buying the painting years before. This gesture acknowledged his early connection to that city and rather slyly put the Scottish organization on equal footing with its English counterpart, or perhaps a bit ahead, since the Scots had the two-thousand-dollar picture without having made the commission or paid the price. The painting was welcomed with grand praise and hung in Saint Andrews Hall (fig. 49) until 1865, when it was moved for safety out of Charleston to Columbia, where it burned with the rest of the city.[98]

North Americans accustomed to seeing prints after Hayter's and Chalon's portraits championed Sully's less formal iteration of the type. Wrote the critic for the *Corsair* in New York, "Other portraits represent her as a youthful Semi-

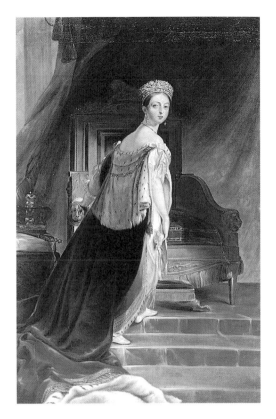

FIG. 48. JOSEPH LÉGARÉ, AFTER THOMAS SULLY, **QUEEN VICTORIA**, 1839.
OIL ON CANVAS, 95 X 61 IN. (241.3 X 154.9 CM). MUSÉE DE LA CIVILISATION,
DÉPÔT DU SÉMINAIRE DE QUÉBEC, CANADA

FIG. 49. COMMITTEE ROOM, ST. ANDREW'S HALL, CHARLESTON, SOUTH CAROLINA.
FROM **HARPER'S WEEKLY**, MAY 5, 1860, P. 276.
COLLECTION OF THE NEW-YORK HISTORICAL SOCIETY, NEG. NO. 77343

ramis—a crowned Christina; but visit Sully's breathing, life-like portraiture of England's queen, and the dignity and pomp of state will vanish, and there stands revealed before you a maiden youth, 'a fair vestal throned in the West,' of an aspect so innocent and lovely, and with a step so firm yet sylph-like, that Republicans as we are, we were half inclined to bow the knee in homage."[99] A poet for *Godey's Lady's Book* encapsulated the American experience of viewing the painting without the encumbrance of subjecthood:

> *Victoria*, she by Sully's skill
> Enshrin'd on canvass, for the usual fee
> Is view'd and worshipp'd—whosoever will
> Adores. *Domestic* deities for me!
> Each to his taste, however;—all are free;—
> "Our glorious ancestors," *et cetera*—fought
> For liberty;—their proud descendants, we,
> Worship or not, as suits us;—so we ought;—
> That privilege we claim, being free in deed and thought![100]

With copies remaining behind in virtually every port of the tour, engravings for sale in shops throughout the country, and the original picture in Philadelphia, Sully's image of Victoria stood for decades as America's concept of the young queen. If the portrait bore a peculiarly American trait, it was its aspect of impiety: a state portrait apparently painted by a rake. The image appealed to those seeking the truth about the queen, and in that regard was not particularly American, but rather non-English. Sully's version of the truth influenced at least two other artists who shared his attitude, if not his homeland. These were artists who, like him, exploited their freedom to portray the queen as they wished, rather than as the court might have preferred. Perhaps the ultimate compliment was paid him by Edwin Landseer in the portrait he painted of Victoria in 1839, just after the publication of Sully's engraving (fig. 50). Sully greatly admired Landseer's works, seeking them out all over London and recording his high praise over and over again. "His expression, composition, coloring and his management of his materials is exquisite," he wrote. "Bold and free . . . yet great breadth of effect."[101] The American artist would have been flattered by the similarity between his and Landseer's portraits of Victoria, both of which not only put forth her creamy shoulders as one of her best physical attributes, but also are anomalies in their free expression of the queen's femininity. In this regard it is interesting to consider Sully's artistic position in relation to that of Landseer, an Englishman who

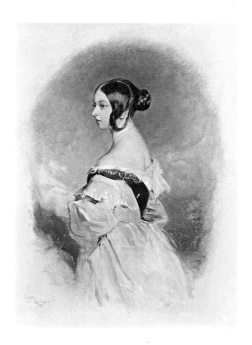

FIG. 50. EDWIN LANDSEER (ENGLISH, 1802–1873), QUEEN VICTORIA,
1839. OIL ON CANVAS, 16 X 12 IN. (40.6 X 30.5 CM).
THE ROYAL COLLECTION, LONDON

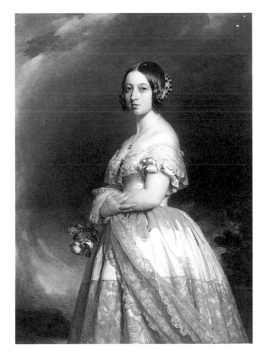

FIG. 51. FRANZ XAVER WINTERHALTER (GERMAN, 1805–1873),
QUEEN VICTORIA, 1842. OIL ON CANVAS, 52 1/2 X 38 1/2 IN. (133.4 X 97.8 CM).
THE ROYAL COLLECTION, LONDON

FIG. 52. FRANZ XAVER WINTERHALTER, **KAISERIN ELIZABETH**, 1865.
OIL ON CANVAS. ROYAL COLLECTION, VIENNA

might have jockeyed for royal position with the rest but for his lack of that particular ambition. Over the years Landseer had a good deal of contact with Her Majesty—she once called the handsome and amusing painter of her pets "the cleverest artist there is"—but conceded to her commissions, rather than seeking them out.[102] With characteristic irreverence, Landseer referred to Victoria as "a very *inconvenient* little treasure."[103]

Victoria liked Sully's portrait of her, she adored Landseer's works, and she was devoted to Franz Xaver Winterhalter, the third member of this group of artists who in their portraits privileged Victoria's womanliness over her absolute power. Winterhalter's 1842 likeness of the queen (fig. 51), which had a companion in a distinguished portrait of Albert, adapted Sully's pose by revealing not only her back and shoulders but also the royal bosom that Sully had been so careful to conceal in his portrayal. The queen thought the likeness "perfect" and proceeded to commission many portraits from Winterhalter, including some stunningly sensual portraits of her daughters. He was well loved throughout Europe for his stirring portraits of royals otherwise accustomed to being painted in modest or bureaucratic modes. His portrait of the great beauty Kaiserin Elizabeth of Austria (fig. 52), which shares its pose with that of Sully's Victoria, was celebrated for its complete lack of official character.[104] Indeed, Winterhalter's name became synonymous with unofficial portraiture, to the extent that in the 1870 inventory of the fourth Marquess of Hertford's collection (now the Wallace Collection), Sully's portrait of Victoria was for a short time mistakenly attributed to Winterhalter.[105] Sully, who still enjoyed the memory of his sittings with the queen, would have been flattered by the misattribution. During the summer of 1871, he made a replica of his original study of her portrait (fig. 53), presumably for practice and pleasure.

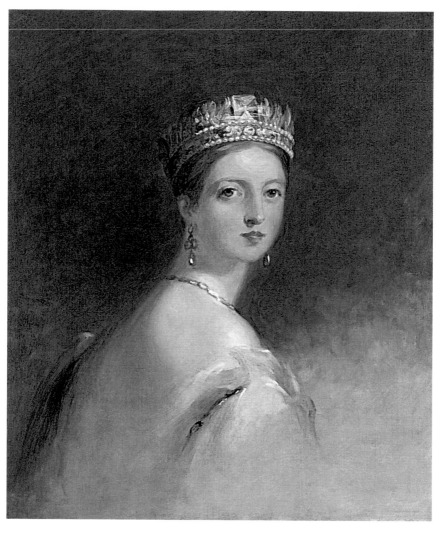

FIG. 53. THOMAS SULLY, **QUEEN VICTORIA**, 1871. OIL ON CANVAS,
30 1/4 X 25 1/4 IN. (77 X 64.2 CM). THE CHARLES HOSMER MORSE MUSEUM OF AMERICAN ART,
WINTER PARK, FLORIDA

*Q*ueen Victoria sat for scores of painters and photographers during her long life, regularly updating her image, especially in commemoration of joyous or glorious events, but even in times of sorrow. For years, she was hardly ever portrayed without her beloved Albert by her side, and often with one or more of her children. Following Albert's death, portraitists had no choice but to portray her in the widow's weeds she wore long after the traditional period of mourning and for the rest of her life. Her public all but lost sight of the queen who had assumed the throne as a girl of eighteen. The memory of her youth emerged full blown at the art exhibition mounted on the extraordinary occasion of Victoria's Golden Jubilee in 1888. The Society of the Sons of Saint George sent their portrait to London, thus celebrating Victoria's fifty years on the throne by calling new attention to the only coronation-year portrait to depict her actually ascending to it.

1. Thomas Sully, Journal, April 4, 1838, Historical Society of Pennsylvania, Philadelphia.

2. Ibid., March 22, 1838.

3. Queen Victoria, Journal, June 24, 1838, The Royal Library, Windsor Castle.

4. John Joliffe, ed., *Neglected Genius: The Diaries of Benjamin Robert Haydon 1808–* (London: Hutchinson, 1990), 176, diary entry for October 30, 1837.

5. Queen Victoria, Journal, May 24 and August 17, 1838.

6. For an extensive list of portraits of Victoria, see Richard Ormond, *National Portrait Gallery: Early Victorian Portraits* (London: Her Majesty's Stationery Office, 1973), 474–93.

7. Cecil Woodham-Smith, *Queen Victoria: From Her Birth to the Death of the Prince Consort* (New York: Alfred A. Knopf, 1972), 68.

8. Simon Schama, "Balmorality: Queen Victoria's Very un-Victorian Ways," *New Yorker*, August 11, 1997, 38. The author discussed related issues of formal and informal portraiture in "The Domestication of Majesty: Royal Family Portraiture, 1500–1850," in Robert I. Rotberg and Theodore K. Rabb, *Art and History: Images and Their Meaning* (Cambridge and New York: Cambridge University Press, 1986), 155–83.

9. Deirdre Shearman, "The Image of Victoria: Patronage, Profits and Patriotism" (Ph.D.

I have written a journal of events since my landing that may amuse you when I return home.

—Thomas Sully to his wife, Sarah Annis Sully (1779–1867)
November 11, 1837

diss., Brandeis University, 1996), 22.

10. On the state portrait, see Oliver Millar, *Kings and Queens* (London: The Queen's Gallery, 1982); and Shearman, "Image of Victoria," 60–121.

11. See Shearman, "Image of Victoria," 77–78.

12. Ibid., 76.

13. The commission is recorded in a letter from Charles Law, Recorder of London, to the Lord Mayor of London, August 6, 1837, Corporation of London, Guildhall Library.

14. Sir George Hayter, Diary, February 13, 1838, typescript at Heinz Archive, National Portrait Gallery, London

15. Ibid., February 13, 1838.

16. Ibid., April 21, 1838.

17. Shearman, "Image of Victoria," 100.

18. "Twiddle-Twaddle Concerning the Queen of England," *New-York Mirror* 15 (January 20, 1838): 237.

19. The queen's sittings for Lane are recorded in Queen Victoria, Journal, July 8–August 12, 1837.

20. Ibid., August 17, 1837.

21. Ibid., August 25, September 27, 1837.

22. See Robin Reilly and George Savage, *Wedgwood: The Portrait Medallions* (London: Barrie & Jenkins Ltd., 1973), 325.

23. Queen Victoria, Journal, November 23, 25, 27, 28, 29, 30, 1837.

24. Ibid., September 2, 15, 16, 1837.

25. Ibid., December 12, 1838.

26. Ibid., November 24, 1837.

27. Ibid., May 5, 1838.

28. Ibid., March 22, 1838.

29. Thomas Sully, Journal, September 19, 26, 1837.

30. "Memorial to Mr. Sully," listing those who pledged funds to help defray the cost of Sully's trip, is transcribed in Edward Biddle and Mantle Fielding, *The Life and Works of Thomas Sully (1783–1872)* (Philadelphia: Wichersham Press, 1921), 48.

31. Thomas Sully's Memorandum Book ("Hints for Pictures"), Yale University Library, entry for March 1, 1837, lists his new fee structure.

32. On this famous portrait, see Robert Wilson Torchia, *American Paintings of the Nineteenth-Century: Part II* (Washington, D.C.: National Gallery of Art, 1998), 151–59.

33. Blanch's letter to her mother, November 16, 1837.

34. Sully's landlord seems to have been an artist, or at least knowledgeable of the arts, for he gave him tips on supply shops. See Thomas Sully, Journal, November 25, 1837. Previous tenants in the house included the painter Benjamin Robert Haydon, who occupied

the first floor from 1808 to 1817, and Gilbert Stuart Newton, who took over Haydon's rooms. See F. H. W. Sheppard, *Survey of London: The Parish of St James Westminster* (London: The Athlone Press, 1963), 261.

35. Blanch's letter to her mother, November 23, 1837.

36. Sully's letter to his wife, March 3, 1838.

37. Sully's letter to his wife, November 22, 1837.

38. Thomas Sully, Journal, December 10, 1837.

39. Blanch's letter to her mother, March 15, 1838.

40. Sully's letter to his wife, February 17, 1838.

41. Thomas Sully, Journal, December 28, 1837.

42. Ibid., January 8, 1838.

43. Ibid., February 2, 1838.

44. Ibid., January 15, 1838.

45. Sully's letter to his wife, February 5, 1838.

46. Thomas Sully, Journal, February 24, 1838.

47. Sully's letter to his wife, March 1, 1838.

48. Sully's letter to his wife, March 16, 1838.

49. Ibid.

50. Thomas Sully, Journal, March 19, 1838.

51. Robin Asleson, *A Passion for Performance: Sarah Siddons and Her Portraitists*, exh. cat. (Los Angeles: The J. Paul Getty Museum, 1999), 81–84.

52. On this subject see Marcia Pointon, *Hanging the Head: Portraiture and Social Formation in Eighteenth-Century England* (New Haven and London: Yale University Press, 1993), and T. H. Breen, "The Meaning of Likeness: Portrait-Painting in an Eighteenth-Century Consumer Society," in Ellen G. Miles, ed., *The Portrait in Eighteenth-Century America* (Newark: University of Deleware Press, 1993), 37–60.

53. Frances Anne Kemble, *Records of a Later Life* (New York: Henry Holt, 1882), 1, 132.

54. Blanch wrote to her mother, December 13, 1837, that she also found great likeness between the sisters: "Miss A. Kemble . . . is quite like Fanny, with the exception of a large long nose and small mouth, her voice and manner so reminded me of her, that several times I was on the point of calling her Mrs. Butler."

55. Sully's letter to his wife, February 26, 1838.

56. Sully's letter to his wife, February 11, 1838.

57. Sully's letter to his wife, March 3 and 13, 1838.

58. Blanch mentions Fanny look-alikes to her mother November 12, December 9, 13, 24, 1837, January 28, 1838.

59. Thomas Sully, Journal, February 11, 1838.

60. Ibid., March 22, 1838.

61. Ibid., December 23, 1838.

62. Waste Book, February 15, 1838.

63. Blanch's letter to her mother, December 4, 1837, and Sully's letter to his wife, February 12, 1838.

64. "Former Queens," reprinted from an English paper in the *New-York Mirror* 15 (October 14, 1837): 127.

65. Thomas Sully, Journal, February 15, 1838.

66. Ibid., March 22, 1838.

67. Thomas Sully, Jr.'s letter to his father, April 1838, quoted in Biddle and Fielding, *Life and Works*, 55–57.

68. Thomas Sully, Journal, March 19, 1838. He records that he "made outlines" of Hayter's and Chalon's portraits "as memorandums of the dress," by which he must have meant sketches or studies.

69. Thomas Sully, Journal, March 22, 1838.

70. See Helmut von Erffa and Allen Staley, *The Paintings of Benjamin West* (New Haven and London: Yale University Press, 1986), 229.

71. Biddle and Fielding, *Life and Works*, 55.

72. Thomas Sully, Journal, March 22, 1838.

73. Christopher Brown, "The Pembroke Family Portrait: An Inquiry into Its Italian Sources," in Arthur K. Wheelock Jr. et al., *Anthony Van Dyck* (Washington: National Gallery of Art, 1991), 38. I am very grateful to Stephen Duffy of the Wallace Collection for calling the Van Dyck portrait to my attention.

74. Thomas Sully, Journal, March 22, 1838.

75. Ibid., May 15, 1838.

76. Ibid.

77. Ibid., April 2, 1838.

78. Blanch's letter to her mother, November 20, 1837.

79. Thomas Sully, Journal, May 17, 1838.

80. Ibid., June 19, 1838.

81. Ibid., June 20, July 17, 1838.

82. Biddle and Fielding, *Life and Works*, 60.

83. "Engravings. The Queen. Thomas Sully," *Art-Union* 1 (February 15, 1839): 52.

84. "Chit-Chat about Art and Artists," *Art-Union* 1 (April 15, 1839): 10.

85. Thomas Sully, Journal, January 12, 1839.

86. "Sully's Portrait of the Queen," *New-York Mirror* 16 (May 18, 1839): 375.

87. "Sully's Portrait of the Queen," *Poulson's American Daily Advertiser*, November 15, 1839, reported from the *London Examiner*.

88. Thomas Sully, Register of Paintings, Historical Society of Pennsylvania.

89. See John Todhunter to Joseph Sill, December 30, 1837, John Kintzing Kane Papers, American Philosophical Society, Philadelphia; and Thomas Sully, Journal, April 12, 1838.

90. Thomas Sully, Journal, November 25, 1838.

91. The details of the lawsuit are recorded in the papers of the Society of the Sons of Saint George, Historical Society of Pennsylvania, Philadelphia. See also "The Society of the Sons of St. George and Thomas Sully," *New-York Mirror* 17 (June 29, 1839): 7.

92. Thomas Sully, Register of Paintings, Historical Society of Pennsylvania, lists both paintings under 1838.

93. W., "Sully's Portrait of Queen Victoria," *United States Gazette*, January 16, 1839. See also the articles entitled "Queen Victoria," *United States Gazette*, December 22, 1838, and June 12, 1839.

94. "Sully's 'Victoria,'" *New-York Mirror* 16 (February 2, 1839): 256. The editors recanted their harsh opinion of the Society in a subsequent issue, after learning that the society would use the proceeds gained from exhibition of Sully's picture for charitable causes, but did not change their view that Sully had been grievously wronged. See "The St. George Society and Mr. Sully," *New-York Mirror* 16 (February 16, 1839): 271.

95. "Sully's Victoria," *New-York Mirror* 16 (November 3, 1838; January 5, 1839): 151, 223.

96. The Society printed a pamphlet to accompany the Philadelphia exhibition: "The Original Painting of Her Majesty, Queen Victoria the First, Painted by Mr. Thomas Sully, Expressly for 'The Society of the Sons of St. George,' Philadelphia" (Philadelphia, 1839).

97. See John R. Porter, *The Works of Joseph Légaré 1795–1855* (Ottawa: The National Gallery of Canada, 1978), 58–60.

98. See "The Painting of Queen Victoria," *Charleston Courier*, August 4, 1845, 2, and "Sully's Victoria," *Charleston Courier*, August 14, 1845, 2. I am very grateful to Maurie McInnis of the University of Virginia for sharing with me her expertise on this matter.

99. "Mr. Sully's Portrait of the Queen," *Corsair*, June 1, 1839, 219. For similarly favorable, if less eloquent, reviews, see "Mr. Sully's Portrait of the Queen of England," *New York Literary Gazette*, June 15, 1839, 159–60; "Sully's Victoria," *New-York Mirror* 16 (June 22, 1839); "Portrait of Queen Victoria," *New York Morning Courier*, July 4, 1839.

100. "The Astonished Painter," *Godey's Lady's Book* 19 (November 1839): 193.

101. Thomas Sully, Journal, May 4, 1838.

102. Queen Victoria, Journal, December 7, 1838.

103. Quoted in Oliver Millar, *The Victorian Pictures in the Collection of Her Majesty the Queen* (Cambridge: Cambridge University Press, 1992), 137.

104. Count Egon Corti, *Elizabeth, Empress of Austria*, trans. Catherine Alison Philips (New Haven: Yale University Press, 1936), 235.

105. John Ingamells, *The Wallace Collection: Catalogue of Pictures: British, German, Italian, Spanish* (London: The Wallace Collection, 1985), 181.

Thomas Sully's Journal

Matthew Sully = Sarah Chester
1725–1815 Died 1793

Harriet Matthew Elizabeth Charlotte Lawrence = Sarah = **THOMAS** Jane Julia Chester
Sully Sully Sully Sully Sully Annis **SULLY** Sully Sully Sully

1772–1843 1773–1812 1769–1804 1779–1867 1783–1872 1780–1834

Sarah Chester Elizabeth Mary Chester = John
Sully Sully Sully Neagle

1796–1856 1799–1821 1802–1845 1796–1865

Thomas Thomas Blanch Rosalie Alfred Elizabeth Sarah Chester
Sully Wilcocks Sully Sully Kemble Sully Sully Sully Sully

1809–1810 1811–1847 1814–1898 1818–1847 1820–1879 1821–1821 1821–1821

Jane Cooper = William Henry Ellen Oldmixon = John Hill
Sully Westray Darley Sully Wheeler

1807–1877 1816–1896 1806–1882

\mathscr{S}ully was a compulsive record keeper. When he began keeping his Journal, probably in the early 1820s, he first wrote retrospective entries from as early as May 1792. He maintained the Journal (now owned by the Historical Society of Pennsylvania, Philadelphia) until 1846. Over that period, it grew to two volumes, and his most extensive entries were written while he was traveling. The entries for his trip to London in 1837–38 are among the richest and most detailed of all, as he intended them to be read by his wife, Sarah Annis Sully, upon his return. That section of the Journal is presented here in its entirety.

The entries begin on September 19, 1837 (the day he decides to go to London) and end on July 29, 1838 (the day he steps on the boat for home). They have not been corrected for spelling, grammar, or archaic terminology. Notes identify most of the people Sully mentioned and works of art that he saw, providing their full titles and present locations when known. References to related Sully papers are also given.

The Journal is just one of a number of diaries and notebooks that Sully kept on hand. Between 1809 and 1871, he carried with him a notebook that he called his Hints for Painting and Memorandum Book (Beinecke Rare Book and Manuscript Library, Yale University), in which he wrote his observations on paintings and other artists, notes on art supplies, and recipes for paint. As edited here, the Journal contains cross-references to this book and provides pertinent excerpts in brackets []. Between 1829 and 1836, Sully also kept what he called his Waste Book (Beinecke Rare Book and Manuscript Library, Yale University). In this he recorded some of his accounts and made additional observations and notes. On both of these books, see Jules David Prown, "Two Manuscript Notebooks of Thomas Sully," *Yale University Library Gazette* 32 (October 1964): 73–79.

In 1851, Sully transcribed and rewrote his Hints for Painting and Memorandum Book, calling the new manuscript Memoirs of the professional life of Thomas Sully Dedicated to his brother Artists (Winterthur Library, Winterthur, Delaware). In 1871 he culled the essence of the Memoirs in a manuscript he entitled Hints to Young Painters (location unknown). Although Sully never submitted any of his writings for publication, his grandson Francis T. S. Darley had the Hints published: Thomas Sully, *Hints to Young Painters* (Washington, D.C., 1873).

Sully kept an Account of Pictures (Historical Society of Pennsylvania, Philadelphia), also known as his Register, between 1801 and 1872. In it he recorded his daily work (portraits and subject pictures), noting subject, size, price, and dates of commencement and completion. The Register has been edited and published on two occasions: Charles Henry Hart, *A Register of Portraits Painted by Thomas Sully (1801–1871)* (Philadelphia, 1908), and Edward Biddle and Mantle Fielding, *The Life and Works of Thomas Sully (1783–1872)* (Philadelphia, 1921).

Thomas Sully's Journal

TRIP TO LONDON AND FRANCE
SEPTEMBER 19, 1837–JULY 29, 1838

SEPTEMBER 19 Saturday, on my suggestion Edward Carey,[1] I could be induced to visit London for a year; he has offered to advance me $100 for pictures to be painted, either in London or on my return.

SEPTEMBER 26 Received 4th letter from Alfred.[2] Mr. Carey, Jr., has agreed to pay Mrs. Sully during my absence $1000 in monthly payments of $100, beginning the first of November Henry Carey,[3] Rockhill,[4] Vander Kemp,[5] and J. K. Kane,[6] have each given me an order for a $300 picture to be painted as, and when I choose; the funds to be invested with Jaudon,[7] at London, these, with what is due for portraits will enable me to go, and I have accordingly taken passage on board the Quebec, Capt Hubbard, for Blanch[8] and myself, and expect to sail on the 10th of October.

1. Edward Carey, Jr. (1806–1845), Philadelphia publisher (Carey, Lea & Carey).

2. Alfred Sully (1820–1879), the artist's son, a West Point cadet.

3. Henry Charles Carey (1793–1879), Philadelphia publisher (Carey, Lea & Carey) and political economist.

4. Thomas Cadwallader Rockhill, Philadelphia merchant.

5. John Jacob Vanderkemp (1783–1855), Philadelphia merchant and general agent for the Holland Land Company.

6. John Kintzing Kane (1795–1858), Philadelphia jurist.

7. Samuel Jaudon, representative of the United States Bank in London.

8. Blanch Sully (1814–1898), the artist's daughter.

SEPTEMBER 28 Gave Darley[9] checks to deposit in his bank for Sarah, amounting to $559.51. Sent home portrait Mrs. DeSilver[10] and subsequently her mask and hair.

OCTOBER 2 Paid the rent & Post bill. Drew from the banks the balance of $257.89.

OCTOBER 3 Sent home Lingen's picture;[11] also on the 4th Miss Downing's[12] and Captain Gwynn's [*sic* for Gwinn].[13] Sent N. Biddle's portrait[14] to the Gallery and had the original portrait cased and sent with two of Mr. E. Carey's to be shipped for London by the Quebec. Appropriated for Blanch and my passage $260, cash in specie $150 and for expenses to and at New York $20.50. Mr. Kane sent me a check for $300, which on the 6th I handed to Mr. Coperthwait [*sic* for Cowperthwaite],[15] cashier, for which I am to receive in London, at Jaudan's Branch bank, credit as also for the 1000 deposited on my acct by Henry Carey for himself, Rockhill and Vanderkemp, the value to be returned in paintings.

OCTOBER 8 Left Sarah in cash $294 out of which she has to pay for coal & c., about 80 dollars. Settled with Earle[16] to the 7th of October, by exchange of receipts.

OCTOBER 9TH Monday, 1837 By the steamer of 6 o'clock Blanch accompanied me to New York, to embark on board the ship Quebec, Capt. Hebard, for London. Tom[17] accompanied us to NYork, where we arrived at about one o'clock and put up at the Atlantic Hotel.[18]

TUESDAY 10TH At 11 o'clock we bid adieu to land & on board the Steamer

9. William H. Darley, professor of music, the artist's son-in-law.
10. Antoinette De Silver (1805–1820).
11. Maria Oldmixon (Mrs. George Lingen).
12. Mary Downing.
13. Captain John Gwinn (d.1849), American naval officer.
14. Nicholas Biddle (1786–1844), American scholar and statesman.
15. Joseph Cowperthwaite, cashier of the Second National Bank of the United States, Philadelphia.
16. James S. Earle (1802–1879), Philadelphia carver, gilder, and art dealer, the artist's business partner.
17. Thomas Willcocks Sully (1811–1847), portrait and miniature painter, the artist's son.
18. In her letter of October 9, 1837 (Winterthur Letterbook, hereafter WL), Blanch Sully writes to her mother, Sarah Annis Sully, some of her observations of New York.

Hercules we accompanied the ship to the anchorage at the Hook where we went on board and arranged our state rooms for the voyage. My State-room companion was Mr. Hardgraves, of Montreal. The other passengers—Miss Mary R. Johnston & Mother—Mrs. Langon & Col. Johnston of Quebec. Mrs. Nixon, Miss Goldsmith. Mr. & Mrs. Caird & child. Two Mr. Smiths. Mr. Cochran & two children. Mr. Woodhouse. Mr. White. Mr. Gambier. Mr. Murray. Mr. Alhousen. Mr. Weeks. Mr. Alabaster. Mr. McCarhan and Lieut. Rubridge.

WEDNESDAY 11TH The Pilot left us, and we cast to sea with a light & fair wind.

THURSDAY 12 Moderate weather. Blanch has continued to be sea sick since we left the Narrows.

FRIDAY 13 Stormy, with rain. Some whales in sight.

SATURDAY 14 Stormy—and in consiquence very sea-sick.

SUNDAY 15 & MONDAY 16 The wind abating, I recovered—but Blanch continued to be ill.

TUESDAY OCTOBER 17 Very light wind—but favourable. All the sick have recruited—are about 700 miles on our way.

WEDNESDAY 18 Head wind, but light.

THURSDAY 19 Wind favourable since yesterday evening.

FRIDAY 20 Fair wind. Long. 49′10.

SATURDAY 21 Blowing fresh & rather against laying our course—yet we have attained upwards of 1500 miles.

22, SUNDAY —Still a head wind. Revd Caird gave us an excellent Sermon.

MONDAY 23 Hazy weather.

TUESDAY 24 Head winds.

WEDNESDAY 25 Passed a ship, supposed to be the Westminster.[19]

THURSDAY 26 Winds rather ahead—but still made progress.[20]

OCTOBER 27 FRIDAY — Until the 31st Tuesday the weather has been too rough to allow me to write. Blanch has done tolerably well since the 20th.

NOVEMBER 1, WEDNESDAY Gale of wind set in this morning, which increased at night as we entered the Channel & so foggy that the land could not be seen until late; and then but for an instant; when we were found to be off— "Start Point"[21]

NOV 2, THURSDAY. The gale has increased to what the Captain considers very severe—took a Pilot this morning who brought us to a safe anchorage off Portsmouth, & near the Isle of Wight. Several of our passengers went on shore that night.[22]

FRIDAY 3 Mr Caird & family, Mrs. Cochran, Nixon, Goldsmith, Blanch & I took the Custom house boat, and landed at Portsmouth. Our luggage was slightly examined; and at noon we took the Coach to London — At Guilford we parted from the kind & worthy Mr. Caird; and reached London about 10 o clock stopping for the night at Hatchets Hotel[23]—Mrs. Nixon proceeded to her daughter.[24]

SATURDAY 4 After breakfast called on Leslie[25] at Pineapple Place 12, who assisted us to find lodgings & we fixed upon Mr. Campbells No. 17 Howland St. Fitzroy Square, at 2 Pounds per week for 2 Rooms on the 1st floor—Cooking & attendence to be furnished. Blanch is to occupy the Bed room, and I am to sleep on the sofa. Paid 2 Sovereigns in advance. Settled my bill at Hatchets, which was amusingly extravagant—one item 5 shillings for 2 eggs at breakfast. Removed our

19. See Blanch's letter to her mother, October 25, 1837 (WL).
20. See Blanch's letter to her mother, October 26, 1837 (WL).
21. See Blanch's letter to her mother, November 1, 1837 (WL).
22. See Blanch's letter to her mother, November 2, 1837 (WL).
23. Hatchett's Hotel, 67 Picadilly.
24. See Thomas Sully to his wife and Blanch to her mother, both letters November 3, 1837, for further information on the journey and Thomas's and Blanch's seasickness (WL).
25. Charles Robert Leslie (1794–1859), English narrative and historical painter.

luggage in a Coach to our lodgings, & took our dinner at Verays in a bowl of turtle soup.

SUNDAY NOVEMBER 5TH Attended Divine service at Westminster Abbey, and afterwards walked to St. James's Park. Dined at Leslies, tea & supper. Met Humphreys [*sic* for Humphrys][26] & Mrs. Clark—Mrs. Leslie's sister, and returned home at 12 oclock.[27]

MONDAY 6TH After breakfast, I left Blanch to write her journal letter[28]—while I set off to deliver letters. Mr. Stewart[29] has called yesterday. I found it unusually hard work to make my way along the Strand, as preparations were being made for the "Lord Mayor's Day." Called on Audubon,[30] 4 Wimpoole [*sic* for Wimpole] St. and saw his family—he was not at home, but had called on us during our absence. Called on W. Vaughan, 70 Finchurch [*sic* for Fenchurch] St.,[31] and delivered his brother's letter[32] and was kindly received. Met Mr. & Mrs. Keeley[33] on my return. After an early dinner, Blanch and I found the residence of John Todhunter, 44 Tavistock Square.[34] The family being out of town we left the books and letters from Mr. Sill.[35] At 5 called on Audubon, and was obliged to sit down to dinner with them, namely Mr. & Mrs. Audubon—Victor and John and wife.[36] Took tea and returned home by 10 o'clock.[37]

TUESDAY 7 rose at ½ 6 and lighted my own fire—dark and foggy morning.

26. William Humphrys (d. 1865), Irish engraver.

27. See Blanch's letter to her mother, November 5, 1837, for a description of their rooms and her opinion of Westminster Abbey (WL).

28. Blanch's letter to her mother, November 6, 1837 (WL).

29. John Stewart (b. 1800, fl. 1828–45), English painter.

30. John James Audubon (1785–1851), American artist and ornithologist.

31. William Vaughan (1752–1850), English merchant and author, 70 Fenchurch Street.

32. John Vaughan (1756–1841), English-born treasurer and librarian of the American Philosophical Society, Philadelphia.

33. Robert Keeley (1793–1869), and his wife Mary Goward Keeley (1806–1899), English actors.

34. John Todhunter, English merchant.

35. Joseph Sill (1801–1854), American merchant, John Todhunter's brother-in-law.

36. Mrs. John J. Audubon (Lucy Bakewell); her sons Victor Gifford Audubon (1809–1860), painter and miniaturist, and John Woodhouse Audubon (1812–1862), portrait and wildlife painter; and John W.'s wife, Maria Rebecca Bachman.

37. See Blanch's letter to her mother, November 7, 1838 (WL).

Breakfast on crumpets. Doughty[38] called—he lives in Grafton St., Fitzroy Square, opposite Heeley's [*sic* for Healy's][39] and near Tottenham Court Road. Mr. & Mrs. Keeley called. We accompanied them in a walk to the Pantheon Bazaar— proceeded to St James's Park. Left letter for Miss Martineau,[40] Fludger St., from thence to Whitehall—along the Strand to Waterloo bridge, where Blanch saw for the first time, the noble Dome of St. Paul's. Went to Covent Garden Market, where we met Mr. Keeley and accompanied them home to dinner. His nieces, the Misses Alexander.

NOVEMBER 8TH 1837 WEDNESDAY. Foggy morning. Osgood[41] brought me a message from Miss Martineau with a request to call on her. At ½ 10 Leslie called. Paid me a small sum due from the remittance made to him some time ago. Introduced me to Mr. Howard,[42] Secretary Royal Academy, at his residence. [His composition proves him to possess poetical reading, if not feeling. His colouring is not agreeable; his drawing seems correct, but the effect of his pictures is hard.] Mr. Charles Landseer[43] joined us. Called on Sir M. A. Shee,[44] who recollected me, and was affable. [I found the practise of Sir Martin Archer Shee, Pres't, R. A., much improved since I was in London in 1810. Drawing, coloring and effect very satisfactory but without any remarkable traits of genius in either—but far better than Howard. It seems a prevalent taste to adopt red walls for painting and exhibition rooms—a favourite tint is composed of Spanish brown, a little black, white and very little yellow. Sir Martin placed me in the painting room chair, once belonging to Reynolds. I observed that his light was high from the floor, as is the general mode here. His exhibition room was lit from above with an opening about 6 feet long and 4 wide. This room led into the painting room which was about 22 feet square, covered with green cloth. The throne of three steps and circular in form; not so large as mine. At the back of the chair and resting on the throne, was a sort of alcove or recess which is intended to keep all accidental reflexions from the subject or sitter—it is painted a negative dark green. From this last mentioned painting room, there followed another room, 22 feet by at least 30

38. Thomas Doughty (1793–1856), American landscape painter.
39. George P. A. Healy (1813–1894), American painter.
40. Harriet Martineau (1802–1876), English author.
41. Samuel Stillman Osgood (1808–1885), American portraitist.
42. Henry Howard (1769–1847), English painter.
43. Charles Landseer (1799–1879), English painter.
44. Sir Martin Archer Shee (1769–1850), Irish painter, president of the Royal Academy, London.

which was used as a private painting room, for his lay figure perhaps, or large pictures, or to study by a greater distance the effect of his pictures.] Called on Sir W. Beechey[45] who was not at home—on Mr. Alfred Challons [*sic* for Chalon][46] to whom Leslie introduced me. [Chalon is a painter of great talent, but the water colored sketches he paints for the public, give but a faint idea of his resources. He must be seen at the 'Sketching Club' or in his works at his painting rooms to know more of him.] Visited the British Institution—Mr. Bernard the keeper, was very kind. [The picture that most pleased me in the British Institution was a Boy by Velasquez—it was once the property of Reynolds. The tone of flesh was true and I thought had been toned down. The features were made out in a scratch fumbling manner. The face was but little disturbed by shadows or even half tint.] Visited Mr. Catermole[47] who occupies in the Albany, the apartments, that were once the lodgings of Lord Byron[48]—was much pleased with the taste of Catermole as an artist. [Catermole has much fancy; and large drawings of his in distemper have breadth and color. His collection of armour is valuable. He had some imitations of brass and other armour, made of Papier Mache that was quite a deception. These are made in Paris.] Rode with Leslie to Kensington gardens to see Sir D. Wilkie[49] who was not at home—called on Sir Augustus Calcott[50]—an accomplished painter and gentlemanly person. Here we parted with C. Landseer, Leslie and I returned homeward. At the corner of Edgeware Road and Oxford I took an omnibus and returned home where Blanch had also returned from her walk with Mrs. Keeley. The following persons have called in our absence. Capt. Hibard. Humphrys. Healey. 28 Grafton St. C. Landseer 8 Southampton St.[51]

THURSDAY 9TH, Yesterday I called on J. Murray,[52] 50 Albemarle St., and left with Mr. Clarks pamphlets and letter for the Quarterly. Before 12, Victor Audubon with Mrs. Gordon his aunt, called on us, to see the Lord Mayor's Pro-

45. Sir William Beechey (1753–1839), English portrait painter.

46. Alfred Edward Chalon (1780–1860), English portrait and subject painter, painter in watercolors to the Queen.

47. George Catermole (1800–1868), English watercolorist.

48. Lord George Gordon Byron (1788–1824), English poet.

49. Sir David Wilkie (1785–1841), Scottish narrative painter.

50. Sir Augustus Wall Callcott (1779–1844), English painter.

51. See Blanch's letter to her mother, November 8, 1837 (WL).

52. John Murray (1778–1843), publisher acclaimed for his affiliation with Lord Byron.

cession—took refreshment on our way, at his house, and proceeded to Mr. Baker, editor of the Courier, in the Strand. Here we had an excellent view although the street was crowded to excess, the policemen kept excellent order. We had a perfect sight of the Pageant and for the first time saw the young Queen of England. She was everywhere greeted with bursts of rapture. At 4 the whole had passed and we made our way home through a gentle rain, that rendered the walking intolerably muddy; and here we had the first specimen of what is called greasy streets. After dinner, Healy called, and we accompanied him to Osgood's room in the story above us, where we took tea. Mr. Thatcher, of Boston,[53] was present. I am still suffering from my old complaint, the Dispepsea.[54]

FRIDAY 10, John and Victor Audubon called to leave me a ticket for the British Institution. Doughty, who has been ill called. Mr. Rand, artist,[55] who lives opposite, called on us. Visited Healy and was much pleased with his progress. He was painting the portraits of Mr. Powers' children,[56] who called while I was there, introduced me to his wife.[57] [At Healy's—who by the way will make an excellent painter—I saw a few pictures by the celebrated Jackson,[58] which disappointed me much—he had a perception of good colour, but he was in all respects far off Reynolds.] In the afternoon, Blanch and I, with Healy, visited the shops of Colnagy[59]—returning, we encountered Murray, one of our fellow passengers.

SATURDAY 11, Clear, and mild. Osgood's painting room is 86 in Newman St. Humphrey's 4 Grove Terrace, Lisson Grove. John Miller, Henrietta Street, Covent Garden—Stewart, 21 Osnaburgh St., Regent's Park. John D. Lewis,[60] 4 Cornwell Terrace, Regent's Park. At 10 o'clock Blanch accompanied me in a long walk. Handed Miller Mr. Carey's letter. Visited Somerset House—looked into the Hall where formerly I went to study from the Royal Academy Schools. Crossed

53. Benjamin Bussey Thatcher (1809–1840), American author.

54. See Sully's letter to his wife, November 9, 1837, and Blanch's to her mother, November 10, 1837, especially regarding the Queen's procession (WL).

55. John Goffe Rand (1801–1873), American portrait painter.

56. Children of Tyrone Power (1797–1841), Irish actor; Healy exhibited the portrait at the Royal Academy of Arts in 1838 (present location unknown).

57. Louisa Phipps Healy.

58. Samuel Jackson (1794–1869), English portraitist.

59. Colnaghi, Son & Co., print sellers, 14 Pall Mall East, St. Martin's.

60. John Delaware Lewis, Philadelphia merchant residing in London.

the square and through the offices to the Terrace that overhangs the Thames. Left letter with Mr. Tilt, Cheapside.[61] Looked into the Temple Gardens, and wandered over the premises. Then to St. Paul's, to Paternoster Row to leave Mr. Longman's[62] letter, next to the monument.[63]—To the bank—to the Exchange; and to the American Coffee House, where we left a card for Capt. Hebard. Came home by way of Holborn. Found that Stewart and daughter had called in our absence. Mrs. Martineau called and left her daughter's card. Murray called. Walked out at dusk in Regent's Street to look at the fine shops. Joshua Bates, 30 Portland Place,[64] sent an apology for not calling, and an invitation to tea.[65]

SUNDAY 12, Heard Divine service at St. Paul's; Leslie and his son Robert joined us there. Met Murray at the door, and we all took an omnibus for Kensington Gardens. Blanch, Leslie and I called on Wilkie by appointment; were introduced to his brother and sister; saw his excellent pictures and left him with a very agreeable impression of his character. [An unfinished picture by Wilkie of the "Finding the Body of Tippo Saib"[66] shows his masterly powers of composition, drawing effect and colouring. He uses a white ground and resisting surface. Tho' some parts of the pictures were bare, and others slightly outlined with charcoal, other portions of the work were not only advanced, but apparently finished!! He has great variety and blending of tints, and seems to do much at one painting in some instances using, as he told me, much magilph and that he varnishes his pictures with a weak magylph into which he drops some Japan to force its drying—'then' said he: it is all of a kind and will agree best. He is very successful in painting the open mouth agreeably. A sketch for a representation of Queen Victoria at her First Council[67] was in progression—but I fear will not add to his fame. He had several portraits in different states. He has great breadth and force notwithstanding exact detail. Leslie thinks he is one of the best living painters (so

61. Charles Tilt, bookseller and publisher.

62. Thomas Norton Longman (1771–1842), publisher.

63. Monument designed by Sir Christopher Wren to commemorate the Great Fire of 1666.

64. Joshua Bates (1788–1864), American banker and philanthropist, partner in Baring Brothers; founded Boston Public Library.

65. See Sully's letter to his wife, November 11, 1837, especially for the particulars of their daily routine, meals, and health (WL).

66. Wilkie, *Sir David Baird Discovering the Body of Sultaun Tippoo Saib,* 1838 (National Gallery of Scotland, Edinburgh).

67. Wilkie, *First Council of Queen Victoria.* (fig. 7). Two watercolor studies (which may be what Sully saw) are in the Royal Collection.

did I until I saw the matchless works of Horace Vernet[68]] Had a delightful walk through Kensington Gardens; and Hyde Park to Oxford St. Leslie gave me Sir. M.A. Shee's letter to the Keeper of the Royal Academy, and a card of admission to the collection, and studies—we separated at corner of Hyde Park, and Blanch and I got home. Mr. Powers and Mr. Todhunter have called. In the afternoon called on Mr. Bates; saw Mrs. B. and daughter,[69] who wishes to have her portrait. Mr. B. advised me to remove into a more fashionable part of the town. Mr. Wilkie sent us a note to get into Guildhall. At 7 visited Stewart. Drank tea with his family and Miss Myers and returned home at 10.[70]

MONDAY 13, At ½ 10 walked to Guildhall with Wilkie's note to Sir P. Laure [*sic* for Laurie],[71] who gave us permission to go into the Hall where the remains of the arrangements for the Lord Mayor's feast was still standing. We squeezed through the crowds with some difficulty, and had a sort of glimpse of the place— yet it gratified Blanch. We next visited the Royal Academy, and were shown all the rooms, in an obliging manner. [In the Royal Academy is a copy of the "Infant Hercules" by P. after Reynolds. It is greatly wanting in detail and correctness of drawing—The effect and colouring were vigourous. An excellent picture by Rembrandt, once the property of Sir T. Lawrence. Two Nich. Poussins—a Guido and several other good pictures. The Council Room was so dark that I could only make out the subject of the pictures. Altho' I esteem the talents of Wilkie very high, I cannot like his general style of portraiture; they are not naturally coloured and his female flesh looks chalky—not so his compositions; in these his colouring, force and handling and all qualities of art are excellent.] Returned home through a dripping rain. Called on Healy—Mr. Power had left me an order for the Haymarket Theatre, and an invitation to dinner for next Sunday—Mrs. Nixon and daughter called—34 George St., Euston Square. Tyrone Power, 14 Abian [*sic* for Albion] St., Hyde Park. We met William Oldmixon in our walk.[72]

TUESDAY 14, Blanch and I called on Sir. W. Beechey. He has grown feeble— is 85—but his painting has become very feeble. [How he has fallen off since I first

68. Emile-Jean-Horace Vernet (1789–1863), French painter.

69. Lucretia Sturgis Bates; her daughter, Elizabeth Anne Bates (1820–1878), later married Sylvain van der Weyer, Belgian minister to England.

70. See Blanch's letter to her mother, November 12, 1837 (WL).

71. Sir Peter Laurie (d. 1861), saddler, city alderman, Lord Mayor of London (1832–33).

72. See Blanch to her mother, November 13, 1837 (WL).

knew him in 1810!!—It would be a benefit to the reputation of an artist that his works should be destroyed when he falls off in his productions.] At 1 Leslie called for us to visit Turner's Gallery, where we met him,[73] and saw with much satisfaction his fine works. [Turner is placed as chief of a class of painters that writers on the art denominate the Bianchi School; their opposite style is called the Neri. The first named colour very bright and also very pure from what is called toning. The other, on the contrary, cherish deep toned hues of colour, avoiding with great care either pure white, or pure black in their colouring. Turner is an ultra Bianchi and certainly does make extravagant attempts; but where the style is applicable, it is surpassing excellent, as for instance his picture of a festival or gala day in Venice. The principal canal is filled with gondolas from which persons are landing. The bright blue sky, white clouds, various tinted buildings, different colored sails. The gondolas bedecked in finery, the gorgeous dressed people—and all this heightened by reflection in the water, forms a scene of unparalled splendour. His former style was too dingy. Perhaps a medium between the two might be better—but no doubt, the proper style is the one suited to the nature of the subject. I observed that the skylights of Turner's long gallery were shaded with muslin screens.] We then called on Mrs. Jenkins—then to Mrs. Nixon's. To A. Stevenson's,[74] and returned home, where I left her to find Mr. Jaudon's. In the evening we went to St. James's Theatre with Osgood and wife[75]—was much disappointed in Braham.[76] The place is small, but tastefully fitted up. Returned through the rain, and took tea before going to bed.[77]

WEDNESDAY 15, Went to find more suitable lodgings and after taking Blanch to see them, selected 46 Great Marlborough as the best. Called on Jaudon and presented my letter of credit from Coperthwait for 250£ which was acknowledged. Called on Mrs. Keeley on our return home, found a letter from the family dated 17 which was most acceptable. Letter also from J. Coates,[78] who is at present at Southampton. A note of invitation from P. Mitchel [*sic* for Mitchell][79] to visit his family at Camberwell—an invite from Leslie. Mr. Jaudon and daughter

73. Joseph Mallord William Turner (1775–1851), English landscape painter.

74. Andrew Stevenson (1784–1857), American statesman, minister to England (1836–41).

75. Frances Sargent Osgood (1811–1850), American poet.

76. Mr. Braham, proprietor and vocalist, St. James's Theatre, King Street.

77. See Blanch's letter to her mother, November 15, 1837 (WL).

78. J. Coates, American merchant, partner to Hillard.

79. Peter Mitchell, Englich stockbroker, 1 Copthall Court, Throgmorton Street.

called on Blanch—took tea by invitation at Mrs. Jenkins, and was much pleased with them and their hospitality.

THURSDAY 16, Called on Miss Martineau. Called on Rand, met Mr. Lewis and Gibson, once my fellow lodger in New York. Mrs. Keeley's order admitted us to Drury Lane Theatre—Carracticus [*sic* for Caractacus] and Don Juan, magnificent spectacle, and excellent music. The house did not seem to be much larger than the New York Park Theatre. Got home at 12.

NOVEMBER 17, Friday Yesterday we met W. Oldmixon, who walked with us. Called on Audubon—on Stewart. On Collard,[80] for the second time—at ½ 5 dined with Blanch at Todhunter's, by invitation. Met his brother Benjamin, Mr. Langley and wife and a Miss Hoblin, and passed a delightful day.

SATURDAY 18, Blanch accompanied me to the city—called on Savoury [*sic* for Savory], the clock and watch maker,[81] and got my watch mended. Called on Mr. Vaughan—introduced to his niece & Petty Vaughan, his nephew; promised to dine with them next Saturday at ½ 5. Called on Mitchel No. 1 Copthall Court, near the Bank. Saw his son, Charles and promised to visit them Sunday week. Transacted Mr. Tanner's[82] message in Seething Lane—Walked to the Tower—into its Courtyard and around it. Began to rain; so we returned home. Found a letter from the office of the Chancellor of the Exchequer to Leslie in answer to my application to land Carey's pictures free of duty—directing me how to proceed—called on Stevenson for further advise. Mrs. Bates left general invitation for Blanch and self for Sundays and Thursdays—Dined at Mr. Colyer's,[83] Mrs. Nixon's stepson, in company with our excellent Capt. Hebard.

SUNDAY 19, Went to Church at the Bavarian Chapel, where strangers pay for their tickets 2 shillings, are shown a seat and hear excellent music. Blanch dined with Mr. Keeley and I accompanied Healy to dine with Powers—it rained hard—before going Mr. Corbit of Philadelphia brought me a letter from Neagle.[84] I wrote to Coates. Stevenson called and directed me how to memorialize the Lords

80. Frederick William Collard (1772–1860), English piano manufacturer.

81. Thomas C. Savory, silversmith, 47 Cornhill.

82. Possibly Benjamin Tanner (1775–1848), American engraver.

83. Edward Colyer, engraver and printer, 17 Fenchurch St.

84. John Neagle (1796–1865), American portrait painter, the artist's son-in-law.

of the Admiralty about the pictures, and of my application by a memorial from the St. George's Society of Philadelphia to the Queen of England to paint her portrait for the Society—Met at Powers Mrs. P. and daughter, Mr. Moore,[85] Mr. Jourdan [*sic* for Jerdan], the editor.[86] Mr. Stanhope,[87] and Mr. Stanfield[88]—a sumptuous dinner. Got off at 10 and called for Blanch at Keeley's and returned home.

MONDAY 20TH, Called on R. Rush,[89] met Mr. Miller. Walked with Blanch through Regent's Street, to the Park, and at home found the second letter from Philadelphia awaiting us. At night attended a lecture on anatomy at the Royal Academy by Mr. Green.[90] [In the area were seated the Royal Academicians and invited guests. The president of the Academy (Sir M. A. Shee) seated in a large arm chair in the center. A railing enclosed the area and the seats for the students occupied the rest of the room and were arranged like the pit of a theatre, one row elevated behind the other.]

TUESDAY 21 Blanch finished her fourth letter to home[91]—I also wrote, and having made up a parcel, we set off at 12 to the Catherine Docks and visited Hebard on board his ship and put the parcel in his charge to be forwarded from New York by Barnet. He accompanied us to visit an American lady, 54 Upper Brook Street—a Mrs. Wraick, where he left us. On our way home, called on Doughty. Oldmixon called on us. After dinner we spent the evening at Audubon's.[92]

WEDNESDAY 22, Rain kept us at home. Wrote to Furness[93] and Neagle [94] Miss Martineau invited us to tea next Tuesday 8 o'clock. Called on Miller and left two letters to be sent by way of Liverpool. Blanch and I visited the Haymar-

85. William Moore (1790–1851), English portrait painter.

86. William Jerdan (1782–1859), English journalist and editor.

87. Possibly Lincoln Stanhope (1781–1840), English soldier, son of the third Earl of Huntington.

88. Clarkson Stanfield (1793–1867), English marine, landscape, and theatrical scenery painter.

89. Richard Rush (1780–1859), American statesman.

90. John H. Green, professor of anatomy, Royal Academy of Arts.

91. See her letter of November 16, 1837 (WL).

92. See Blanch's letter to her mother, November 21, 1837 (WL).

93. Reverend William Henry Furness (1802–1896), American clergyman, pastor of the first Congregational Unitarian Church in Philadelphia.

94. Sully to Neagle, November 22, 1837 (WL).

ket Theatre. Knowles[95] play The 'Love Chase'—well played overture 'The Bronze Horse' well played.[96]

THURSDAY 23, Paid my lodgings—gave half a crown to Ellen and removed to Great Marlborough St. 46, Mrs. Atherston's. 3 rooms, one a front parlour, a bed chamber, and 2nd. small chamber; 2 pounds 10 per week.[97] Fuel 5 shillings per week. Arranged our things and went out to make calls. Called on Sir M.A. Shee who gave me the address of Miss Tunno. Was very civil to Blanch, and turned away his model that he might have us in his painting room. [In (his) painting room: whole length of a gentleman just finished. Well composed, good colour and forcible effect. He has a powerful breadth and yet plenty of detail.] He very politely requested that on my next visit to the Lectures at the Royal Academy, that I would sit with the R.A.s. Called on Mrs. Hillard, 39 Devonshire St.; tried to find J. D. Lewis and the Count Survilliers[98] but failed. Called on Mrs. Jenkins. Mr. Rush called to see us.[99]

FRIDAY 24, Mr. Atherston lent me a "Master Key." Called on Mr. & Mrs. Jaudon, Brunswick Hotel, Princess Street, near Regent. He has fixed his Banking house 22 Old Broad St., near the Bank of England. Saw Koecker, 5 Conduit St., Hanover Square.[100] He seems in excellent health and was very kind in his reception of me—called on our minister Andrew Stevenson—in his parlour there is placed a portrait of an old woman by Jackson which is more than up to his high reputation as an artist. I have since been informed by Mr. Brett[101] who is the owner of the picture, that it is not by Jackson. Called on Mrs. Bates. It is arranged that her daughter will sit to me next Monday. Left card for Mrs. Todhunter, who is very ill. Saw Mrs. Keeley; called on Mr. Price[102] at 13 Tavistock Square. Met Keeley on our way home. After dinner went with Blanch to the Haymarket theatre.[103]

95. James Sheridan Knowles (1784–1862), English dramatist.

96. See Sully's letter to his wife, November 22, 1837 (WL).

97. The Sullys lived two doors down from Alfred Chalon; their rooms were previously occupied by the painter Gilbert Stuart Newton. Sully to Neagle, November 22, 1837 (WL).

98. Joseph Bonaparte, Count de Survilliers (1768–1844), Corsican statesman, formerly King of Naples and King of Spain.

99. See Blanch's letter to her mother, November 23, 1837, in which she describes their new lodgings.

100. Leonard Koecker, German-born dentist, 5 Conduit Street, Regent Street; practiced in Philadelphia and London.

101. John Watkins Brett (1805–1863), English telegraphic engineer, art collector and entrepreneur.

102. Stephen Price, manager of the Park Theatre, London.

103. See Blanch's letter to her mother, November 24, 1837 (WL).

SATURDAY 25, By Mr. Atherston's advice I furnished myself at Sherborn's with materials for painting—perhaps I could not have found a more indifferent shop. Rented the use of an easel. Mr. Price and lady called. Engaged to paint her portrait. Mrs. A. Stevenson[104] called on Blanch—was instructed that in England it was not customary to escort visitors to your door, as in America, but the bell was touched to call your servant to do that office. Blanch and I took a cab, and at 6 was put down at Mr. Vaughan's, where at dinner we found Mr. & Mrs. Leslie. Miss Vaughan, Petty Vaughan, Mr. Bernard, keeper of the British Institution, and Mr. Thornline, (M.P.). Mr. V. has undertaken to forward a letter I had written to my sister[105] in Charleston. Passed a delightful evening and rode home with Leslie.[106]

SUNDAY 26, After breakfast we walked to St. James's Palace and about the premises,—found it quite cool. Passed through the Park to Buckingham House. Next to St. Martin's Church, where we heard service. At 2, Charles Mitchel called, and we walked to his parents' residence in Camberwell, Surrey; about 4 miles. His house is pleasantly situated, having the open fields in view from the back windows—and a nice garden, which London houses rarely have. Mr. & Mrs. Mitchel gave us a hearty welcome and we soon felt at home amongst these excellent and warm hearted people. They have one daughter and three sons. Miss Ann seems about 16. Peter 26. William 23 and Charles about 21. Our conversation was chiefly about C. King,[107] whom they sincerely love. They have placed an excellent portrait of him (by himself) in the bed-room of his little wife—as he used to call Ann, also one of Mr. Mitchel, and one of RL who lately died. Althó the day was clear, it changed to rain shortly after we got in; and continued so all night. We hired a coach to return.

MONDAY 27, A bright cold day, but no frost. At 10 Miss Bates sent me an apology for not sitting as engaged—is going into the country, will call on Wednesday next. I have entirely got over the Dyspepsia. But Blanch has caught a severe cold that makes me anxious. Wrote to C. King. Attended the Anatomical Lecture at the Academy; and as Sir M.A. Shee had requested I joined the company in the

104. Sarah Coles Stevenson (1789–1848), wife of the American minister to England.
105. Elizabeth Sully Smith (Mrs. Henry Middleton Smith).
106. See Blanch's letter to her mother, November 25, 1837 (WL).
107. Charles Bird King (1785–1882), American painter.

ante-room. Charles made me acquainted with his brother, Edwin Landseer[108]—middle size—manner protending and confident—about 40—light hair in profuse curls. Introduced to Lee, the landscape painter.[109] Saw Philips,[110] who has grown slender and quite grey. Adjourned to the lecture room and was much pleased with the manner of Mr. Green, the lecturer—his demonstrations were finely exemplified on the nude figure of a young man—Returned home at 10 and took tea with Blanch.[111]

TUESDAY 28, The Quebec leaves the docks this day for New York. Blanch and I called on Mrs. Jaudon, Mrs. Rand, on Mrs. Nixon at Mrs. Collyer's. Left Blanch at Mrs. Keeley's, and went to the Banking house of Jaudon, 52 *New Broad St*, and left my request with his brother. The rain obliged me to ride home. Dined at 6. The rain having ceased, at 8 we walked to Miss Martineau's thro' the Park—we took tea, which was handed to guests as in America. Met a gentleman from Birmingham who is acquainted with Mr. Harold. A Mr. Taylor and daughter, and a young gentleman recently from America. Miss Bell, a very handsome person. Did not reach home until 12 o'clock; and should not have obtained entrance but for the kindness of our fellow lodger, Mr. Bell, a surgeon, whom we roused from his pillow.

WEDNESDAY 29, Called on Jaudon at his lodgings early this morning and by his advice I shall leave my funds in his hands and by this means I shall have some interest. And he proffers to save me the trouble of visiting the Bank by paying me at his lodgings. This morning I drew my first bill, on him for 20£. Healy called on us, and introduced Mr. Greenough, landscape and portrait painter, brother of the sculptor now at Florence;[112] residence 74 Newman St. Miss Bates gave me a short sitting—her negligent manner of sitting for her portrait shows me that I am considered as not *able* to do her justice; otherwise she is very amiable, and her mother very kind. In the course of the morning she sent Blanch the Cottage Piano she had promised to lend us. In paying a bill the shopman required me to put my signature on the back of the 5£ note I gave him!! At 7 strolled with Blanch through

108. Edwin Landseer (1802–1873), English animal painter and sculptor.

109. William Lee (1809–1865), English watercolorist.

110. Probably Thomas Phillips (1770–1845), English portraitist.

111. See also Blanch's letter to her mother, November 27, 1837 (WP).

112. John Greenough (1801–1852), American portrait and landscape painter, brother to Horatio Greenough (1805–1852).

Bond St. It reminded us of the appearance and width of Chestnut St. at home. Blanch continued to be plagued with a cold, and was taken quite ill in the night.

THURSDAY 30, Rainy day. Blanch better. Dead colored the head of Miss Bates from a pencil sketch. Rained too hard for Blanch to go with me to Mrs. Bates; the streets were liquid mud. Walked to Bates in thick boots, my pumps in my pocket which I put on in a private room. Dined at 7. Mr. & Mrs. Baker; Mr. Ker; the Belgian Minister;[113] Lady; and gentleman from Connecticut. At 9 joined the ladies in the withdrawing room. In the dinner room was an excellent picture of Niagara Falls by Cole;[114] the only poetical representation of that place that I have seen—and I dare say the truest copy; it would have honored Salvatore Rosa. Mr. Saul and other company drop't in. Got home at 10; found that Blanch has been amused with a Philadelphia [] which Mrs. Audubon had sent her. Hebard had called when we were out, and left his card; he joins his ship at Portsmouth.[115]

DECEMBER 1, FRIDAY Blanch is well except a slight cold. Leslie called for us and we visited S. Rogers, the poet.[116] An old gentleman of middle stature. *Very* pale, and very mild and courteous; of very unpretending manners. We were received with great kindness, and he seemed to take much pleasure in showing us his valuable and varied collection of precious works and relics—statuary, gleaning from Egypt, Pompeii and etc., but to me the most interesting were his exquisite pictures.[117] After a short time he left us possession of the room, as Leslie remarked that we might enjoy it without restraint. The whole house seems to be stored with objects of taste. Some precious designs by Flaxman meet you at every turn—or valuable gems from the antique. The frieze of his hall is from a cast of the Elgin marbles. Etruscan vases in all variety of form are at once the furniture and decoration of the entrance, stairway and passages; add to this, a collection of pictures selected from the best masters of several schools, and you have in a small compass a world of art. Mr. Rogers has expended in these matters a large sum; but much of what we saw had been presented to him. A 'Nolé me Tan-

113. Sylvain van der Weyer, Belgian minister to England.

114. Thomas Cole, *A Distant View of the Falls of Niagara* (location unknown; 7 feet long), painted for Joshua Bates.

115. See also Blanch's letter to her mother, November 19, 1837 (WL).

116. Samuel Rogers (1763–1855), English poet and art collector.

117. On Rogers's art collection, see G. F. Waagen, *Works of Art and Artists in England*, 3 vols. (London, 1833), 2:131–63; and Mrs. Jameson, *Companion to the Most Celebrated Private Galleries of Art in London* (London, 1844), 391–413.

garé by Titian[118] in his early manner—but I refer for particulars in painting to my 'memorandum of pictures." [It is pure in every respect and of Exquisite truth & the tone is not a subdued hue as we find produced by a glazing of asphaltum over the whole work, but a rich golden atmosphere that is produced by the proper tempering of his tints—I have seen nothing of this great master that has pleased me more in regard to colour. My notion on examining the manner in which it was conducted is as follows: the ground of canvas light—perhaps white. After the figures were outlined, the effect glazed in with warm colours—burnt terra Sienna— vermillion—a dark brown. The canvas by this process is nearly covered; as wherever the colour is thinly laid I perceive a warm ground work; the effect, of consequence, is a rich tone. The flesh tints are deeper, more solid and less broken than those of Rubens (in the same room). The shadows are warm. Drapery much glazed. A drapery of crimson is left almost white in the lights, and has been repeatedly glazed to a deep hue with lake. The white drapery in some places painted thin of colour, which as it passed over darker ground produced thereby the half teints. The lights were loaded. The picture is in perfect preservation, free from cracks, fading or any decay. There was also a colored sketch by Titian in his old age. I believe an apotheosis of the Emperor Charles 5th, but excepting its depth of tone, I could not care for it. A small picture by Rubens, 'Mars parting from Venus', it is called a coloured sketch, but it is full of sweet and rich coloring. I know of no good colorist whose palette in his works is so easily detected as in Rubens; but I do not mean by this remark to detract from his excellence in the least—indeed it is a merit to effect so much with so simple means. In the color of Titian's ground (the picture before mentioned) I had some doubt if it had been a tan colour or lighter, but in this of Rubens the ground had positively been white. The outline and effect had been put in with warm colours in a glazing manner, like the picture by Titian, for in both the shadows were thin of colour. The flesh of the female was very fair. It seems as tho' Naples and white for the light was rounded off with neutral tint—say vermillion, black and white—this teint was strengthened in darker parts by the addition of Venetian red, and the darkest shadow of Venetian and burnt umber. Delicate tints of blue and white, Venetian and white and a greenish middle shade. Darker flesh, as that of Mars, was of Venetian Red and white; the shadows olive, like raw umber and white; that strengthed with Venetian red. The deepest shadow of burnt umber and vermillion and the union of the middle shadow and light flesh cleared with tints of the

118. Titian, *Noli me Tangere* (National Gallery, London).

neutral color. His Rembrandt, notwithstanding his vulgarity, is solid, careful and true. Has several by Reynolds, and indeed his best works, in which the utmost license of handling colour was employed. Glazings often repeated. Parts solidly painted until it was loaded with colour and of a fat and rich texture. His pictures of the 'Girl and Bird', 'Sleeping Girl',[119] 'Puck',[120] and 'Cupid and Psyche' and the 'Strawberry Girl'[121] are all in the same style.] The house of Rogers is the resort of all distinguished persons; Leslie has seen there Siddons,[122] Scott,[123] Lawrence[124] and others. Parted with Leslie to pay some visits; called on Stevenson, Count De Survilliers. Mrs. Osgood; our old Landlady, Mrs. Campbell. Mrs. Todhunter; who received us, tho' she was confined to her sofa. Returned to dine. Koecker called in and passed the evening with us.[125]

SATURDAY 2, Last night was a bright star lit night, but this morning a dense fog obscures everything. Doughty called; Miss Bates came to sit half an hour after the appointed time and was so restless, that together with the dusky daylight, I was fair to give up and dismiss the great part of the sitting. Mrs. Bates in her kind way brought Blanch a tumbler full of Calf's foot jelly. Dined at 5 and was kept prisoners by fog.

SUNDAY 3, One month to-day since our arrival in London—I wish it were the last month of our stay—yet, had I the power, I would not break off until my task is finished. It would be said why undertake more than you have the courage to perform? In the meantime I am improving in health, and hope to acquire some useful hint in my profession. Foggy morning. We visited a church at the top of Regent's Street, where it was dark enough to be twilight. The service was so encumbered with ceremonials as greatly to resemble the Catholic forms. A tolerable picture of an "Ecce Homo'; a large organ but played indifferently—singing out of tune. The aisle in the center was large to admit benches with backs, where such as do not choose to pay for a seat in a pew, may find a place. The church was very

119. Reynolds, *Sleeping Girl*, 1790 (private collection).

120. Reynolds, *Puck*, 1789 (Executors of the Tenth Earl Fitzwilliam).

121. Reynolds, *Strawberry Girl*, 1773 (The Wallace Collection, London).

122. Probably Charles Siddons, English actor.

123. Sir Walter Scott (1771–1832), Scottish author.

124. Sir Thomas Lawrence (1769–1830), English painter.

125. See also Blanch's letter to her mother, December 2, 1837, for her description of the visit to Rogers's house (WL).

cold, and the coughing incessant. We should have preferred the Unitarian Church in Little Portland but it did not open until ½ 11. Wrote to Miss Tunno and enclosed Dr. Tidyman's[126] letter of introduction. Mr. W. Vaughan and nephew called—also Mr. John Bristow, Windham Club, St. James Square. He called to acknowledge a letter, sent through us from Mrs. Hughes to his mother. Todhunter called, and fixed upon Tuesday next to sit for his portrait. Drank tea with Audubon, Mrs. A. has been ill.

MONDAY 4TH, Foggy morning; has been a slight frost. Count Survilliers sent invitation to dinner next Friday. Last evening made up another parcel of letters, notes, cards etc., for Sarah; Blanch has also completed her 5th letter. Wrote to E. Carey and to Sill—to go by Liverpool. Miss Bates sat. The day not clear—alas! for painting in London in the winter. The Belgian Minister, Mr. Van Derwere was admitted. Took a cab and rode to Price's to dine at 6. Present: Mr. Twiss, an author[127] and lady. His daughter Fanny,[128] who is related to Fanny Buttler [*sic* for Butler].[129] Mr. Ogden and lady, of New York or Connecticut—Dr. Blood and Lady. Mr. Phelan and lady, of New York, and Mr. McGregor. Price warned me that people here thought much of etiquette, and admonished me of one or two blunders I had made. Returned home at 12.[130]

TUESDAY 5, Mr. Todhunter sat at ½ 10. Paid me one half in advance, according to the custom here. Bates sent me an apology. Yesterday I met Capt Levy: Leslie called with a letter from S. Rogers, complying with my request to be allowed to copy a Reynolds in his collection—but that it must be done at his house. Rand called. Mrs. Osgood and Mr. Thatcher. Visited Mrs. Keeley. Called on Kemble[131]—out of town, 11 James St., Park Place. At 20 minutes before 6, took a cab and arrived at Vaughan's exactly 15 minutes past 6. Met with Mr. Lough[132] and lady, just returned from the Continent. Mr. & Mrs. Leslie; Mr. King and son of New York. We returned at 12.

126. Dr. Philip Tidyman (1777–1850), Charleston physician.
127. Horace Twiss (1787–1849), English author.
128. Fanny Kemble Twiss (Mrs. Thomas Twiss), headmistress of a girls' school in Bath (the actress's aunt).
129. Frances "Fanny" Anne Kemble (Mrs. Pierce Butler; 1809–1893), English actress and author.
130. See Blanch's letter to her mother, December 4, 1837, in which she reports on the previous week.
131. Charles Kemble (1775–1854), English actor.
132. John Graham Lough (1806–1876), English sculptor.

WEDNESDAY 6, Mr. Todhunter sat at ½ 9. Cold and cloudy. Blanch has taken fresh cold—London air does not seem to agree with her—Miss Mitchel has written to her. Called on Koecker and took the names of his trades people that I might deal with them. Called on William Oldmixon, Margretta [*sic* for Margaret] Street, Cavendish Sq., and met his brother John, who had just arrived from Paris. Called on Audubon, and in my absence, he and his sons[133] had called on Blanch, who is again quite unwell. Sad trouble, now that we are so far from home. Called on Mrs. Todhunter. On my return, found Stewart with Blanch. Miss Mary Atherston kindly nursed Blanch, and by her father's advice, who has some skill in medicine, she is better.

THURSDAY 7, Dark day and a thick snow falling—'tis well, I have no sitter, as I could not manage to paint. Blanch better; but not well enough to take tea with Mrs. Hillard as appointed, so I took her excuse. Leslie called with a card from President Shee to admit me to the ceremony of distributing the prize medals to students. Also a card to the National Gallery. Remained at home and passed the evening with music.

FRIDAY 8, Fine day, and Blanch quite well. Set my palette for Mr. Todhunter, but he disappointed me—fear that Mrs. T. is worse. Finished my letter to Sarah. Miss Bates sent to renew her sittings. Waited for Leslie, but he did not come— perhaps on account of this sudden change to rain!! Called on Doughty. And on Brown to order tubes of paint.[134] Todhunter called and has been ill. Osgood called. Blanch dined with Mrs. Keeley. At ½ 7 I took a cab and repaired to dinner at Count Survilliers. Mr. Maitlant,[135] Mr. Bates, Mr. King and son, of New York, and others. He seems to be in good health. Several of his best pictures are here.[136] The dinner was magnificent and served in the French style. Mrs. Bates and daughter dropped in at 10, and I returned home. Fine moon-lit night; and at 12, Blanch was brought home by Mr. Kelley.

9TH, SATURDAY Called on Stevenson on subject of the Queen's portrait. Her

133. Victor and John Woodhouse Audubon (see note 36).
134. Thomas Brown, artists' supplies, 163 High Holborn.
135. William Fuller Maitland (1813–1876), English collector.
136. On the Count de Survillier's collection, see E. M. Woodward, *Bonaparte's Park* (Trenton, N.J., 1879), 55–66.

Majesty is at present sitting to Hater [*sic* for Hayter][137] for the City's portrait. Mrs. Stevenson accompanied by Mrs. & Miss Bates called on Blanch. Took a sitting from Miss Bates. Miss Hinkley accompanied her. Visited Mrs. Price and called on my way there for Blanch who was at Mrs. Keeley's. At 9 visited the Royal Academy to see the prizes delivered and heard an elegant discourse from Shee. Met Landseer, Mr. Lea. Introduced to Mrs. Lover[138] and Maclise;[139]— rather fopish, wears a profusion of black curls. Sat next to S. Rodgers and near Lord Lyndhurst.[140] Leslie remained with the R.As, to elect officers to the Academy for the ensuing year. Returned home through the rain at eleven.

DECEMBER 10TH 1837 SUNDAY Clear sun-shine for this season in London. Attended service in Mr. Taggart's Church, Portland St., good discourse but the Church very cold. Called on Audubon. Todhunter accompanied us to the door. In our absence from home Petty Vaughan and Mr. Bristow called. At 9 we took a cab, went to Mrs. Bates' soiree. Mrs. Ogden, Miss Hinkley, Van De Weyer, Jaudon, young Sturbide.

MONDAY 11, Thick atmosphere and dark. Blanch has brought back her cold by yesterday's exposure in the damp cold church. Mr. Todhunter sat, and Miss Bates at half past the time fixed. The Garrick Club have elected me an honorary member for three months. Left my last letter to Sarah with Miller which will be sent on the 16th. In the evening attended Mr. Green's lecture on anatomy. Left Mary Atherston with Blanch. A clear mild night.

12TH, TUESDAY Tolerably clear day, and the streets seem dry!! I find that the climate of London agrees better with me than with Blanch. I had overlooked to write down in its proper place our walk with Capt. Hebard through "Hounds Ditch" and "Rag-Fair." Called at the Garrick Club in New St., and left my note of acknowledgment of the honor done me. Leslie procured me admittance to the National Gallery in Pall Mall[141] previously to their removal to the Academy. The

137. Sir George Hayter (1792–1871), English historical and portrait painter to Queen Victoria.
138. Wife of Samuel Lover (1797–1868), English painter.
139. Daniel Maclise (1806–1870), Irish narrative painter.
140. John Singleton Copley, Jr., Baron Lyndhurst (1772–1863), English barrister, Lord Chancellor.
141. On the National Gallery's collection in 1838, see John Landseer, *A descriptive, explanatory, and critical catalogue of fifty of the earliest pictures contained in the National Gallery of Great Britain* (London, 1834).

principal Col. Thwaites was very attentive and placed me in the direction of Mr. Twiss, who patiently showed and explained things. I must confess some disappointment in the excellence of some vaunted pictures of the Old Masters: they seemed to my judgment far over-rated. Too much reverence for a celebrated name merely. It is true that we should be on our guard not to expect qualities of excellence in celebrated painters, who had not cultivated a particular department of the art: for instance—good drawing or grace is not to be looked for in the works of Rembrandt—or Rubens—nor very harmonious coloring in the Roman school, and so on: but I cannot persuade myself to admire a bad picture, tho the name of Titian or Raphael is appended to it. [The two famous Correggios, which cost 8000 Pounds, disappointed me—one 'Education of Cupid' seems worn by cleaning.[142] The colour has become monotonous; the shadows of the flesh too green; the composition and drawing, not very commendable; the face of the Venus is ill drawn and ugly. The other picture, an 'Ecce Homo' is in good preservation; some passages beautifully true, a fine breadth of effect and tone; excellent expression.[143] But the body of Christ is ill drawn; looks as tho' it did not belong to the head. The handling is very careful and laborious; the surface reminded me of Allston's. Here are several Reynolds. One in perfect preservation; portraits of three ladies at full length, painted as the 'Graces'—a ridiculous composition.[144] The flesh is cool in colour for Reynolds, but true and delicate, somewhat more accurate in detail, but yet very broad in effect. The outline quite lost. The arms and fingers painted with large brushes and as tho' no outline had been made. The trees executed like scene painting, as also were the landscape and drapery. His portrait of Lord Heathcote [*sic* for Heathfield], Governor of Gibraltar, a half length, is said to be his best portrait; and it is remarkably simple in its means—I conclude that the great essentials of a picture are to have the composition, drawings and effect good; without these being just, no detail or care will avail.[145] Portrait of a Jew-Merchant by Rembrandt.[146] Exceedingly simple in its execution and with little variation of teint; and upon the whole is the best portrait I have seen by this Master. Reynold's large picture of the 'Repose on the Flight of

142. Correggio, *Mercury Instructing Cupid Before Venus* (*The School of Love*), mid-1520s (National Gallery, London).

143. Correggio, *Christ Presented to the People* (*Ecce Homo*), late 1520s (National Gallery, London).

144. Reynolds, *The Montgomery Sisters* (*Three Ladies Adorning a Terms of Hymen*), 1774, transferred from the National Gallery, London, to the Tate Gallery in 1968.

145. Reynolds, *Lord Heathfield*, 1787 (National Gallery, London).

146. Rembrandt, *Jacob Trip*, c. 1661 (National Gallery, London).

Egypt'—Parts of the work of Sir Joshua; but there must have been some experimental colouring used in passages of the picture.[147] The fingers of the Virgin have turned into the resemblance of lumps of chalk. The St. John has turned blue from the hips to the feet and the heels are tipped with a red lead tint. I had a fresh opportunity of inspecting the two famous compositions by Rembrandt, once owned by Angerstein: 'The Woman taken in Adultery' and the 'Birth of our Saviour'.[148] Both are of his best manner—but the difference in price is remarkable. The first mentioned cost 5000 Pounds. It is more carefully finished but not superior in excellence to the other, which was purchased for 300 Pounds. One of Lawrence's early pictures of a lady at full length, resting on a harp.[149] A discredit to his name. She looks like a vulgar loose person.] On my return home found Mrs. Audubon, Jr., walked with her to Wimpoole [*sic* for Wimpole] St. Met Mr. Kemble. Called with Blanch on Mrs. Hilliard, on Mrs. Jenkins. After tea, attended a lecture on Calicoe Printing, at the Adelphi[150] and found much pleasure in looking at Barry's[151] celebrated pictures; there is considerable excellence in them; and at gas light, the want of good colouring is not so much felt. After the lecture Mr. P. Vaughan conducted me, together with all who had heard the lecture, to a sort of ante-room where was provided tea, coffee, bread and butter. Got home at eleven.

WEDNESDAY 13, While setting my palette this morning, I received a polite note from Frank Johnson to attend his concert to be given in Surrey St., Strand, by his coloured band—was prevented attendance by business. Mr. Todhunter sat, after which I was tempted by the bright sunshine to walk out with Blanch. We called on Mrs. Todhunter. On Brown, my colorman to pay his bill. By some blunder I have mistaken the day in the above memorandum—it should be Thursday. For on the day before I took sittings of Todhunter and Miss Bates and continued to paint while Blanch paid visits. Mr. Bristow called; he observed that Lounsdale [*sic* for Lonsdale][152] and myself charged the same price for portraits.

147. *The Holy Family*, transferred from the National Gallery, London, to the Tate Gallery in 1949.

148. Rembrandt, *The Woman Taken in Adultery*, 1644, and *The Adoration of the Shepherds*, 1646 (National Gallery, London).

149. Lawrence, *Mrs. Francis Robertson*, c. 1800, transferred from the National Gallery, London, to the Tate Gallery in 1919.

150. Society of Arts at the Adelphi Theatre, Adam Street, Strand.

151. Sir Charles Barry (1795–1860), English painter.

152. James Lonsdale (1777–1839), English portraitist.

FRIDAY 15, Clear, bright and about the temperature of the middle of October in Philadelphia—too warm in fact for an overcoat in the open air. Blanch appears to have resumed her usual health; and I have not felt so well for many years. Todhunter sat. Painted on the portrait of Miss Bates until past 2; then took advantage of the fine weather to walk. We visited Mrs. Langley in John St. Called on Doughty and Healy—left card for Count Survilliers (lost my handkerchief) At 9 we visited Kemble. Miss Adelaide[153] received us. Much company. Miss Adelaide played and sang exquisitely. Portraits in group of Mrs Siddons[154] and Fanny Kemble—so so.[155] Fannys rather better—portrait of her child Sarah Butler,[156] very good. Mrs. C. Kemble out of town.

SATURDAY 16, Last evening we walked home from Kemble's it being fair, mild, and an uncommon bright moonlight. This morning is quite fair; it is thought that we have uncommon fine weather. Painted until 3 on the portrait of Miss Bates, Blanch assisting me as manikin. Miss Kemble called, but we did not see her. Mrs. Rand, and the Rev'd Vogel called and stayed a long time for having dispatched my painting my door was open to receive company—we regretted that Miss Kemble had not called later. At 4 we walked to Audubon's and passed an hour, returning we were overtaken by rain—the weather changes here so rapidly that it is not prudent to go out at any time without being prepared for a change. At seven we repaired by invitation to Koecker's, and passed a very pleasant musical evening. Blanch gave Mrs. Koecker's letter to her son Leonard, together with some handkerchiefs. Mr. Sappio and son, Dr. Robertson, W. Oldmixon, Mr. Rocker, wife and daughter, a child of 9, who played well on the piano.

DECEMBER 17, 1837 Sunday A dark and misty day. Was up at ½ 4. At 8 awoke Blanch for Breakfast. Rained too fast to venture to Church. Drew a pattern for my painting room carpet in Philadelphia to direct the workman in making one. Began a letter to Sarah. Dined at ½ 5 and at 9 we took a cab and visited Stewarts. Large party, chiefly musical. An oboe and basson from the Opera and first rate. A German on the flute, and a guitarist were very fine. Excellent harpist, and Miss Myer, on the piano, was beyond any player I have heard. Was introduced

153. Adelaide Kemble (b. 1814), later Mrs. Edward John Sartoris.
154. Sarah Kemble (Mrs. William Siddons; 1755–1831), English actress.
155. Henry Perronet Briggs, *Sarah Siddons and Fanny Kemble*, 1830 (Boston Athenaeum).
156. Sarah Butler (b. 1835), later married Dr. Owen J. Wister of Philadelphia.

to Etty[157] the painter—he reminded me in appearance of Jarvis.[158] Mr. Roberts, landscape painter,[159] and daughter. Walked home through the rain at 12. I find that to speak of the necessity of living within your means whatever they may be, is not considered in bad taste here. Mr. Mitchel called during the day, and engaged us to dine with his family at Camberwell next Christmas at 2 o'clock—and this reminds me of dining with him in company of King, 27 years ago on the same occasion. Todhunter called before dinner and took home his portrait to show Mrs. Todhunter.

MONDAY 18, It still rains, but is mild weather. Received a friendly letter from Miss Tunno. Painted all the morning on Miss Bates' portrait—but I can make nothing good of it. At 3 called on Audubon and left his umbrella. Mrs. A. very ill. Left cards at Miss Kemble and Miss Martineau's. At 9 we drove to Langley's. Pleasant dancing party, but we took French leave before 12 and rode home.

THURSDAY 19 Todhunter brought me his portrait to finish, the likeness is approved. This quite mild weather, and but for smoke would be clear. Mr. Hilliard and Mrs. Osgood called. We dined at Todhunter's. In the morning while I was painting, it became so dark and rainy, I had to desist. Mrs. T. could not dine with us, as she had undergone an operation from the hand of Sir A. Cooper.[160] Tickets for the Opera Buffu came after dinner and Mr. T. insisted on our seeing it. At 9 we reached the Lyceum and were in time for the fine overture. About 50 in the orchestra; amongst whom were the famous Dragonnetti [*sic* for Dragonetti],[161] Lindley,[162] Morey [*sic* for Mori][163] and other talented men, Bellini sustained the part of La Parello in the 'New Figaro.' This piece went off well from the force of the performers—yet I did not like it. The Queen, accompanied by the Dutchess Sutherland,[164] Countess Mulgrave,[165] &c. &c., were present, and of course en-

157. William Etty (1787–1849), English painter.

158. John Wesley Jarvis (1780–1840), American portrait and miniature painter.

159. David Roberts (1796–1864), Scottish landscape painter.

160. Sir Astley Paston Cooper (1768–1841), English surgeon.

161. Dominico Dragonetti (1755?–1846), Italian double-bass player.

162. Robert Lindley (1776–1855), English violoncellist.

163. Nicolas Mori (1796–1839), English violinist and music publisher.

164. Harriet Elizabeth Georgiana Leveson-Gower, Duchess of Sutherland (1806–1868), Mistress of the Robes.

165. Martha Sophia Maling Phipps (d. 1849), wife of Henry Phipps, first Earl of Mulgrave and Viscount Normanby.

gaged much of our attention. In leaving the theatre, we witnessed the departure of many persons of rank—but I looked in vain for any distinguished beauties amongst them. Got home at 12 & found a letter from the Admiralty, or I believe Treasury—granting me permission to land my pictures free of duty, with some stipulated conditions.

WEDNESDAY 20TH — Still raining, and at 8 o'clock, inconveniently dark. Had to comply with a request from Mrs. Bates to make a pencil drawing of her daughter's head;[166] which I sent to her, with the Order from the Treasury for Mr. Bates—nearly finished Todhunter. Called on Koecker. On Brett and saw some admirable pictures.[167] Blanch and I took tea at Mrs. Hillard's. Met there Mr. & Mrs. Osgood, Capt. Sturges, of the packet ship Sansom. Returned home at 11.

THURSDAY 21, Last night was fair, and this morning is bright and clear. An invitation to dine with Wilkie and sister on New Year's day. Since changed to Wednesday 3d. on account of the Royal Academy's dinner. Miss Bates gave me a *sort* of a sitting. Blanch walked with me to Upper Brook Street, where I left the pamphlet for Miss M. Tunno sent by Dr. Tydeman. Visited Leslie, found them at dinner, got home by dark, and remained there.

FRIDAY 22 Mr. Todhunter sat, Miss Bates sent excuse. Mr. Wright, the author,[168] called, Mr. Bristow and child and sister called. Mrs. B. Todhunter called.

SATURDAY 23, Mr. Todhunter took his last sitting. His wife is so ill, that he has relinquished his intended dinner party for today. Heard from Mrs. Sill, his sister[169]; who says that our family are well—I forgot to state yesterday, that we dined at Keeley's with a Mr. Gerald. Returned at 9 and found that the case of pictures belonging to Carey, was sent by Mr. Bates; on opening the case which has been slightly nailed at the Custom House, I found they had knocked a hole in the picture of Beatrice[170] and much injured the frames; and had the effrontery to

166. The location of the drawing is unknown.

167. On Brett's collection, see *The Illustrated Catalogue of the Valuable Collection of Pictures and Other Works of Art . . . of that eminent connoisseur John Watkins Brett*, London: Christie's sale catalogue, April 5 and 18, 1864.

168. George Newton Wright (1790?–1877), English author.

169. Jane Todhunter (Mrs. Joseph Sill; 1801–1877).

170. *Fanny Kemble as Beatrice*, 1835 (fig. 17).

send me word, that it had happened from ill packing. This however is the only unpleasant thing that has occurred to me in London, so I must forgive it. Saturday in continuation after, Miss Bates took her last sitting. Leslie called meantime, and escorted Mrs. Bates to Chalon's rooms. After Mr. Bates left us I accompanied Leslie to Brett's, and had much pleasure in again looking at his fine collection. [The best picture by Carlo Dolci I have yet seen. Softness, breadth, effect, and good colour. A fine copy by G. Dow from Rembrandt. He has a whole length of Charlotte Montague by Reynolds,[171] which I think one of his best portraits. I found more simplicity of colour, light and shade, and 'making out' than I have been endeavouring to acquire. The effect of the whole together seems to have been the chief object of Reynolds.] Called on Smith, picture dealer, Bond St.,[172] and at Leslie's suggestion engaged him to repair the damage done to Carey's pictures. He has some excellent pictures. Walked with Blanch to Cozen's [*sic* for Cousins][173] who was at dinner so left my card. We called on Lough; and as we promised, returned to them at 7 to take tea, we found her three sisters, the Misses North. We had some good music from recollections of Handel and much talk of Italy—They gave us an old English game of "Snap Dragon", that greatly amused the two little girls. We bought a cap to send home to Sarah, by Leslie's package and with it a letter No. 6 by Blanch.

SUNDAY 24 Little rain today. When we returned to dinner, we found a note from P. Vaughan inclosing 3 letters from home, which gave joy to our repast. The dates were 25th of November, and they had not then received news of us!! Passed all the rest of the day in writing home. Messrs. Audubon called.[174]

CHRISTMAS DECEMBER 25 MONDAY Fair and mild; in fact we have had no cold weather as yet, nor even frost enough to harden the mud in the streets. Blanch found, on opening her chamber door this morning some suger plums, a bottle of perfume and some soap, as the accustomed presents on this day—but of an humble sort, but it may serve as a remembrancer. Painted on the portrait of Miss Bates until 12. Todhunter called and accompanied us to Charing Cross where we took the coach to Camberwell. Got out at Camberwell Green, and a

171. The location of the painting is unknown.
172. John M. and Samuel M. Smith, carvers and gilders, picture dealers, 137 New Bond Street.
173. Samuel Cousins (1801–1887), English engraver.
174. See Sully's letter to his wife and Blanch's to her mother, December 24, 1837 (both letters WL).

few steps brought us to the North Terrace, and a hearty welcome of Mr. Mitchel and his excellent family. After a slight luncheon, Mitchel, the daughter, Peter and Charles, invited us to a long walk—I mistake—Peter remained at home, not being well, and William accompanied us. We went through the venerable Churchyard across the fields—to Dulwitch [*sic* for Dulwich], roamed over the hills, enjoying the lovely, cultivated scenery, in a bright day, and balmy atmosphere, and after a walk of at least ten miles, we returned to dine at 5 o'clock. The health of Charles King, and Mrs. Sarah Sully with her fireside connections was drank in bumpers. The rest of the evening after dinner was spent in music. Miss Ann played on the piano prettily and Peter accompanied her on the violincello. Blanch and I joining in with our portion. Got home by 12 o'clock.[175]

DECEMBER 26, TUESDAY Foggy morning. Mr. Koecker, Mr. Rush and son called yesterday during our absence. Finished the portraits of Miss Bates and Todhunter. Mrs. Todhunter, Doughty, Mr. Price and Miller with whom I left the last letter I had written to Sarah—say No. 5—left a note for Jaudon to appoint a time for his sitting to me.

WEDNESDAY 27 Blanch has begun her 7th letter for home. Made a design for a "Charity", suggested by a sketch from King. Miss Bristow, brother and his son called. Audubon and wife called. Returned with them for tea.

THURSDAY 28 Yesterday I left a plan of my painting room. Exhibition room carpets, with Jackson and Graham, to give estimates.[176] Mr. Jaudon sat at 10; dead colored the whole picture, and then—it being a pleasant warm day; we visited Miss Kemble, Martineau, Price. Mr. Stevenson called to read me a letter from Lord Melbourne[177] in answer to the Memorial, to say the Queen would sit to me for her portrait next February. Doughty called and drank tea.[178]

FRIDAY 29TH —The air today was pure and warm as in April. Mr. Jaudon gave me a short sitting for drapery. Worked on my design. Carpet man sent me

175. See Blanch's letter to her mother, December 26, 1837, for her description of the visit to Camberwel and Dulwich (WL).
176. Jackson & Graham, upholsterers &c, 37–38 Oxford Street.
177. William Lamb, Second Viscount Melbourne (1779–1848), statesman (Prime Minister, 1834–41).
178. See Blanch's letter to her mother, December 28, 1838 (WL).

estimates for several kinds of stuff; have selected that called Kidsminster, and find the cost will be about 20£. Called on Mr. Cousins, in Albany Street saw him and made some arrangements as to the charge for an engraving from N. Biddle's portrait. He was busy with the engraving of the Queens portrait by Chalon. Was also engraving from a picture by Lanseer of two children. Cousins accompanied me home, and after inspecting Biddle's portrait he agreed to the work for 100 guineas; size to be 10 ½ by 9 inches. And may be done next October. All impressions struck off will be six guineas per 100. Sent the portrait to his house by Mr. Smith's man. And I also sent to Mr. Smith the frame of Beatrice to be mended. We took tea at Audubon's and met Dr. Philips and lady last Wednesday which I had overlooked. Today we dined at Mr. Todhunter's with Mr. Graham and Mr. Wright. Mrs. T. was too unwell to join us, so that Blanch was the only at the table. Mr. Graham saw us home. The stars shone brightly and the air was mild as April. While I was at Cousins this morning, Mr. & Mrs. Price called. They left word for me with Blanch, that she was about to leave town, but would sit to me on her return, which would be on the 8th of January, Tuesday at 12.

DECEMBER 30, 1837 SATURDAY Mr. Jaudon sent an apology for not being able to sit this morning—being obliged to leave town immediately—I painted in a careful outline of my design. At 3 we called on Mrs. Audubon who is again ill. The day before yesterday I left a card for Levy—Called J. D. Lewis, 11 Cornwell Terrace; on Mrs. Langley, who is out of town; on Mrs. Hillard, and Mrs. Osgood, at No. 86 Newman Street, to where they have removed. Mrs. Bates has sent for her daughter Elizabeth's portrait—thank fate they like it—I cannot. Wrote to Mr. Bates requesting to pay Custom House charges for Carey's pictures which he had attended to for me. Dined and took tea at home.

SUNDAY 31, Rained a little last night but the sun shines brightly at present. Staid home to write, as I feared to expose Blanch to the cold Churches. Wrote to N. Biddle, Esq. At 2 we walked to Belgrave Sq.,—looked at Chesterfield House. Called on Audubon. On Keeley—home to dinner, and at ½ 6 to Stewart's to a family tea. Mr. Fraser, artist of Edinburgh.[179] Doughty and Healy. We staid supper and sat the old year out—by which we did not get home until 1.

JANUARY 1, 1838 MONDAY, Rained a little, but cleared off at 2. The residents say, that the season is unprecedented for its mildness and clearness.

179. Alexander George Fraser (1786–1865), Scottish painter.

Painted in the effect of my study with glazing colors. At 3 we went to Audubon's and Mrs. Todhunter's, who are both recovering. Called on Mrs. Stevenson—but she has gone with her husband to Paris.

TUESDAY 2ND, Mild but rainy. Blanch has her plague of a cold. Painted all day on my design. Mr. Corbit, of Philadelphia, and Mr. Martin called. They are just from Paris; they are on their way to the north and mean to return to Philadelphia this month. Gave me a friendly letter from Mr. Saul, and left me letters for Doughty and for Humphrey—which I promptly delivered. Blanch and I walked to Fenchurch St. We met Mr. Vaughan and niece—we left Biddle's letter to be forwarded by Petty Vaughan. Doughty took tea with us and I accompanied him to Mr. Lowell's, John St., passed an hour with his family.

WEDNESDAY 3 Another fine day, and last night the moon was bright. Painted until 3 in my study. Visited Healy, Blanch returned his book, and borrowed another, met Mrs. Jauden there. Am glad to find that Healy is improving, becoming known and getting into good practice. At 6 we took a cab and rode to Sir D. Wilkie's to dine; as we arrived, Leslie and wife drove into the yard; and other guests were alighting from their carriages. We assembled, Wilkie, brother, and sister, Mr. Hart[180] an artist, Mr. Rice, Lady and daughter, two young ladies whom I did not know, as it is not the custom to introduce guests particularly unless requested by the party themselves. Their names are announced by the servants when they arrived. Mr. Allan Cunningham,[181] the author, to whom I was presented; and who is a lively and agreeable Scotsman. Our dinner was scotch—so was some delightful music, played and sung by Miss Wilkie. Wilkie showed us the famous head of Marché [*sic* for Marchi] by Reynolds.[182] Told us some stories of Walter Scott that were to me new—we took leave at ½ 10 and reached home through a fair night. London is the place to find contrasts of all kinds, physical and moral. Benevolence and purity of character has its ferocious opposite. Splendor! its contrasts of misery and so on, without end.[183]

THURSDAY 4 Painted on my study until 3. Audubon called and lent me a folio volume of the Musée Napoleon. Walked with Blanch to Humphreys and gave

180. Soloman Alexander Hart (1806–1881), English painter.
181. Allan Cunningham (1784–1842), Scottish author, secretary to Sir Francis Chantry.
182. Probably a copy of Reynolds's portrait of Giuseppe Marchi (Royal Academy of Arts).
183. See Blanch's letter to her mother, January 6, 1838 (WL).

him Corbit's letter from Neagle. Home at 5 and found an invitation to dinner from J. D. Lewis, for next Wednesday.

FRIDAY 5 So dense a fog that we breakfasted by candlelight, nor could get on without its aid until ½ 9. Blanch has finished her 7th letter to home, which I left with Miller to be forwarded by the Liverpool 8th Packet. Could paint but little today as the fog continued. Calls from Mrs. Hillard, Mrs. Osgood and Mr. Audubon Jr., Brett called to invite us to his party of Thursday next—but we had previously engaged ourselves to Mrs. Hillard. We remained at home this evening and found much amusement in reading the papers sent us from New York by Mr. Corbit.

SATURDAY 6 We find that even the news-paper advertisements from home have an interest for us. Mr. Smith of Bond St., has sent me the Beatrice and frame mended. We dined with Mr. Bristow at his lodgings. His brother, sister and his child are with us and a Mr. Sands of New Brunswick. We were at first very cold and uncomfortable, but by nine o'clock we had got into better condition. The fire was brighter. Young Bristow is about to sail for Canada via New York, by him we shall send a parcel home. We were rejoiced to get home at 10 o'clock, altho nothing could be better intended than the hospitality of our kind entertainers— but a lodging house is no place to get up dinners in. We found a note at home from Petty Vaughan enclosing a ticket for the Society of Art; but we are engaged previously.

JANUARY 7, 1838 SUNDAY Rather cold, made up our parcel for Mr. Bristow and directed it to James C. Barnet at New York. Todhunter with his wife's sister, Miss Webber called—engaged to dine with them on Tuesday—Mr. Vaughan called. Mr. Jaudon (brother to the cashier) and Mrs. A.G. Ralston, of 23 upper Harley St., who I find has resided here 3 years—was at Philadelphia last year and also Mr. Dixwell, 12 Devonshire St., Portland Place. We remained at home all day. In looking over my accounts, I find we have expended at the rate of 30£ per month and this notwithstanding the most guarded economy.

MONDAY 8TH, Quite cold this morning, with snow. At 10 we set off for a walk—called on Smith and paid him my bill for repairs. Called at Bristow's and left the parcel. We then walked to Kensington and found Sir David at home. He took us into his painting room to see the progress he had made in his picture of the "Queen's First Council." He gave me useful hints for my conduct in painting

her Majesty. Advised me to be at the appointment two hours previously in order to make preparations. He always supplied himself with duplicate articles—even a second easel he found useful to place Drapery for a background—and of course palettes, canvas &c. Make it a rule to use the full title seldom. He marked the first address: "Your Majesty"—and *Madam* afterwards. *Never* ask questions. He received her in the room appropriated to the purpose of being painted at Brighton—and made a profound bow at her entrance; then waited for her to speak. Had a platform provided on which to place her chair, as it was etiquette that he should stand. If it had been requisite that he should sit to his work, he would have addressed his wishes to the Lady in attendance on the Queen—and if anything is to be communicated to her during the sitting, it is most polite to whisper the matter to the person in attendence—for instance you may require a change of position &c., &c. The Queen after sitting an hour and a half showed symptoms of fatigue; whereupon he said: "Your Majesty has now favoured me with a longer sitting then is usually given, and I ought to leave off." She then named another time to continue the sitting and left the place. He mentioned to the lady or lord in waiting when he had received sittings enough. On one occasion, upon her retiring, he preceeded, and opened the door, bowing her out. And on every occasion of her retiring, followed a few steps and bowed profusely. Never turn your back. Dress, as though going to a party—on one cold day he wore an overcoat. He did not tell me if it was also requisite to salute other persons about the Queen. On leaving Sir David, we returned through Kensington Gardens and the Park. It continued to snow lightly. We saw "Newton Pippins" advertised.[184]

TUESDAY 9TH, *Very* cold and snowing. Water froze in Blanch's room last night. The houses here are miserably constructed for keeping out the cold, and a common fire will not warm the room. I think we manage this matter better in Philadelphia. Mrs. Price sat, and I made preparatory sketches for a kitkat[185]—the little lap-dog Flora, is to be included. The rest of the day I employed in adjusting my composition. V. Audubon called. At 5 we went to dine at Todhunter's. Still snowing, and the pavements taken up by slides—where the streets are not too crowded. Miss Webber and Dr. Gay of Birmingham.[186] Mrs. T. is still confined. After dinner we rode to Covent Garden Theatre, Opera "Amelie" Orchestra of

184. See Blanch's letter to her mother, January 8, 1838 (WL).
185. The location of the sketches is unknown.
186. Possibly Martin Gay (1803–1850), American physician.

upwards of 50 performers, fine chorus and Miss Shireff[187] as principal, sang charmingly. The pantomime of Peeping Tom, was very droll. But the chief pleasure to me, was Stanfield's Diorama!!![188]

WEDNESDAY 10 Very cold, but clear. I cannot say it is as cold as we have it in Philadelphia. But not having those little conveniences we have at home, I am more exposed to feel it. This completes the 3rd month of our departure from home, and I look with dismay forward to the time that is to come before our return. I have indeed set myself a painful task. Healy and Doughty called on us last night. We did not get over our breakfast until 10 o'clock owing to our last night's dissipation. Mrs. Price's design occupied me until 3—took notes of excuse to Lough and Miss Kemble. Snowing yet. At ½ 6 Blanch and I trudged through it to dine with Mr. Lewis. Met there Mr. Dixwell, Mr. Bates, Mr. & Mrs. Kaile, Mr. Aspinwall,[189] Lady and two daughters—Got home at 12 safe by the defense of our thick shoes.[190]

JANUARY 11TH 1838 THURSDAY It was a beautiful night when we returned from Lewis'; this morning it snows again, with the wind at N.W. and bitter cold. Mrs. Price sat at 12. At 3 Blanch and I made our visiting calls—on Mrs. Keeley, who was still in the country, and Mrs. Todhunter. Last night the Royal Exchange burned down—we saw the reflected light as we walked home at ½ 9. Rode to Mr. Jenkins—a dancing party; and as usual, to those who do not dance, a very stupid affair. Mrs. Leslie left us early; her husband not being well. We got off at ½ 11 and walked home. Mr. Jones, the surgeon who rents the ground floor of our lodgings, is dangerously ill.[191]

FRIDAY 12 The cold is severe, and a dense fog obscures us, so that we had to burn candles until past 10 o'clock; too dark to paint, so that we employed ourselves in washing off the soot or mud from our windows—the glaziers who are employed for such work, charge extravagantly—the cost of cleaning our windows would be 2 pound 5 & which would only keep clean a month in this detestable

187. Jane Shirreff (1811?–1883), English soprano.
188. Stanfield, *Scenes at Home and Abroad*, 1837, painted as scenery for William Charles MacReady's performance of *Harlequin and Peeping Tom*.
189. Colonel Thomas Aspinwall (1786–1876), U.S. consul at London 1815–53.
190. See Blanch's letter to her mother, January 10, 1838 (WL).
191. See Blanch's letter to her mother, January 11, 1838 (WL).

atmosphere. At 12 it cleared enough to allow me to paint until past 3. Paid some visits with Blanch.[192]

SATURDAY 13, *Very* cold. The water in Blanch's chamber froze so as to break the handle of the pitcher. Yesterday Mr. Bristow and sister called. John Audubon and wife called. Doughty took tea with us. He finds the cold more searching than in the States; but I think this day the most severe we have had; it is with difficulty I could paint or write. Dead colored the entire portrait of Mrs. Price Mr. Coffin called upon us, C. Leslie and V. Audubon, who took Blanch to Regent's Park to see the skating. She dined at Audubon's, and I with Price, who gave a Gentlemans dinner. Present: Col. Aspinwall, Mr. Dunn, of Drury Lane Theatre, Mr. Frank Broson, a writer, Doctor or Surgeon Liston;[193] Dr. Blood, Mr. Roberts, artist,[194] Mr. Lenny, Crew, the sculptor from Brighton (Carew).[195] Price made me some friendly professions, and promised to get me a good place for any picture I chose to send to the Royal Exhibition. He avowed the cold to have been to him for the last five days more intense than he had experienced it in America, altho the Thermometer in London had not been lower than 2 below zero. Got to Audubons by 10, and home before 11.

SUNDAY 14 Weather moderated; snowing hard. Sent my account to Mr. Bates for his daughter's portrait. And made arrangements for sending Carey's two pictures for Exhibition to the British Institution. John Audubon called; also Mr. & Mrs. Langley. At ½ 5 we walked to Charles Leslie, took tea and spent a pleasant evening. We looked over a set of designs by Michael Angelo for the Sistine Chapel's fresco paintings. In these the Chiaroscura was all that could be desired, and Leslie assured me that a copy he once saw of the Prophet Jeremiah, was equal in truth of color to a Venetian picture so it appears, this great artist was not insensible to the advantages of minor ornaments. Returned home in a bright moonlit night; but cold.

MONDAY 15, I think, this is the coldest morning we have had; I really suffered, while painting, with the cold. Mrs. Price sat at 12. Mrs. J. Audubon called

192. See Blanch's letter to her mother, January 13, 1838 (WL).
193. Robert Liston (1794–1847), Scottish surgeon.
194. Probably David Roberts (1796–1864), Scottish landscape painter.
195. John Edward Carew (c. 1785–1868), Irish sculptor.

and took Blanch out—and then Mrs. Leslie took her out. My two pictures and letters are taken by Smith to Mr. Bernard at the British Institution. At eight we visited Brett who gave a large party—and but for the intense cold weather, would have been very pleasant—but there was no resisting such an attack of Jack Frost, and woe to the ladies who had on thin dresses that night. Mr. Marsh,[196] an accomplished harpist, played and sung. Mr. McNeal, picture dealer—Mr. Prout, artist; nephew to the well known artist of that name[197]—Pickersgill[198] and family. He is about 56, small stature—dressy and very marked in his politeness—perhaps a little vain and consequential [*sic*]; but very communicative and affable. He spoke of his early difficulties and struggles to get bread—his want of natural talent and having acquired his present standing as an artist, by labour alone—would willingly abandon the profession if he could live without it—all of which I could not quite believe. He inquired when I should begin the Queen's portrait—so that I find the fact of her going to sit to me is generally known even here. We did not get home until one o'clock.[199]

TUESDAY 16 Snowing. Mrs. Bates sent for the plaster bust of her daughter. And Mrs. Price sent an apology for not being able to sit. Employed the morning in making a sketch for Murillo's Beggar Boy.[200] At 3 Blanch accompanied me in a walk. January 16, 1838 in continuation, Called at Price's and left the book he lent us. Enquired of Mrs. Todhunter's health. Of Mrs. Keeley, who has returned. Left card at Jenkins. Called on Lough. Returned to dinner and spent a confortable evening at our own fire-side—I find, on looking into my accounts, that incidental expenses have increased my disbursments to about 2 pounds, a week, on an average.

WEDNESDAY 17, It snows but the weather is milder. I am thankful for having escaped a cold, which I felt strong symptoms of from the effects of Brett's party, where, added to the cold, there was strong draughts of air from door and infirm windows. Blanch has observed that many respectable females in society here, wear rouge. Mrs. Prince, not being well, deferred her intended sitting until tomorrow—therefore painted on my design. Mrs. Osgood and Mrs. Hillard called,

196. Stephen Hale Alonzo Marsh (1805–1888), English composer and harpist.
197. Nephew to Samuel Prout (1783–1852), English watercolorist.
198. Henry William Pickersgill (1782–1875), English painter.
199. See Blanch's letter to her mother, January 15, 1838 (WL).
200. The location of the sketch is unknown.

who left us some American papers. Blanch and I called upon Koecker, Brett and Kemble. And passed the evening at home in reading the papers. Mr. Bates sent me a cheque on his banker for the amount due for his daughter's portrait after deducting charges for Carey's pictures.

THURSDAY 18 Mr. Jaudon sat at 10. Mrs. Price at 12. Went to Bishopsgate Street, No. 8, to cheque the draft on Baring paid me by Bates—it was there endorsed and cashed at 68 Lombard St. near "Change Alley." As it snowed much I took an omnibus. Left Blanch's note of excuse at Mrs. Bates. As my chimney is to be swept tomorrow, and it will take all the morning to clean the room, I have put off my sittings until the following day. Luckily, sweeping chimnies is not often required in London; twice in the season suffices, except for kitchens, which must be cleaned every six weeks.

FRIDAY 19 In my visit to the city yesterday, I was struck with the dismal appearance of the smoking ruins of the Exchange which was burned last week. The snow storm then raging, added to the melancholy of the scene. I hope it will be rebuilt on the same model, for tho' old in taste, it was handsome. J. Audubon and father called; they told us of Strickland[201] and Mr. Struthers having arrived at Liverpool. Mrs. Lowel sent Blanch an invitation to tea. At 5 dined at Audubon's. Mrs. A., Blanch and the two sons went to a child's party at Mrs. Gordon's, sister of Mrs. A. Sr. I returned home at 9 and Blanch got home at one.

SATURDAY 20, Mr. Jaudon was punctual to his appointment, but it was too dark to paint. And fortunately Mrs. Price sent an apology—in fact it was so dark that we had to light candles until 2 oclock—and to complete the list of agreeables, it is as cold as ever. The water froze in our chambers. Yesterday I left cards for Ralston, Dixwell and Dr. Lowel. Saw four able-body looking paupers, shouting their distress, in the middle of the street, and imploring relief !!! They were not the only mechanics we saw during the severe cold. There was gardeners, weavers and their families, werrymen, in addition to the usual mendicants.[202]

SUNDAY 21 I had neglected to record that last Friday during my absence the Misses Patterson, of Philadelphia, called upon Blanch. I have heard that Struthers

201. William Strickland (1787–1854), American architect.
202. See Blanch's letter to her mother, January 20, 1838 (WL).

has not accompanied Strickland. The weather has moderated a little and the sun is *almost* visible. Mr. Jaudon has kindly brought Blanch several Philadelphia newspapers, up to the 20th of December, which affords us great amusement. Passed the day at home in reading them. Doughty took tea with us.

MONDAY 22 Great change in the weather, wind south west, and a thaw has commenced. Mrs. Price sat. John Audubon called.

TUESDAY 23 Temperate, but not clear. Have had some clothes made which I do not find *much* cheaper than at Philadelphia and they are badly cut. Jaudon sat. Has proffered to send the portrait, when finished, to Mrs. Coperthwait at Philadelphia. Mrs. Price sat an hour. Blanch and I visited the Misses Patterson at her cousin's, Dr. Guthrie.[203] Called on Osgood, and Mrs. Todhunter, who is worse, and Mr. T. is ill also.

WEDNESDAY 24 At 10 last night, we were agreeably surprised by a visit from Strickland, and still more by the packet of letters he brought. One to me from Ellen, one from Tom, one from Sally to Blanch, one from Fanny Buttler containing letters of introduction—to Lady Francis Egerton,[204] Bridgewater House; and to the Marquis Landsdowne,[205] Landsdowne House. We had much talk with Strickland, he has brought his daughter Elizabeth with him. When he left us, we sat until our fire went out, while we read our letters—find that they have not received my 1st letter until December 15. This morning Mrs. Price sat. Blanch went out alone to pay some visits. We afterwards called on Mrs. Bates, Miss Strickland, 12 Devonshire St., Mrs. Hillard and returned her magazines. Put the letters brought by Strickland to Mrs. Rawle[206] and others, into the Two penny post.

THURSDAY 25 Mr. Jaudon sat. And Mrs. Price's lap-dog. Mr. Hubbard, artist,[207] and his friend called. He is just from Paris. Miss Bristow called to say farewell. Blanch and I called on Todhunter. Mr. Miller, to whom we gave her 8th

203. George James Guthrie (1785–1856), English surgeon.
204. Harriet Catherine Greville (1800–1866), English author.
205. Henry Petty-Fitzmaurice, third Marquis of Lansdowne (1780–1863), English statesman, Lord President of the Queen's Council.
206. Possibly the wife of William Rawle (1788–1858), American attorney.
207. Richard William Hubbard (1816–1888), American landscape painter.

letter to be forwarded. Dined with Price. Mr. Manning and Mr. Cook[208] present. We did not get home until 1 o'clock. Mr. M. said that by a self registering thermometer at Dulwitch [*sic* for Dulwich], the cold was 8 below zero last week !!!

JANUARY 26, 1838 FRIDAY Have ordered through Atherston a frame for the portrait of Mrs. Price, to cost 17£. Painted in the drapery of Jaudon's picture. Audubon and son called. Called on Rand who is very ill. Called at Mr. Dunlop's and left Blanch's letter of introduction and card. Drank tea at Audubon's and returned his 'Museé Napoleon.' Home at 11.

SATURDAY 27 Dark morning: Mr. Jaudon sat. Leslie called and paid me a balance due King of 10£. Took a sitting from Mrs. Price's dog. Brett called. Blanch and I visited Dr. Lowel and family; and the Stewarts, 21 Osnaburgh St., Regent's Park.

SUNDAY 28 One cannot see to do anything accurately at this time of the year. At 8 in the morning, without candle light, and you again require its aid at 5 in the afternoon. Began a large letter for home. Wrote to Miss B. Bridgen inclosing her 4£ on King's account and three to Mary Hatten, which is the amount Leslie paid me for King and to be so disbursed. Mr. Hilliard called and sat with us until we repaired to Keeley's to dine. Met there Mr. John Golden of the Customhouse, Miss Alexander, the niece of Mrs. K. and Mrs. Keeley's sister, Miss Gower. Did not get home before 12. It has been snowing. Found a card from Mr. & Mrs. Langley.[209]

MONDAY 29 Mild weather, and the sun melting away the snow. Painted on the portrait of Mrs. Price until past three. Called on Healy and gave him charge of the letter with money to Miss Bridgen as he lodges there. Called on Doughty who is confined with a cold—on the Todhunters who are better. Met Dr. Black of Philadelphia.[210] While absent Strickland and Mrs. Allenson with their daughters called on Blanch. We passed the evening at home.

TUESDAY 30 Mild enough for April, but very dark. Painted until 4 on the portrait of Mrs. Price. Rain. Went out to purchase certain articles. Dined at 6—it

208. Richard Cook (1784–1857), English history painter, or Samuel Cook (1806–1859), English watercolorist.
209. See Blanch's letter to her mother, January 28, 1838 (WL).
210. Possibly James R. Black (1785–1839), Philadelphia judge.

should be 5 but one servant had too much to do, to be punctual. Continued my letter home, and accompanied Blanch in some music.[211]

WEDNESDAY 31 The last day of January goes off in fog and gloom. It is not very cold however. I cannot but rejoice as the time flies between this and my return home; although I have every reason to be grateful for the blessings and advantages I enjoy—in fact all the expectations I had in visiting Europe, are so far successful. The day was dark and rainy. Painted on the drapery of Mrs. Price's portrait until 4 o'clock. Find the want of a manakin. Visited the Pantheon with Blanch by way of exercise and in the interim, Mr. & Mrs. Dunlop and Miss Gamble called. Mr. Thatcher called and returned the newspapers.

FEBRUARY 1ST, THURSDAY Last night Doughty called to see us. Mr. Healy and Mr. Wythe called. Returned the latter his hymn book. Healy told me that the money presented by King to his old friends was received with lively gratitude and that Betty Bell will write to thank King. Mrs. Price sat. Had to dry the picture by the fire. Painted on Jaudon's portrait. We visited the Soho Bazaar and bought Blanch an ornament for the head. Mr. Petty Vaughan sent us a letter from home, which was brought by the St. James—letter no. 4. Mr. Thatcher called and took tea with us.

FRIDAY 2ND J. Audubon called this morning. Finished my 6th letter. Painted on Jaudon's portrait. Blanch called on Koecker for professional services. The Misses Patterson and Miss Gutherie called. They warned me not to take an impression from Sir D. Wilkie of the sort of etiquette to be observed in waiting on the Queen, as he is noted for a nervous man. Miss Webber called—a Mr. Bayley, in mistake, supposing me to be an acquaintance. Mr. Stewart called. Sent home the portrait of Mrs. Price—in a few days, Mr. Atherston is to be paid for the frame now making for her portrait. Petty Vaughan sent me a letter from E. Carey, who desires to have pictures by E. Landseer, and Sir D. Wilkie for which he will pay 300 guineas each. A beautiful moon-lit night.[212]

SATURDAY 3 Mr. Jaudon gave me a short sitting. The day being fair, Blanch walked with me to Mr. Vaughan's, and sat with him a short time. Left my 8th let-

211. See Blanch's letter to her mother, January 29, 30, 1838 (WL).
212. See Blanch's letter to her mother, February 3. 1838 (WL).

ter for Sarah to be forwarded. Called on Mitchel at Copthall Court, and sat with him and Charles—treated us to some fine bunns by way of luncheon. At 6 took a cab and rode to Price's to dine, it being Mrs. Price's birth day. Mr. Jones, J. Hughes, J. Anderton, a City alderman, Mr. Manby, Mrs. Cook (sister to Mrs. P), Mr. Hollingshead, and Carew the sculptor. Stanfield was prevented by the extreme illness of his son. We got home at 1 in a bright moon lit night.

SUNDAY 4 Rose late. A clear, bright and cold morning. Find that my portrait of Mrs. Price is approved. Todhunter with Miss Webber called. Has letters from Sill, 9th Jany., all well at home. Petty Vaughan called. Stayed within doors all day. Thousands of skaters were on the river.

MONDAY 5 Fine cold weather. Called on Audubon. Went to the British Institution, it being the day for varnishing. Room crowded with artists, some like myself, to look on, and some to retouch (a bad practice) and varnish their works. Met Wilkie and proposed to him Carey's commission for a picture; the which he seemed inclined to. Turner was busily engaged in retouching his large sea piece;[213] I think with *water* colors !! which he afterwards toned with yellow varnish—I cannot approve of the daring liberties he takes in coloring—a lemon-colored boat, towed by the vessel, is outrageous. The picture was gaudy with much white; and I did not think it a happy specimen of his new style of coloring. Landseer's dogs, and stags, were in the best manner; free, yet true, like nature and in the best style of art—on pictures &c See my book. [Ladies and Gentlemen artists were busy in retouching and varnishing their pictures. Turner was seated on a plank supported by the steps of two stepladders placed opposite to each other. He was busily engaged in retouching his sea piece, I observed an opened box of water colors by him; but I did not see him use them. But whatever he did use in retouching I saw the whole picture toned with a brown liquid before he left it. On the ladder above him, was an artist retouching his own picture; and seated on the floor beneath Turner were two others at work. I cannot say that this sea piece by Turner is a happy application of his present style. Dogs by Landseer—more perfect than anything I have seen in paint—Landseer in his department is unequalled. . . . Some admirable landscapes and other works . . . My own works, I see, are on too low a scale of color, and my usual fault of weakness

213. Turner, *Fishing Boats, with Hucksters Bargaining for Fish* (The Art Institute of Chicago).

of effect is very apparent here. Brett has had the 'Clive Family Picture' [214] cleaned and it appears fresh and forcible.][215]

FEBRUARY 5, 1838 MONDAY IN CONTINUATION, Portrait of an old woman by Bowen [*sic* for Boaden][216]—very forcible and like Neagle's work. Some admirable landscapes and other good pictures, which I thought made my pictures look weak and dingy. Went to Todhunters'; and on my way Mr. & Mrs. Dunlop were called on. Met Mr. Wright,[217] of 24 Albany St. We walked to Murray's, 50 Albermarle. Met Strickland on our way. I was much pleased with the Murrays. The son is handsome and well informed—and the father was kind and affable. Met Mr. Hill there, who is said to be the original of Paul Pry. I cannot tolerate the use which people make of their eye glass, in staring at a stranger; it is rude! And they think so, for they do not dare to use it to examine a person of consequence. Called on Brett, showed me a bad copy of Van dyke (female and child) which he insisted upon being good. On my home found a letter from dear Jane, 10th of January, and in part written by Hal.[218]

TUESDAY 6 Clear and cold; wind still easterly, as it has been without a few hours' variation for these two months. There is still good skating. Invited to dine at Murray's on Saturday next. Called on several persons with Blanch; Mrs. Langley, Allenson, Strickland, Hillard. Invited to dine with Mr. G. Ralston next Friday. Painted on the portrait of the dog in Mrs. Price's picture.

WEDNESDAY 7 It hailed all night; this morning the wind is South East and a thorough thaw—fine walking!!! Sent home the unfinished portrait of Jaudon to be criticised. Mr. Wiggin. Painted a little on the portrait of Mrs. Price. At 2 visited the Garrick Club. Met Mr. & Mrs. Price there, then Mrs. Tavis and Mrs. Blood— There is a numerous collection of theatrical portraits in the rooms of the soci-

214. Reynolds, *George Clive with his Family and an Indian Maidservant*, 1763–66 (Gemäldegalerie, Staatliche Museen zu Berlin-Preussicher Kulturbesitz, Berlin).

215. See Blanch's letter to her mother, February 4, 1838, and Sully's to Jane and Hal, February 5, 1838 (both WL).

216. John Boaden, *Head of an Old Lady* (location unknown).

217. Possibly Thomas Wright (fl. 1815–48), English miniature painter.

218. Jane Cooper Sully Darley (1807–1877), the artist's daughter, portrait painter; and her husband, William Henry Westray Darley.

ety—they furnish seven rooms and also the stair way.[219] Some of them are excellent. The best are by Zoffani,[220] Harlow,[221] Clint,[222] Stewart, a Dutch Painter and Lawrence. The curator invited me to visit the club often. Doughty spent the evening with us. Since the hydrants in the houses have been stopped by the frost, the city authorities have caused to be fixed in the streets at convenient distances, temporary hydrants fixed on the fire plugs, where domestics can get water. Labourers go about to supply kitchens with pails of water.

THURSDAY 8 Wind S.W.; a clear sunshine, and very mild temperature. At 12 the rain commenced. Mrs. Price gave me the last sitting for her portrait. Returned her finger rings. Mr. P. called for them. Recommended me to visit Christie's rooms, and thinks he can procure the loan of a Reynolds. Had a call from Mr. Savory, of Sussex Place, Regent's Park, who invited me to see his painting by Zoffani. Mr. Wright called, with a request that I would dine at the Blue Posts, Cork St., with him, Todhunter and Graham next Saturday. Declined an invite to dine at Allenson's Thursday.

9, FRIDAY It rained all night, and still continues. In America, I think, our rainy storms are more furious but they are sooner over than in England. This date completes the 4th month since we left our own door in Philadelphia. A novel set of mendicants passed through the street, this morning; Manchester weavers out of employ, and their families; singing hymns and occasionally telling their distress. Finished the portrait of Mrs. Price. Mrs. Dunlop and Miss Gamble called. Mr. D. is unwell. At before 5 Blanch took a cab to Audubon's to dine; and nearly 7 I rode to Archibald Ralston's.[223] Met some Americans there. Mr. Hutchinson, Consul at Lisbon; was brought up in Reeve Lewis'[224] Counting house. Strickland, Mr. King and nephew. Bates, Jaudon Gerard,[225] Ralston, Dr. Boot whose face and manners I like. Mr. Stevenson, the railroad contractor. Aspinwall and

219. See Geoffrey Ashton, *Pictures in the Garrick Club* (London, 1997). On this visit, Sully promised to paint for them a portrait of Edwin Forrest, whose likeness was not yet a part of the collection. See Sully's letter to his wife, February 10, 1838 (WL).

220. Johann Zoffany (1733–1810), English painter.

221. George Henry Harlow (1787–1819), English painter.

222. George Clint (1770–1854), English painter.

223. Archibald Ralston, American merchant, proprietor of A & G Ralston, 87 Tokenhouse Yard.

224. Reeve Lewis (1781–1820), Philadelphia banker.

225. Possibly James Watson Gerard (1794–1874), American attorney.

others. Took French leave at 10, called for Blanch and we walked home by a bright moon-lit night.[226]

SATURDAY 10 Clear frosty morning. J. Audubon called for Blanch to shop with her. Wrote to Sarah; and then visited Mrs. Jaudon with Blanch. Mrs. Stevenson left cards for her and saw Mrs. Osgood. Called on the Lady F. Egerton and left Miss Buttler's letter of introduction and my card. Also at Landsdowne House with the same. After dining with Blanch, I rode at 7 to dine with Murray and altho I was exact to the appointed time, I was too early. Miss Murray received me; her two sisters joined and then the mother. Miss M. reminded me of the portrait by Sir Peter Lely that Dr. Cox of Philadelphia owns. The affability of the ladies put me quite at my ease, altho I had not been introduced. Their manners were similar to our Philadelphians, except a little more timid. We were joined by Murray, Jr., the father, Mr. Smith an elderly gentleman, rather lame with gout; he is author of 'Rejected Addresses'[227]—the famous Tom Moore[228] and son, who belongs to the army. Capt. Back,[229] of North-pole memory, and Edwin Landseer, made up our number. Landseer appeared modest and diffident—which I do not think is his real character. Capt. Back truly modest, silent and well bred, and a very winning contenance. Moore complained of being ill; but I found him to be the sparkling joyous creature he was represented. I wish it were in my power to remember all the pleasant things he uttered. The Murrays, with excellent tact, contrived to bring out the talents in conversation of their guests. The ladies left us with the dessert and when coffee was announced, I took leave and got home at 10. Mr. Brett has passed the evening with Blanch. And I found notes from P. Vaughan and the Marquis Landsdowne who has appointed an hour tomorrow for me to call on him.[230]

FEBRUARY 11, 1838 SUNDAY Beautiful, clear morning, and frosty. Heard an amusing and characteristic story of Wilkie's absence of mind: with his hat and gloves. Todhunter called; spoke of Mr. Hill being much pleased with my pictures. Mr. & Mrs. Hillard called and took Blanch to see the skating on the Ser-

226. See Sully's letter to Jane and Hal, February 10, 1838 (WL).

227. James Smith (1775–1839), English writer, author of *Rejected Addresses; or the New Theatrum Poetarium* (London, first edition 1812).

228. Thomas Moore (1779–1852), Irish poet.

229. Sir George Back (1796–1878), admiral and Arctic navigator.

230. See Sully's letter to his wife and Blanch's to her mother, February 10, 11, 1838 (four letters WL).

pentine river. Mr. H. has taken charge of her letter, No. 9, which he had burnt a little in trying to dry the writing. Master Koecker called; his father is ill. During Blanch's absence I had a visit from Lord Frances Egerton,[231] who introduced himself by sending up his card. He is a very handsome man of about 30. Very affable, delicate and intelligent. Invited me to see his collection—that my name should always be a passport when I called. But if I can call at between 11 and 12, shall find him at home. Dined at 6!![232]

MONDAY 12, Frosty, clear and cold. Leslie called and invited me to see the pictures of Constable[233] which was to be arranged for sale. I called, and met there Chalon Junr.—but previous to going there, I paid my visit to Lord Landsdowne—a porter opened the gate of the inclosure that surrounds his house—a semicircular paved walk led to the portico of the house, which stood in front of a lawn bordre with shrubbery and trees. Two servants in livery opened the hall door. a *gentleman* received my card and ushered me into an ante-chamber, where I found plenty of amusement in pictures by Raeburn, Lawrence and Reynolds.[234] After the dismissal of a previous visitor, Lord Landsdowne admitted me into his cabinet. I found him a cheerful lively and polite person, about 55. He greeted me with a warmth of welcome, that won my good feelings. We talked of many things, and much of Mrs. Buttler—he requested that I would take an early occasion of visiting his statue gallery; but at present the place was undergoing repairs. There hung in his room a portrait of Sebastian del Piombo that for dignity and high bearing, far eclipsed a Titian that hung near it. His family's portraits by Reynolds, were a pretty good specimen of the master.[235] I took leave with an agreeable impression. After leaving Leslie, I went to Stevenson's, whom I met. He promises to see Lord Melbourne on the subject of the Queen's sitting. Overtook A. Chalons at his door and entered his painting room where I staid with him a short time. Mrs. Bates with Mrs. Crider called—wants an alteration in her daughter's portrait. We drank tea with Osgood and Mr. Coates of Boston, merchant.[236]

231. Lord Francis Egerton, first Earl of Ellesmere (1800–1857), English statesman, poet, art collector.

232. See Blanch's letter to her mother, February 12, 1838 (WL).

233. John Constable (1776–1837), English landscape painter.

234. On Lord Lansdowne's collection, see Waagen, *Works of Art*, 2:257–65; and Jameson, *Companion*, 285–338.

235. Reynolds, *Maria Theresa, Countess of Ilchester, and Children*, 1779 (Earl of Shelburne, Bowood).

236. See Sully's letter to his wife, February 12, 1838 (WL).

TUESDAY 13 Finished the portrait of Jaudon. Mrs. & Miss Bates called. Brought me a picture by Wm West,[237] which I varnished. We walked to Belgrave Sq. Very cold raw weather. Mr & Mrs Stevenson had called in our absence. Invitations from Mrs. Jenkins to tea next Friday. Mr. Humphreys called. Walked with him to hear a lecture at the Adelphi, on the ruling machine invented by Gobright [*sic* for Gobrecht] of Phila,[238] but which fact the lecturer denied; giving the invention to the French in 1813 an account of which is to be found in the book 'Magniere Tourner'.[239]

WEDNESDAY 14 St. Valentine's day, and accordingly Blanch has received a poetical letter by the Two penny post—which is evidently Charles Mitchel. Cold and clear day. Our servant has left us and our new attendant, Jane Dodsway, took her place. Letter 6th from Jane and newspapers from Barnet of New York—wrote to Coperthwaite advising him of my having drawn on him for 200$ in favour of Darley. Wrote to Mrs. Steth and Haven for Mr. Wright. These I gave to Hillard to forward for me. Wrote till past 3. Drank tea at Mrs. Hillard. Osgood and wife present—but we called previously on Mrs. Todhunter, whom we found very weak and who I doubt of her ever recovering. Today we dined at 5 without requiring candlelight. Mr. Coates and Little were at Mrs. Hillard; and we did not get home until 1; and had difficulty in getting entrance.

THURSDAY 15 Very cold, windy and dusty. Painted on the drapery of my design, until J. & V. Audubon called to walk with me to Colnagi's to see Hayter's whole length of the Queen, painted for the City—I think the picture a failing, both as a work of art and portrait.[240] It is too old, too large, and too cross looking. Tried to find the residence of Mrs. B. Rawle of Philadelphia, who is here with her daughter. Invitation from the Marquis Landsdowne to dinner on next Saturday. Took tea with Mrs. Jenkins, Mr. J. called on during the day. We met Riviere[241] and wife—the artist who copied my Vandyke. Mr. Webster called, a Cambridge Student. Mr. Davis and two daughters and others. Dancing until past 11, when we escaped supper and got leave to retire.[242]

237. William Edward West (1788–1857), American painter; the picture in question was probably West's portrait of Joshua Bates of c. 1835 (Boston Public Library).

238. Christian Gobrecht (1785–1844), American medallist and engraver.

239. See Blanch's letter to her mother, February 14, 1838 (WL).

240. Hayter, *Queen Victoria* (fig. 6).

241. Henry Parsons Riviere (1811–1888), English watercolorist.

242. See Sully's letter to Jane and Hal, February 17, 1838, and to his wife, February 16, 1838 (WL).

SATURDAY FEBRUARY 17, Snowed during the night and this morning it hails. Yesterday Chalon and his brother[243] called to see us and sat some time. Reviere lives at Bath Place, New Road. We were much pleased last evening at Jenkins' with an instrument that is a substitute for a small band in dancing; it is called an Orchestrina—cost 80£.

FEBRUARY 18, 1838 SUNDAY I have just closed my ninth (9th) letter to Sarah;[244] passed the day in reading and drawing—Jones the picture dealer,[245] called. Was in hopes he would have avoided me; as I certainly shall keep away from him. At ½ 6 rode to Price's to dine. Dr. Blood and wife, her brother and sister, Mr. and Miss Dance[246]—heard with much pain the Kembles abused—Charles was excepted but Fanny had her full share; has all that was said, was mere matter of opinion, I had nothing to say, but my differing—but I am consoled to find that her warmest friends and admirers, are amongst the best and most influential—Home at 1 through mud.

MONDAY 19 Mild weather, but opaque sky. Breakfast at ½ 9. Painted industriously on the 'Charity'. Mrs. Bates called; Mrs. Price and Mrs. Blood. Have at length caught an English cold and it has plagued me for some days. Blanch has a worse cold than I so I left her at home, while I took a cab and rode to Leslie's. On our way the street was blocked up by a crowd to witness a house being burnt; so I was detained sometime within 30 feet; I had a good view of the manner of the firemen in the business. Met at Leslie's her sister, Mrs. De Charm and husband. Mr. Powel and Mrs. Dunlop failed to come as they promised. I was persuaded to stay late that I might have the comfort of riding part of the way home with De Charm—After remaining until past 1, I started off alone but in a quarter of a mile from the house, I met the carriage, which I stopped, and was glad to return with the DeCharms and escape the worst walking on the ice and for some distance in the dark. They dropped me at the corner of Oxford and the New Road and I got home at 2 and to my chagrin found that Blanch had sat up for me and had made me some flaxseed tea.[247]

243. John James Chalon (1778–1854), English landscape and genre painter.

244. See Sully's letter to his wife, February 18, 1838 (WL).

245. Edward Jones, oil, lead, and color merchant, 6 and 7 Tooley; or Henry Jones, oil, lead, and colorman, 69 New Church Street, Edgware Road.

246. Charles Dance (1794–1863), English dramatist.

247. See Sully's letter to his wife, February 20, 1838 (WL).

TUESDAY 20, Clear and frosty. Painted until ½ 3 on my design. Called on Koecker. Spent the evening at home in reading; music and writing. The rain has continued since four p.m.

WEDNESDAY 21. Has rained all night, my cold better, thanks to the Flaxseed and Liquorice. This climate does not agree with her. She has head-aches incessantly. Audubon called. Mr. Atherston our landlord stepped in. Took my 9th letter to Miller which will go to Liverpool tomorrow. Lord Landsdowne defers his dinner party until next Monday—being invited on Saturday by the Queen. Rain kept us at home.

THURSDAY 22, A dismal dark day, but am glad that it is warmer; painted until past three. Miss Webber and Dr. Gay, of Birmingham, called. Mrs. Leslie, also, to inquire after Blanch's cold—which is better, but is still plagued with a headache. At 4 left cards at Allenson. Saw the Loughs and passed the time with them. Got home just at dinner time. Had the piano tuned and in the evening we made music. Mr. McMurtire's [*sic* for McMurtrie's][248] letter sent through the Two penny post by his nephew Tilghman—Sally had written a few words in the envelope. Dated 22 of January.

FRIDAY 23 Rainy morning. What an atmosphere for a painter is this London!! Persevered to paint notwithstanding the mist till past two o'clock. Had a visit from two strangers; an elderly gentleman and as I suppose, his daughter. He said that he was induced by the sight of the 'Beatrice', now exhibiting at the British Institution to call upon me. He seemed to be conversant with pictures and from what he said, must possess a collection—but I thought his judgment was vague. He was very affable and complimentary; but I did not learn his name—from his carriage and servants he was either of the navy or army. Captain Levy called, had yesterday returned from Paris, where he said he had experienced a greater degree of cold weather than he ever felt in the States. Resides corner Maddox and Regent's Streets. Healy called at dinner time, but would not partake.[249]

SATURDAY 24 The rain has been incessant until the present time; and it is now too dark to paint conveniently. The confined space allowed for a house in

248. James McMurtrie (1784–1854), Philadelphia art patron and amateur portraitist.
249. See Blanch's letter to her mother, February 17, 1838, and Sully's to his wife, February 23, 1838 (WL).

the streets of London; obliges the use of water-closets, and as they often get out of order, the inconvenience is great. The water pipes leading to ours have become frozen, and for the present is abandoned—luckily there is a subterranean place, for the servants, to reach which a lighted candle is required to wind your way through dark and dismal passages. Mrs. Bates called for her son's portrait which I have varnished—she tells me that the Queen's physician has disapproved of her sitting for more portraits at the present time. I wish I were relieved from the uncertainty of her sitting to me! I am quite tired of suspense on the subject. The rain kept us indoors; we read and talked until bed-time.

FEBRUARY 25, SUNDAY Rained until 7 this morning; when the wind changing; it blew like March weather. Yesterday my butcher sent me a bill for meat that I had previously paid and luckily had his receipt for it. Mr. Dixwell called. Mr. Todhunter and sister. Blanch and I took a long walk in the park, the day being very fine. Mr. T. says that Mr. Murray has it in his power to borrow me pictures by Reynolds to copy. By night the sky became overcast and it rained.[250]

MONDAY 25. Finished my picture of "Charity."[251] It rained hard all day. Called on Stevenson who recommends me to get Lord Landsdowne to speak to the Queen about the time of her sitting. Received two letters from home Jane's no. 7 and the other from Sally filled with news and one news-paper from Barnet—all most acceptable. Todhunter called to take Blanch home to dinner—I being engaged to dine with Lord Landsdowne—accordingly I took a cab and repaired to my appointment at three quarters past the stated time, and was the first guest arrived. Lady L. received me with great courtesy as the friend of Fanny Buttler. Mr. Rodgers followed me, then Lord Landsdowne from the "house" and in quick succession, other guests. I was a little surprised to observe that one gentleman wore boots. So I concluded that it would be respectful enough to wear "stocking-boots." Trousers and shoes will do any where, except when "Full dress" is commanded by the particular occasion. White gloves seemed general, and few were without their hats on entering the "Drawing room"—Mr. Rogers had his—but he is quite a beau. This seems to me an inconvenient and improper custom; unless it be in some such parties as I have been at in Washington, where you are in danger of losing your hat by leaving it in the passage with servants. I

250. See Blanch's letter to her mother and Sully's to his wife, both February 25, 1838 (WL).
251. Sully recorded this picture in his Register as "erased" at a later date.

was received on alighting at the Portico by several waiters in livery; they assisted me off with my over coat; and having got my name; a gentleman ushered me the way into the drawing room where my name was announced. A magnificent establishment and replete with good taste in pictures, statues and furniture. The works of various masters hung on the walls. Rembrandt, Vandyke and Reynolds, fine examples of each—but I shall understand them better by day-light. Numerous sofas, divans, ottomans and chairs, and other furniture scattered about the room, not placed in order, as in America. Two ladies were guests and one was handsome, and of a noble presence. The dinner was simple and perfect in its kind—conversation brilliant. I had the good fortune to be seated on the right of Samuel Rogers. I noted that challenges to take wine is rarely done. Lord L. called upon me and I suppose it was a pledge of hospitality to a stranger. The custom in other houses that I have dined at, was the usage in America. *Shortly* after dinner we followed the ladies to the withdrawing room and after coffee, my cab being arrived, I stole off. Lord Landsdowne, on my application to him, to ask the Queen when she would allow me to begin her portrait, declined the office, as it would not be proper for him to interfere in a matter that belonged to the Lord Chamberlain Conynham [*sic* for Conyngham].[252] I met Eastlake,[253] the painter at dinner, and was much pleased with his quiet manners, and good sense. I got home at 10 Blanch was still out, so I continued my letter, writing home until Todhunter brought her at home at 11.[254]

TUESDAY 27 A disagreeable rainy day—abandoned all idea of going out, so continued my letter, and finished all my writing. J. Audubon called. Letter to Blanch from Miss Vaughan. Called on Brett and left Mr. McMurtrie's letter to him on subject of panoramas. Sir D. Wilkie called, and remained half an hour. Healy called, and left with me B. Bell's answer to King, touching his present, and kind remembrance. He proffered me the loan of a kit kat frame to exhibit my picture of "Charity" in at the Suffolk Street Gallery. We had a little music this evening before bed-time.

WEDNESDAY 28 Rained all night—a slight clearing up at 9—but it soon clouded over again. Received a card from Lady F. Egerton, for a Rout. At ½ 11

252. Francis, second Marquess Conyngham, (1797–1876), Lord Chamberlain to Queen Victoria.
253. Sir Charles Lock Eastlake (1793–1865), English painter.
254. See Blanch's letter to her mother and Sully's to his wife, both February 25, 1838, especially for information on the Lansdowne dinner party (WL).

I visited the Gallery of Lord F. Egerton.[255] The room is lofty, about 25 feet high, by 30 wide, and about 100 feet long. It is divided into three compartments by columns at either end—and say 25 feet from the wall. The sky light or lantern sprung from about 6 feet off the side, leaving only that space of flat ceiling and was two panes of glass high; say three feet high. The floor paneled with oak. I was examining the pictures when his Lordship joined me, and took me through his apartments which were also filled with choice pictures—I think there were four rooms. He loitered with me until it was time for him to attend the House of Parliament. When he (February 28th 1838 Wednesday for continuation), requested that I would remain to look at the collection at my leisure—I did inspect the pictures for some time, but I must pay many visits before I can derive any benefit from looking at them. [Some choice pieces by Claude—and two by Titian that were indeed excellent; one, the Diana and Acteon, the other Diana and Calisto; I thought they had suffered a little from too much cleaning, but they are still rich in color and effect. There was much glazing in the flesh of asphaltum, especially in the shadow in some flesh on the light parts there had been glazing or toning of a transparent yellow with asphaltum. In other figures, Burnt Terra Sienna with asphaltum; thereby making a variety of complexions. In the gallery was the Venus rising from the sea. It had so little to recommend it of any quality, that I turned away from it without the least desire to see it again. In a picture by Bordone I was pleased with the truth of the flesh; the high lights were of Naples and white, going into Venetian and white; it had a semi effect of light. Rembrandt's portrait by himself—little variety of color, but a powerful effect; but I prefer the one at Landsdowne House, in which the palette is held with some pencils in the hand. It had more color, but everything else than the head was painted very slight and bold like a dead color, and very thin in the shadows. There are three valuable Raphaels in his different manners; a large picture by Delaroche just finished. 'Charles insulted by his Guards' I don't like the composition; t'is well drawn, strong expression, very exact, hard, harshly colored. After going over these and hundreds of others, more or less good, I had the pleasure and instruction in the painting of a family picture by E. Landseer—such a delightful union of form, color, effect. "So distinct, yet so blended, so exact, yet so free." The finishing is complete, and still no part is tortured by elaboration. So easy is the conduct of even a portrait to Landseer, that you may see the ground of his canvas, and often the dead coloring through the work. It seems as if he must

255. On Lord Egerton's collection see Waagen, *Works of Art*, 2:41–80; and Jameson, *Companion*, 77–163.

retouch or paint the second coloring on an oiled surface—or at least a glazed one, the work is so fluid. Parts are judiciously and boldly relieved by masterly touches, or broad oppositions; while others are sweetly commingled in the surrounding ground—in fine, for manner, he and Wilkie are exactly to my mind.] After one o'clock visited Brett; and we called on Pickersgill in Soho Square. We found him in his long exhibition room, where he could best retouch the effect of a whole length he was preparing—for other remarks, as also for Egerton's pictures, I refer to my memorandum on pictures. [The greater length of the room enabled him better to judge of the effect of his work. He has at command quite forty feet. He possesses much force. Tolerable good color and composition— drawing not elegant—I should place him a degree below Sir M. A. Shee,—except in painting female portraits. The whole length of a Clergyman he has just finished is his best effort; and is a well painted and well conceived portrait. . . . Pickersgill showed me a head he had done in black and white, then tinted it bright in water colors and finally secured it by toning it in oil—the beginning was also in oil colors. It was very clear and had force.] Pickersgill is overindustrious, and very devoted to his art. He has accumulated expensive and valuable materials for his painting room, such as dresses of Eastern costume, and draperies of great variety. His daughter[256] paints well in miniature and is a very successful copyist of old pictures which she does in water colors. Called and left cards for Stevenson at Lansdown's House, 2 cards. Called to see Hurleston [*sic* for Hurlstone][257] in Chester Street as requested by Mrs. Buttler. He is not equal to Pickersgill. I could not see much resemblance to Mrs. B. in his portrait of her. Quite tired.[258]

MARCH 1ST THURSDAY Called on Stevenson. He has given me a letter to the Right Honorable The Marquis of Conynham, etc. etc. to whom we are referred as the proper person to arrange the time of the sittings for her Majesty's portrait—he being the Lord Chamberlain. The note apprised him of the Queen's having consented to sit to me; and required of him to fix the time when it would suit her Majesty to see me. Left a card for J. D. Lewis, called on B. Wiggin, Esq., saw Mr. W. and made them a long visit. Called on Mr. Savery, 22 Sussex Place.

256. M. A. Pickersgill (fl. 1832–38), English miniaturist.
257. Frederick Yeates Hurlstone (1800–1869), English portrait and historical painter.
258. See Sully's letter to his wife, February 27–28, 1838, and Blanch's to her mother, March 1, 1838, especially for information on the Egerton party (WL).

He has given me cards to visit Mr. Vernons[259] and Mr. Cartwright's[260] collections. The rain having ceased, I returned home for Blanch, whose cough is still troublesome. We called on Audubon and Hillard. The rain has recommenced. At Mr. Audubon's, we met Dr. Philips—his story of a Route in his vicinity. The mistress taken suddenly ill—Dr. P. finding she would die, ordered the house to be kept quiet—guests would finish their frolic!!!!![261]

FRIDAY 2ND, Rained all night, but is mild. Mr. Rush, Jr., Secretary to Andrew Stevenson, is very ill with small pox. I learned that this fatal complaint is common here which makes me anxious on account of Blanch. Called at the Lord Chamberlain's office; he not being visible, I left my card and letter with his principal official, who enquired of me the purport of the communication before he would promise to deliver it. Called at Stevenson's, who was too ill to see any person. As it still rains, I returned home. My last letter, No. 10, was sent to New York by the St. James on the 12th. John R. Coates and step-son called—Mr. Moons. They reside at Mrs. Fuller's, 63 Russell Square. Mr. Jaudon called to get information of Charles Inman, who has applied to him for assistance to procure a passage home to New York. Blanch received a kind note and some medicine from Miss Webber. Have just sent her 10th letter to Mr. Vaughan to be forwarded to Philadelphia. Osgood called. His wife has recovered health enough to have some friends to tea, and requested our company. But the rain prevented our going out.[262]

SATURDAY 3 This completes the 4th month of our residence in London. Has rained hard all night—but seems now to be clearing up. Answered Mrs. Buttler's letter. Invitation to dine at Mr. Vaughan's—declined. Received by the Quebec, via Portsmouth, letters from Henry Darley and Barnet. Visited Miss Linwood's[263] exhibition of needlework, with Blanch; it has faded much since I saw it in 1810 and has but few new pictures. We visited the Panorama of Mount Blanc, and was much pleased. Called to see S. Cartwright's pictures, Old Burlington Street; some are excellent; particularly one by Edwin Landseer. On our return home,

259. Robert Vernon (1774–1843), English art collector.
260. Samuel Cartwright, English dentist and art collector, 32 Old Burlington Street.
261. See Sully's letter to his wife, March 1, 1838 (WL).
262. See Sully's letter to his wife, March 2, 1838 (WL).
263. Mary Linwood (1755–1845), English composer and artist in needlework.

found cards from Murray, wife and daughters. Mrs. Jauden called and took home with her the portrait of her husband. Doughty drank tea with us. The frame for Mrs. Price's portrait was brought home, and I directed it to be taken to Price and hung it up with the portrait. At eleven I took a cab and was put down at Lord Francis Egerton's—Regiment of servants in waiting. Was shown into a room to adjust my dress, and the maids put away my coat and cap, placed a ticket on it, and gave me the same number. Mounted the grand stair case, my name being announced before me (March 3rd 1838 Saturday, in continuation)—was shown into the room of reception—I could not mistake Lady Egerton, and approached to make my respects. Lord Francis joined me and introduced me; and I presently made way for other guests who were crowding in. The large Gallery, and five additional rooms were on the same floor, thrown open, and by 12 o'clock they were filled. Dutchesses, Dukes, Earles, Lords, Ladies and commoners in profusion; it was for the first time in my life I had been in such a galaxy of splendor. Certainly this was the highest in rank of any gathering in England, next to the Queen. The Duke of Wellington[264] attracted my earnest attention. Sir R. Peale [*sic* for Peel].[265] Brougham.[266] Dacres[267] to whom I was introduced. Lord Francis pointed out to me the Dutchess Cumberland[268] and of Cambridge[269]—they were as fat as the saying. Querie, are all Dutchesses fat? Lord and Lady E. paid me much kind attention; she has promised to send me a letter for F. Buttler. I was most pleased with dresses of black velvet, which many ladies wore, the gentlemen were generally in black; some in 'shorts' especially such as wore the Order of the Garter. Some had white vests; and very few had white cravats. White gloves, universal and with but one exeption, every one had their hats—that one was the host. The custom of shaking hands prevails here. During the evening, I often stationed myself besides Landseer's exquisite family picture[270] that I might listen to the remarks made. They were generally in a fault finding strain; although it is amongst the best pictures in the gallery. But the principal reason is that Landseer is alive—in about one hundred years from his death, the picture will be

264. Arthur Wellesley, Duke of Wellington (1769–1852), English general and statesman.

265. Sir Robert Peel (1788–1850), English statesman (Prime Minister, 1834–35), art collector.

266. Henry Peter Brougham, Baron Brougham and Vaux (1778–1868), English jurist and politician.

267. Thomas Brand Dacres (1774–1851), twentieth Baron Dacres.

268. Frederica Caroline Sophia Alexandrina (1778–1841), wife and cousin of Ernest Augustus, Duke of Cumberland and King of Hanover.

269. Augusta Wilhelmina Louisa of Hesse-Cassel (1797–1889), Duchess of Cambridge.

270. Landseer, *The Return from Hawking*, 1837 (private collection).

famous. In gaining the passage on taking "french leave" I found a sedan chair in waiting. I got home at 12, highly gratified by my visit and not displeased to find that there was but a few things to remind me that it was not an American party. Light refreshments were occasionally handed round; such as ices, light cakes, and delicate beverage—I saw no wine.[271]

SUNDAY 4 It rains hard, and has done so part of the night. Finished my 11th letter home, and Blanch has begun her 11th. Mr. Todhunter called and chatted some time with us. The Audubons called also.[272]

MONDAY 5 Last night Koecker and his son Leonard called before tea. Blanch has suffered with toothache these few nights past. I shall be glad on her account when we are embarking for home, for London does not agree with her. It rained all night. On Sunday, early in the day, articles are taken through the streets to sell, as on ordinary days; and many shops are kept opened. I waited until two for Mr. Wright, then went out. Passed Blanch and Miss Webber in Regent's Street, returning from their shopping. Left cards at Lord Egerton's. Saw Rainy's pictures—returned home. Stevenson has written to say that the Lord Chamberlain has received the note, and will attend to the request therein contained, immediately. Lady Francis Egerton has sent me a letter to forward to Mrs. Buttler. Included it amongst a parcel I made of several letters, and handed it to Mr. Hillard to forward for me. Langley called and invited us to dinner next Saturday—or Friday. Mrs. B. Rawle, Mrs. Bulkley, her sister and Miss Rawle called on us. They intend to return to Philadelphia next August. We called on Coates, at Russell Square. Was introduced to Mrs. C. They are hurried home by the death of their daughter, Mrs. Morris. Mr. Wilmere, of Philadelphia, boards in the same house. He has been ill of a consumption all the winter and too weak to be removed home. After tea we made music until Bed time. J. Audubon called and left the picture borrowed from Dr. Philips with me.

TUESDAY 6TH Rained all night. But this morning we have the novelty of a clear blue sky. Whilst waiting for Mr. Wright I employed the time in making a water colored sketch of the picture Dr. Philips lent me. Blanch went to Mrs. Lang-

271. See Sully's letter to his wife, March 3, 1838, and Blanch's to her mother, March 4, 1838, especially on the Egerton party (WL).

272. See Sully's letter to his wife, March 4, 1838 (WL).

ley's to get off dining with them next Friday, and returned with Miss Webber. It being two o'clock I went to Wright's, and found by his servant that he had been waiting for me—my blunder. So I have promised to call upon him to-morrow. Went to visit the pictures of Sir T. Baring,[273] Devonshire Place, 21. The family out of town; but the housekeeper showed me his pictures.[274] [A group of three gentlemen, members of the family, half length, on a canvas 8 by 5 feet.[275] The composition is simple and natural. The whole arrangement of color, agreeable. The flesh tones are very true. The breadth of effect, extravagant to boldness. Lawrence has painted a companion picture which hangs in the same room, and is in some respects better; especially in the composition and the grouping of colors.[276] But the flesh tints and tones are not equally good; it falls into the brick hue; and where he avoids that fault he is often grimy or of a charcoal hue in the half tints.] Called at Dixwell's and left card. Also at Lord Ashburton's,[277] Bolton St. in Piccadilly. His sister's recent death, prevented my seeing his pictures. On my return home found Blanch had gone to dine at Audubon's. At 5 Brett called, and we repaired to Pickersgill's to dine. Was introduced to his family. Mrs P is an unaffected and amiable. (March 6th Tuesday 1838 in continuation) The daughters are talented and agreeable. Has two sons; one is married, and I was much pleased with him and his wife, who is a German. We had a pleasant evening; and by comparing dates, Pickersgill and myself had been fellow students under Fuseli.[278] Talked much of the late Stoddard [*sic* for Stothard],[279] whose paintings place him in the high class of artists. [How strange it is that the great merit of the late Stothard should be so little known; those who now speak of him with admiration, are the undoubted judges of merit. Mr. Pickersgill has a Venus reposing by that gifted painter, that has the excellence of Titian, without his faults. Mr. Samuel Rogers had many of his works—his Canterbury Pilgrims—when a few years more have sanctified his memory, the lovers of his painting—or should I say, pretenders—will know their loss.] Pickersgill seems to be a warm hearted en-

273. Thomas Baring (1799–1873), English financier.

274. On Baring's collection, see *A Catalogue of the Pictures, Works of Art, etc. at Northwick Park* (London, 1864).

275. Reynolds, *Lord Ashburton with the Marquess of Lansdowne and Colonel Barre*, 1787 (Barings Bank, London, collection of Lord Northbrook).

276. Lawrence, *Sir Thomas Baring and Members of His Family*, 1810 (private collection).

277. Alexander Baring, first Lord Ashburton (1774–1848), English statesman.

278. Henry Johann Heinrich Fuseli (1741–1825), Swiss painter.

279. Thomas Stothard (1755–1834), English painter.

thusiast. Stayed until 12 and returned home by a bright moon. Found Blanch had just returned from Audubon's.[280]

WEDNESDAY 7 A clear blue sky and temperate weather. The west brings clear weather; but S.W. or N.W. brings rain. N.E. cloudy S.E. rain—so that we have plenty of sources of foul weather in London. Pickersgill is acquainted with the Hazelhursts[281] and Latrobes[282] of Philadelphia. At 12 was at Wright's, and he took me to Finden's.[283] Mr. F. has promised to use his influence to borrow me a picture by Sir J. Reynolds to copy. At 11 tomorrow I am to call, when he will have a collection of engravings from his pictures, out of which I can select those I would copy—18 New Road. Received a polite note from Lord Ashburton, to say that I could see his collection on any day, between the hours of 11 and 2. Note from Mr. Dunlop to dine with them on Wednesday 14, at 6. At which hour we are engaged. Blanch returned from the exhibition and we walked to Mr. Vaughan's; and in returning rode partly home. She went to dine at Todhunter's, at ½ 6 I accompanied Mr. T. to his club at the Blue Posts, Cork Street, where we dined with Mr. Graham and Wright. Got home with Blanch at 12. Find that Carey's pictures in the Institution's Exhibition please the public.[284]

THURSDAY 8TH Fair day. Visit from Mr. Wythe. Blanch and I visited several places—left a card at Pickersgill's. Went to Mrs. Osgood's. Mrs. Nixon's; Mrs. Keeley's. Mrs. Price who requested my bills; spoke of the satisfaction the picture gave. Complained of the frame maker, who had not yet hung the picture. Mr. Price and Jones were just going out. We next called on Dunlop's and were much pleased with his pictures. Lastly to Murray's—the ladies were at home and received us with kindness. Returned; J. Audubon called. Miss Atherston says that Lady Dacre called on us yesterday; in consequence of a letter received by her from Mrs. F. Buttler who requested her to do so—and this evening sent me an invitation to dinner for Saturday 17th. Blanch was taken by Mrs. Jaudon to ride in the park previously to dinner. At 6 I joined them at 43 Bryanston Square. At 7 Jaudon and brother arrived and we dined at 7. After tea and at 11 we walked

280. See Sully's letter to his wife, March 6, 1838, especially on Lord Baring's collection and Pickersgill's dinner party (WL).

281. Family of Samuel Hazelhurst, Philadelphia merchant.

282. Family of Benjamin Henry Latrobe (1764–1820), English-born architect.

283. William Finden (1787–1852), English engraver and publisher.

284. See Sully's letter to his wife and Blanch's to her mother, both March 7, 1838 (WL).

home, altho Mrs. J. was very pressing for us to take her carriage. We hear that some nights ago, the Temple Chambers were much injured by fire.

FRIDAY 9TH A fine day—frost last night. Called on Mr. Wright who accompanied me to Finden's—but we found that he had not been able to borrow a copy of Reynolds' works. I returned home and took Blanch with me to the publishers of his engravings—Messrs. Hodgson & Greaves, 6 Pall Mall,[285] I selected from the works 8 prints: the whole work in three volumes being too expensive (10 guineas per vol.) We visited Lord Ashburton's collection, where there are some valuable pictures, particularly of the Dutch School. [The Ariadne of Reynolds must have been a very fine picture, but it has faded into a mere sketch. Some masterly sketches by Rubens. Portraits by Rembrandt and Van Dyke; and one of Titian's best pictures.] We visited Miss Martineau—Charles Bulwar, M.P. and brother were there. On our return home we found that Mrs. Wiggin had called. Charles Mitchel called. After dinner we took an omnibus corner of Oxford and rode to the 'Wheat Sheaf' and a short walk brought us to Leslie's. Blanch joined Mrs. Leslie and Mrs. Clark, her sister; and I was shown into Leslie's painting room; where some of the members of the Sketching Club were assembled, this being the night of their meeting.[286] The room was furnished with a long table to accomodate 8 members and 2 invited guests: there were the like number of slight desks on the table, on which rested stretching frames covered with drawing paper. To each were allotted drawing materials as charcoal, black lead pencils, painting pencils, assorted and some with very long handles. A saucer of color partly dissolved, either black or brown with three empty saucers to mix weak tints. Cup of water and some waste paper. Tea was brought in and the subject fixed upon to make a design of was discussed—it was the story of Inkle and Yarico, from the Spectator.[287] One place was assigned me, and I continued to hammer out a sketch in light and shade. This employed us about 2 hours and a half. The drawings were at the allotted time taken off by the president or host of the night, without ceremony and without inspection, when a light supper was served, after which the drawings were severally exhibited by the President at the

285. Hodgson & Greaves, print sellers, 6 Pall Mall.
286. In his Memorandum Book, Sully copied the rules and regulations of the Sketching Club, made extracts from recent minutes, and recorded his own observations that almost entirely duplicate material he wrote in his journal. See Memorandum Book, entry for March 9, 1838.
287. George Colman (libretto) and Samuel Arnold (music), *Inkle and Yarico; an Opera in Three Acts* (London, 1787; first published as no. 11 of *The Spectator*).

end of the table to all present; and were freely remarked upon; these became the property of the host. (March 9 1838—in continuation) The members are limited in number to 8 and at present comprehend the two Chalons, Leslie, Stanfield, Uwins,[288] Bone,[289] Partridge[290] and Stump.[291] I intend to acquaint myself with their laws and regulations, that I may get up one in Philadelphia. We left Leslie's at 12. Saw Mrs. Clark home at Lisson Grove; and at 1 got to bed.[292]

SATURDAY 10 This day five months ago, we left the Hook, near New York. At 10 I took a cab and drove to the Catherine Docks, where I found the Quebec, and was pleased to be again on her substantial deck. Had a long talk with Captain Hebard. Dr. Mccauley came passenger in her from Baltimore. I received my packet of letters, newspapers, and eyeglass sent by Jane, and soon reached home—and after getting rid of Mr. Coffin, was soon fully engrossed in the contents of our precious parcel and had hardly got through the perusal before 5 when dinner was served. Sent Leslie's letter from his sister, by the two penny post. At 7 we took tea at Osgood's, where we met Mr. Little, Coates, Peabody, and the Misses Williams. Got home by 12 in a bright moon-lit night.

SUNDAY 11TH A clear cold day. Sat down to our letters and newspapers after breakfasting. We wrote until Todhunter and sister called for us to walk with them. Visited Regent's Park, and returned to dine at Todhunter's—a young gentleman—Silvester, present. We remained until after supper.[293]

MONDAY 12 Healy has lent me his copy of Reynolds "Sleeping Girl" which will aid me in the copy I am to make from the original in possession of S. Rogers, Esq., I had neglected to write, that Price sent me a check for his wife's portrait last Saturday; he also paid for the frame. Painted until 5; Blanch dined at Audubon's. At ½ 7 I took a cab, and was put down at Lord F. Egerton's. There were many guests at dinner. Mr. Babbage,[294] the only name I can remember.

288. Thomas Uwins (1782–1857), English painter.
289. Robert Trewick Bone (1790–1840), English narrative painter.
290. John Partridge (1790–1872), English portrait painter.
291. Samuel John Stump (d. 1863), English portrait and miniature painter.
292. See Blanch's letter to her mother and Sully's to his wife, March 9, 1838, especially on visits to Lord Ashburton's home and Hodgson and Greaves's shop, and in Sully's letter about the Sketching Club (WL).
293. See Blanch's letter to her mother, March 11, 1838, for her description of the zoo in Regent's Park (WL).
294. Charles Babbage (1792–1871), English mathematician and scientific mechanic.

Lady E. told me of a blunder I had made in answering her note of invitation, I had addressed a note to her; the contents of which were intended for Lady Dacres; and in course, I had sent to Lady Dacres the note intended for Lady F. Egerton. After dinner we adjourned to the rooms and gallery above stairs where much company was assembled. The beautiful consort of Lord George Gordon[295] was there. Landseer came. The two pictures by Titian[296] appeared to great advantage by lamp or gas light. At 12 I returned home, and found Blanch waiting for me. Mr. Atherston stepped in to say that a frame had been sent to Price which was not the proper one, but a loan until the new frame could be finished; which will be the case at once.[297]

TUESDAY 13 A rainy day; rode all the morning; then went to leave cards &c., Left two at Lord F. Egerton's. At Jenkins'. Wrote to Price an explanation respecting the frame. Also an excuse to Humphrey for not accepting his invitation to visit the Graphic Club. Met W. Oldmixon, who had just returned from the country. Brett drank tea with us.

WEDNESDAY 14, It rained all yesterday and is still overcast, but has not exceeded slight showers. Finished the water colored sketch from Philips' picture. Blanch had yesterday visited Mrs. B. Todhunter in the country where she staid all night; this morning after her return we went to Miller's to have her 11th letter forwarded to Philadelphia. From thence to Dixon & Co., bankers in Chancery Lane,[298] where I cashed Price's checkque. Audubon called. At 6 took a cab and were put down at Langley's where we dined. Todhunter and Miss Webber, the only additional guests;—discussed the advantages &c., of club houses. Convenient for a *bachelor*. Entrance fee 30£ and 5£ per annum; can dine from 1/6 to any extravagant rate; every article being of the best, and at a fair charge. Great difficulty in getting admitted. Bad for married men; makes them strangers at home. Good story of the Dutchman, a member of the "silent and agreeable" in which a song, or story, is required every six months. Leonard's turn, his constant reply: "Can't sing"—obliged to recount his travels in Germany,—warns them that they will die of laughter when he recounts what happened to him there. Recounts his

295. Elizabeth Brodie Gordon (1794–1864), Duchess of Gordon.
296. See list of five paintings by Titian in this collection in Jameson, *Companion*, 128–31.
297. See Sully's letter to his wife, March 13, 1838, especially on Egerton's dinner party (WL).
298. Dixon, Brooks, & Dixon, bankers, 25 Chancery Lane.

walk—the long wall,—at last a small door—rings—then again rings—Master opens door himself, receives him very politely, and shows him through the large house, which from his description must be a lunatic asylum—left to wander by himself—traverses long passages—stopped by a door fastened—peeps through the key hole—and the boasted laughable winding up of the story, is, that a lunatic spits in his eye.[299]

MARCH 15, THURSDAY Painted on my copy of Reynolds until 5. John Coates and Morris called. Jane's 9th letter and newspapers arrived by the Wellington—a most delightful treat . . . and we read the letter over several times. Varnished a Dutch picture for Todhunter and sent it home. Invitation from Miss Vaughan for Saturday the which we had to decline. Miss Martineau returned Furness' letter. Mrs. Bates sent for us to tea—but we preferred to stay at home.

FRIDAY 16 Clear and windy & Blanch went to Audubon's to consult in the purchase of a dress. After finishing my letter and receiving a visit from Mr. Brett and Mr. Allenson, Blanch accompanied me to the Colosseum, and were highly gratified with the view, (March 16 Friday 1838) an admirable panorama of London which was taken from the top of St. Paul's. But we had little cause to be pleased with the drenching rain that overtook us on our way home; and which provokingly ceased as we reached home. If we had not gone out of our way to call at Langley's, we should have escaped. At ½ past 6 Leslie called for me on his way to the "Sketching Club" which was held at Landseer's. All the members were present. Subject for design was 'The Merry Wives of Windsor'—I excused myself not being conversant on the subject. Chalon made the best drawing, Uwins, the next, and then Leslie. Rode home with Chalons and Stump, at 12 found Blanch sitting up for me.[300]

SATURDAY 17 Cold, clear sky, and blowing a gale of wind. The size of the table used by the club is 12 by 5 feet; a common deal board resting on 3 "horses" on a table. Four candles and a branch holding three lights placed in the center— but see my 'Hints for Pictures' for an exact account.[301] Dr. Black called, he has been ill. Capt. Hebard called; Blanch dined at Todhunter's At ½ 7 I rode to

299. See Sully's letter to his wife and Blanch's to her mother, both March 15, 1838 (WL).
300. See Sully's letters to his wife, March 16 and 19, 1838 (WL).
301. See Memorandum Book, entry for March 9, 1838.

Lord Dacre's to dinner. His appearance reminded me of Col. H. Perkins;[302] and his manner of Hon. Davis. Lady Gray, Mrs. Babbage—some Judge whose name escaped me. Mr. Seaton, and E. Landseer were at our party. He—Landseer—was friendly and sociable. Told him of Carey's commission, the which he seemed inclined to accept. Was much surprised & pleased with the skill Lady Dacre possesses in modeling horses. Lady Grey is a proficient in water color painting—so Landseer observed. So that ladies of title can find time to attain excellence in the Arts. I was much gratified to find that Mrs. Buttler is held in great estimation by this circle—and that amongst persons of good standing and rank she has the warmest admirers. I passed a pleasant evening, and got home at 12, where I found Blanch had returned.

SUNDAY 18 Wrote to Neagle—Chip. Darley and Elizabeth Neagle, and arranged my parcel to send by the Quebec. Todhunter called, left me an invitation to dine at Finden's next Thursday. Mr. Uwins called to put off an engagement—and we are to dine with him on Monday 24th inst. Humphreys called. Retired early, and having a teasing cough. Blanch made me Flax-seed tea.

MONDAY 19 It rains. Wrote to Hebard to engage our passage home with him next August. Audubon called; talked about the Queen's sitting to me, and was of opinion from what had passed in the negotiations with our minister, that she would not be painted by me. Mr. Allenson called; agreed to dine with him next Wednesday. Called on Graham and Jackson, Oxford St., and ordered the Kedeminster carpet. Visited Mrs. B. Rawle—Mrs. Jaudon and left cards—on Lord Dacres. After dinner J. Audubon called—Before bedtime, we amused ourselves in music.

TUESDAY 20 It rained during the night. It is windy, but clear this morning—Stanfield's story, of his curly hair offending Chantry[303]—giving a shilling to him, to have it cut—as they entered the Academy passed the money to the doorkeeper; his queer notion that Chantrey sent him the shilling in way of reproof. Blanch went to Todhunter to meet the mantua-maker; meantime I took my letters &c. to the Quebec. Mrs. J. Audubon called—Blanch accompanied me to Doughty's—left our names, and also at Healy's. Weather much like April; it rains and showers—quite a risk of being overtaken by rain on the most promising

302. Thomas Handasyd Perkins (1764–1854), American philanthropist.
303. Sir Francis Leggatt Chantry (1781–1841), English sculptor.

day—umbrellas indispensable. At 7 we took a cab to Mrs. Wiggin's to dine—party of about 17—Mrs. & Mrs. Jaudon, Stevenson and lady. T. Wiggins and daughter, she talked of the Rev'd Morton [*sic* for Moore][304] of Philadelphia whom she met during his travels in Scotland and England. Rode home with Jaudon.

WEDNESDAY 21 At two o'clock we visited the workshop of Chantry. Leslie had given me a letter of introduction which admitted us to the establishment. We did not see him, but Allen Cunningham, his secretary, paid the honors. The present Great object of attraction was the Colossal Statue of Monroe [*sic* for Munro], for the East Indies.[305] In this design the artist had deviated from the usual mode of giving action to the horse and repose to the man—and I did not find it to be an improvement; it is an immense bronze statue, not less than 30 feet high with its pedestal. Chantry's establishment is princely. His large and numerous work rooms are filled with his works either in marble or plaster models. As a portrait sculptor he merits his reputation; but for the higher qualities of high art, he is inferior to Flaxman. On our way home through the park, we encountered John Coates, wife and Morris. We remained with the crowd collected to see the Queen as she rode by. At 6 we went to Allenson's to dine—met Dr. Macauley of Baltimore, Mrs. Allinson, daughter and widowed sister, Mrs. Goldsborough—very pleasant people. On our return home, I found a note from Lord Francis Egerton, to say that Lord Melbourn had answered his application on my behalf, to say the Queen will sit tomorrow to me.[306]

MARCH 22, 1838 THURSDAY The servant of Lord F. Egerton, who brought the note to my lodging last night, had gone to many places where I visit, to look for me—Stevenson also wrote to say that Lord Melbourne had given him the like message—but from what has taken place, I am persuaded that I am indebted to Lord Francis for the success of this business. At 10 I called on Chalon to consult him about the proper deportment in painting the Queen. He had not yet made his toilet, but he kindly received me and gave all requisite information. My dress which was black, shoes and trousers was quite in the right, and full respectful. In conversation with her Majesty, not to play the first card, or lead off. Not to ask

304. Henry Jackson Moore (1807–1890), American clergyman.

305. Chantry, *Major General Sir Thomas Munro*, 1838 (City of Madras).

306. See Blanch's letter to her mother, March 21, 1838, especially on her sighting of the Queen outside St. James's palace and the visit to Chantry's studio (WL).

questions, or argue, not to turn your back on her—with some other trifling hints that put me on my guard. I purchased some Bristol board, provided some black lead pencils—hired a carriage by the hour and drove to Bridge-water House. Lord Francis received me in his library at about 11 o'clock. He apologized for intermeddling in my affairs; but desired to serve me—which he surely has. Recommended my calling on the Prime Minister, Lord Melbourne, as perhaps it might be requisite to send a messenger to apprise the Queen of my waiting on her—accordingly I drove to Lord Melbourn's, received me in his bedroom where he was sipping his breakfast, having just got out of bed, and but partly dressed. He is in figure somewhat like Clay of Kentucky—is affable; but pompous. I sat and talked a few minutes. He said that her Majesty expected me at 12, and that no further arrangement was necessary. At a little before 12, I was set down at Buckingham House—not through the front entrance, as that was not permitted to any but private carriages. I therefore was admitted at the entrance in Pimlico. A centinel was pacing the front—I rang at the door, gave my card for the Baroness Lehzen[307]—I and my pasteboard were consigned to a Page and led forward to other Pages until we arrived at the grand hall of Entrance; where some gentlemen of the household were seated before a large fire—to one of these my card and business were confided, and he marshalled me the way onward to a staircase leading to the private rooms. I was surprised to find on this stairway at the first landing, a candelabra with a lamp burning. In fact the place was so dark that I found in my subsequent visits that it was always lighted. The above rude plan, is but a small portion of the long passages and open courts I had to pass through; and in which I frequently missed my way, when unattended by a servant. The floors of these passages were of marble and partially carpeted. After reaching the anti-chamber of the room appropriated to painting—and which I afterwards learned to be the Queen's closet, I had time to look about me. It was sumptuously furnished in yellow damask silk and gold and the walls were well covered with pictures and miniatures in enamel. Here I put off my great coat and was ushered into the painting room, where the page brought me a master-carpenter—Mr. Martin—and two assistants that I might have the room adjusted to my mind—I requested the window to be partially darkened with the lower shutters, but they would nail up cloth, and put down a red drugget over the carpet, as they said "the Queen liked to see things tidy." A painter's Throne and chair was placed—wished to know if I would have some drapery over the bookcase—everything being ready, the

307. Louisa Lehzen, governess to Victoria.

Baroness Lehzen entered, and recognized me and my commission in a very agreeable manner—wished to know if I required the Queen to be in costume this morning—but as I was chiefly concerned in this first sitting with the face, I preferred having that arrangement for the next visit. The baronness left me to bring in the Queen and in ten minutes after the appointed time she was announced and entered the room, she curtsey'd politely and with the assistance of the Baroness ascended to the chair I had arranged for her—of course I made a low bow at her entrance and exit without saying anything. "Am I in the position you require Mr. Sully?" (March 22nd 1838 Thursday—in continuation) were the first words she addressed to me, and in a rich musical voice. I requested that her Majesty would indulge me by turning her head in another position. While making my sketch on the Bristol board, which I held in my hand, she remarked to me, that perhaps I found that mode of proceeding inconvenient—and by her manner intimated that I must consult my own wish as to accomodation while at work—I assured her that my present way was the one I always used in executing a portrait. The Baroness, who is her secretary, was meantime seated at a table near the fire, where she was writing—observed to me "You are acquainted with Mrs. Buttler, perhaps"—Yes, I replied, intimately; she is to me almost as one of my children— The Queen observed—'She is not so pretty as her sister, I believe'—I gave my opinion in favour of her expression and exquisite eyes. "I think", said the Queen, "Miss Kemble is rather thin" and as she said so, moved her hand down her face. After a pause, she asked me if the present was my first visit to England. I told her the fact of its being my birthplace; and of my former visit when a student with West.[308] I also discanted on the changes I had discovered, and its great improvement in every appearance. She inquired if I had painted any portraits during my present visit. When I had done my sketch, I bowed, she understood the intimation that I had done; and calling to the Baroness, she rested on the hand and shoulder offered and descended the steps. I discovered in my subsequent visits that althó quite alert and active on the floor, it gives her pain to ascend or descend steps—this does not proceed from any defect in the foot or ankle, but I fear from something wrong in the knee. And perhaps this may take somewhat from grace and ease in her walking. She is short—5 feet 1 & ¼ of an inch—of good form, particularly the neck and bosom—plump, but not fat. Neatly formed head, perhaps rather infantine in the contour of the face. Forehead well proportioned— eyes a *little* prominent but kind and intelligent. Her nose well formed and such

308. Benjamin West (1738–1820), American painter, president of the Royal Academy of Arts (1792–1820).

as I have frequently seen in persons of wit and intellect. A lovely, artless mouth when at rest—and when so, it is a little open, showing her teeth—eyes light blue and large—hair light brown, smoothly braided from the front. And to sum up all, and apart from prejudice, I should say decidedly that she was quite pretty. Before leaving the room she inquired when I desired to have another sitting. I asked to be allowed to name next Monday—after a moment's consideration, she replied "I cannot say at present, whether or not that time will suit me, but I will take care to let you know" She asked if I wished any alteration in her dress at the next sitting—I replied that I should like to add the crown to my sketch, and she promised to wear it. The baroness had subsequently promised to give me a letter to the Dutchess of Sutherland, the Mistress of the Robes; where I could be allowed to inspect them. The ladies curtsied to me, and left the room by a door opposite to the one I entered. I should be gratified, if I were able to give an idea of the sweet tone of voice, and gentle manner of Queen Victoria! It was impressive of dignity and mildness, and at the same time I felt quite at my ease, as tho in company with merely a well bred lady. When left alone I cast my eyes about to find some trifle that I might bring away, as a relic, —an old pen, a card—but nothing presented itself but her foot-muff; out of which I plucked a little of the wool. I found some trouble in wending my way through the palace to my carriage—I returned home to give Blanch an account of my first visit to the Queen. Called on Stevenson, and he showed me how much interest and pains he had taken in the business. Left cards at B. Wiggins. Called on Brown, the colorman, and purchased portable paint box, easel, &c. Returned to dress for Finden's dinner. Blanch dined at Audubon's. Called on Wright and accompanied him to Finden's. 13 at dinner. Mrs. Finden and daughter, Finden's brother,[309] Jaudon of the Literary Gazette, Stanfield to whom I am quite partial. Got home at 10 and took Philips' picture to Audubon's.[310]

MARCH 23, 1838 FRIDAY To-day it has snowed, hailed and rained. Modelled my sketch of the Queen in oil colors on a kit kat canvas.[311] Mr. Price send me an impatient note on his disappointment respecting the frames—and as I think with good reason—I showed Atherston the note, as he is the responsible person; he borrowed the note to show the frame maker, but as it is to be done tomorrow,

309. Edward Francis Finden (1791–1857), English engraver.
310. See Sully's letter to his wife, March 23, 1838 (WL).
311. Sully, *Queen Victoria*, 1838 (fig. 21).

we hope it will be set right again. But Mr. Atherston says that the man has made a more costly frame that was bargained for—if so, it must be at his own risk.

SATURDAY 24 A bright day, and somewhat warmer. In the parcel of letters to send by the Quebec, are Blanch's 12th and my 13th letters Yesterday received notice from the secretary of the Travellers' Club—Mr. Singer—that I was elected to the priviledges of the House for one month. Blanch has gone to Mrs. Todhunter to meet the Mantua maker. Mr. Vaughan sent me word that my last letter was forwarded to NYork by the Mediator. Blanch bought a piece of music for Blake, and Mrs. Todhunter put up some garden seeds, all of which are added to the parcel to go by the Quebec. Doughty took tea with us—he means to return to New York next June. I omitted to mention in the proper place, that the Queen asked me if I had painted the President U. S.[312]

SUNDAY 25 Wind West, quite clear, rather cold. Blanch takes one cold after another, and certainly seems more thin than usual. In fine, a London winter does not agree with her. Made some drawings from Reynolds, and a design for a Gipsey. Todhunter and Miss Webber called—invited us to take family dinner with them. Mr. Coates brought Mr. Bell to see me—an Irish gentleman with whom I boarded in Baltimore, 20 years ago—I well remember the 17 March, when it was so warm that we dined with windows opened. Todhunter will write to Sill by the steamer Sirius. He invited me to leave my trunks and things at his warehouse when we go to Paris.

MONDAY 26 Tolerably fair. Began a letter to go by the steamer. Doughty called. Mr. J. D. Lewis. Mr. Lewis[313] publisher of Indian Biog's. called, and presented me with a number. He has met with no success in England. Has sunk money, and has been ill; is very anxious to return to Philadelphia. Mrs. Osgood— husband, and Mrs. Hillard called. A. Mr. Collyer, frame maker,[314] called to inquire about R. Sully who left London in his debt 17 pounds for frames!!! Dr. Mcauley and Thatcher called. The 10th letter from Jane arrived with postcripts from Tom and his mother and good news of Moggy. Called on Price—not at home. On Finden, who returned me Carey's letter. Met W. Oldmixon, who ac-

312. See Sully's letter to his "Dear Friends" (his family), March 24, 1838 (WL).
313. Samuel Lewis & Co., Publishers, 87 Aldersgate Street.
314. John Collyer, carver and gilder, 63 Frith Street, Soho.

companied me to my door. Blanch and I took an omnibus towards Paddington and a short walk brought us to Uwins, 10 Paddington Green, where we were kindly received by his niece, Miss Elwin, and shown into the painting room. He has much ability in composition. A composition of "The Woman taken in Adultery" painted on a whole length canvas, turned landscape wise—it was on the easel—it was rather feeble in effect and wanted depth of tone and a fuller brush; but had good expression and character. His style somewhat resembles that of Wilkie. Showed us some of his sketches from nature in Italy. Also his portion of the sketch club pictures; which were highly interesting; and in which one might best see the powers of an artist in composition. Leslie was there seen to be of a great order and E. Chalons nearly his equal. Miss Jones the miniature painter[315] dined. Mr. Rudol, flute maker. Mason, M. P. McHavil [*sic* for Havell], landscape painter, who went to China with Lord Amherst.[316] And Doctor Herring were our party. Dr. H. recommend that for rooms heated by stoves, there should be used unslacked lime—about one table spoonfull, to a gallon of water.[317]

TUESDAY MARCH 27 Foggy morning—by this day four months I hope we shall be on board the Quebec for home! Mrs. Langley called, also J. Audubon and J. Coates. we shall not see him again until we happily meet in Philadelphia. Letter from the Baroness Lehzen to say that her Majesty will give me a sitting on Wednesday next, at ½ 4. Wrote an answer.[318]

WEDNESDAY 28 Yesterday afternoon I gave my letter to Mr. Hodgson for Philadelphia, to go by the steamer. A note from J. Murray, Esq., inviting us to dinner at ¼ before seven. Mr. Lockhart[319] to be there—answered and accepted. Blanch visited Mr. Todhunter (March 28th 1838 Wednesday, In continuation). Prepared a sketch from Reynolds "Girl and Bird" for the purpose of advancing the copy I am to make from the original in possession of S. Rogers, Esq. At one, Blanch went to Todhunter's, and at ½ 2 I took coach and went to the Palace with my painting materials. Had my things conveyed to my room at the Palace—whilst I was getting ready the Baroness visited me to make the Queen's excuse; she was

315. Charlotte Jones (1768–1847), Welsh miniaturist.

316. William Pitt Amherst (1773–1857), diplomat and statesman; William Havell, Jr. (1782–1857), English landscape painter.

317. See Sully's letter to his "Dear Friends" (his family), March 26, 1838 (WL).

318. See Sully's letter to his "Dear Friends" (his family), March 28, 1838 (WL).

319. John Gibson Lockhart (1794–1854), English author, biographer of Sir Walter Scott.

fatigued by riding and requested the sitting to be put off until Friday at 3 o'clock. I strayed through the Palace into the Audience Room; a long gallery filled with pictures of exquisite value. [I saw . . . the famous picture by Rembrandt which so pleased me in 1810 "A Burgomaster at the Toilet of his Mistress." It was almost as bright as a picture by Rubens.] Some were modern—as Reynolds [Cimon and Epheginia, his Death of Dido, these two pictures would alone be sufficient to establish his fame][320]—Stewart Newton[321]—Granet's Capuchin Chapel—difficulty in finding secret doors through which I had passed, as they are cut into the walls and opened by touching a spring—on one occassion, in leaving the palace, I mistook my way, and opened several doors to discover it. On opening one, a gentle voice said "Come in" but I shut it and retired without ever finding out whose voice addressed me. Called on Dr. Macauley, but he had removed from the Clarendon.[322] Visited the Exhibition in Pall Mall, called the British Institution. Then the Travellers' Club.[323] Met Mr. S. Roger who invited me to breakfast next Saturday; called on Koecker. Blanch and I got to Murray's to dine at 7. Mr. Lockhart and the Capt, his brother, were the only guests besides ourselves.[324]

MARCH 29, THURSDAY Paid Atherston 10£ for Price's frame, as the charge is 15£ some one must lose. Dead-colored my copy of Reynolds Girl and Bird. Blanch went to Audubon's; and returned accompanied by Mrs. Rand. We went to Allinson's and left cards. At near 5 to Audubon's to dine. We met Doughty there. When dinner was almost over, the Honorable Liddel [*sic* for Liddell][325] dropped in by accident and sat down with us. He seemed like one of the family, and appeared quite content with a cold dinner. His father, Lord Ravensworth[326] is a warm friend of Audubon's. In the evening Mr. Nolti [*sic* for Nolte] called.[327] He is the promoter of that beautiful art of the ruling machine, by which clever imitations of medals are produced. One, a likeness of Queen Victoria, he presented in person at the palace yesterday; and he seems delighted with the gra-

320. Both remain in the Royal Collection, London.

321. Gilbert Stuart Newton (1794–1835), British painter.

322. Clarendon Hotel, 169 New Bond Street.

323. Travellers' Club House, 106 Pall Mall.

324. See Sully's letter to his "Dear Friends" (his family), March 29, 1838, especially for further description of the palace (WL).

325. Henry Thomas Liddell (1797–1878), later first Earl of Ravensworth, statesman.

326. Sir Thomas Henry Liddell, Baron Ravensworth (1775–1855).

327. Nolte, German medallist and inventor, assistant engraver at the London Mint.

cious reception she gave him. He has promised me letters to De La Roche [*sic* for Delaroche][328] when I visit Paris. Home by 10; found cards from Lieut. Rue-bridge, our fellow passenger, and from Dr. Elwin [*sic* for Elwyn].[329]

FRIDAY 30 At 3 took a cab and arrived at the palace. A Page was desired to say the Queen could not sit today; and that the Baroness Lehzen would send me a note when to come. Called at the Travellers's Club on my way home—called and left card for Dr. Elwyn—at 6 we visited Lough. London St. 12. Mr. King took tea there also—a dandy and most disgusting specimen of the class—home at ½ 11.[330]

SATURDAY 31 At 10 took breakfast with Rogers and as we were alone I enjoyed a great pleasure in his company. His invaluable collection seemed even better to me than ever—He has in a very sincere way given me the priviledge of his house. He has two Titians; one an early picture; fresh and pure; the other a clumsy sketch made in his last days. [The 'half prepared' canvas by Brown is exactly to my taste. Mr. S. Rogers had the original head of Christ by Guido, once owned by West—who bought it for twenty Guineas and it was afterwards held at one thousand!! The high price at which they fixed the valued pictures of the old masters is beyond reason—for instance the Head of Rembrandt, owned by the Marquis of Landsdown, 700 guineas.]

SUNDAY APRIL 1ST Mr. Nolti presented me with a work on medal engraving and some pamphlets on the subject. We called on Mrs. Bates, Hillard and Dixwell who were out. Visited Mrs. Todhunter. In the evening Brett took tea with us. This morning Nolti called for me at 1 and we walked to Pimlico to see Weeks [*sic* for Weekes],[331] the sculptor. He is a young artist of ability, very like the style of Chantry, for whom he works. He has the best and indeed I think the only likeness of the Queen I have seen—except the medal. Visited Chantrys and again walked through his establishment. The statues of Bp. Heber,[332] and Monroe are both packed to go to India. It snowed a little, and is very cold. On my return found Blanch had gone to dine at Todhunter. At 6 I went to dine at Roger's.

328. Hippolyte (Paul) Delaroche (1797–1856), French painter.
329. Dr. Alfred Langdon Elwyn (1802–1884), American philanthropist.
330. See Sully's letter to his "Dear Friends" (his family), and Blanch's to her mother, both March 31, 1838 (WL).
331. Henry Weekes (1807–1877), English sculptor.
332. Chantry, *Rt. Reverend Reginald Heber*, 1838 (St. George's Chapel, Madras).

Met there Turner, Wells,[333] and Jones[334] of the Royal Academy, Miss Rogers, a very pleasant lady.[335] I passed a very pleasant day; at 10 joined Blanch—took supper and got home at 11.30.[336]

MONDAY 2ND, At 9 a Page from the palace with note from the Baroness to say I am expected at 11—got there at 10 in time to prepare my palette. At ½ 11 the Queen sat. She had on the crown. Her ladies of honor were introduced, and greatly aided me by keeping up a lively conversation; it was of advantage as the Queen could throw aside constraint and laugh and talk freely like a happy innocent girl, of eighteen—Long may she feel so light of heart! The lap-dog of (Miss Lisson?) [*sic* for Lister][337] one of her ladies in waiting, attracted much of her attention—but the stupid dog knew nothing of the respect due to a sovereign, and comported himself in a very independent republican style, altho the Queen caressed and even kissed his unworthy head. She asked why I had an extra canvas besides the one I painted her upon. The baroness said that I was expected at the Palace last Saturday. (April 2nd 1838 Monday in continuation) I convinced the Baroness that it was her own mistake. The Queen in speaking of some one—said they had "clever eyes" Enquired of her Ladies if they knew who was to be presented at the next Levée. Asked my opinion of her portrait of Hater, the which I condemned as too old, careworn, and too large, and the expression severe. The Baroness defended the propriety of the expression as being fit and proper to the occasion of receiving her Parliament—I said no more. The Queen made an apology for not being able to give a longer sitting than three quarters of an hour; but promised to give me "a good long sitting on Wednesday next." They all looked at what I had done and warmly approved of the design. After putting away my colors and rolling up my pencils to wash at home—I returned on foot through the park. Called on Price with Blanch and left cards. Thatcher took tea with us. Has removed to 6 Goodge St.[338]

TUESDAY 3, Fair day, but cool. Invitation to dine with Mrs. Bates next Wednesday. Kind note from Lord F. Egerton, who is on his way to Bath—he gives

333. George Wells, English painter.

334. George Jones (1786–1869), English painter.

335. Sarah Rogers, Samuel Roger's sister.

336. See Sully's letter to his "Dear Friends" (his family), April 1, 1838 (WL).

337. Miss Lister, a Maid of Honour to Queen Victoria.

338. See Sully's letter to his "Dear Friends" (his family) and Blanch's to her mother, both April 2, 1838 (WL).

me notice of my privilege at the "Travellers' Club" and mentions having spoken to Lord Melbourn about the portrait of the Queen. Blanch and I left cards at Stevenson, at Jaudon's, Rawles. Called on Audubon. John is better. On Chalon, Had a visit from Mr. Nolti; for Healy. Note from Baroness Lehzen to say that her Majesty will expect me at 11 tomorrow.[339]

WEDNESDAY 4 Has rained in the night. At 10 I went to the Palace; met the Baroness in the great passage—she consigned me to the care of a Page—fire was soon kindled in my room and all things in readiness. It was nearly 12 before the Queen sat. Two Ladies in attendence, were announced by a page, to the Queen, who desired them to be admitted, and after making their salutation were requested to be seated. Their dog was with them, and what with caressing the animal and cheerful conversation, the sitting went merrily on. I perceive her Majesty is fond of anecdotes and by the interest she takes in stories of sympathy, must have a humane disposition. Sir David Wilkie was announced to be in attendance and had brought his picture of the Queen at her first Council, to show her Majesty for her criticism. He had to wait however until the sitting was over. She promised to sit to me again on Saturday at 11. She came behind me to look at the picture—and moved to the door which I opened for her. The Baroness brought the crown to me to paint from with an injunction to let her know when I had done with it, as she could not trust the crown jewels out of her deputed trust. Finished with it at 3, having sent for her, delivered it safe into her hands put away my things and left the palace. As my way through the palace was by the audience room, the door being open, I saw a large company assembled, met officers of the household in full uniform—heard the announcement of high rank; and persons splendly attired leaving the presence chamber—as I passed the grand entrance I was touched with the appearance of an old Comodore in full uniform hobbling to his carriage on crutches—by all this movement I concluded that there had been a Levée in the Audience Chamber while I had been busily employed close to it, in copying the Crown. A lady once remarked to me, by way of apology for receiving me with her family in the bed room, that physicians, painters, clergymen and old women were allowed to be a privileged class. On reaching home, found Blanch had gone out—so after washing brushes I sat down to write. How smoothly has Providence thus far shaped my course!! By some secret impulse I have visited London; and at a time when through the "pressure of the times" I

339. See Sully's letter to his wife, April 3, 1838 (WL).

might have been unemployed at home. My health improved by the voyage, my daughter for a companion, and who has by this means some advantage in seeing the world; and my residence abroad made—at least comfortable by her presence. Introduced to distinguished people, and kind friends, enabled to converse familiarly with the Sovereign of the present greatest empire in the world—and if I succeed in painting an approved portrait of her, the firm reputation it will give me in my adopted country and home, !what! but gratitude, and an endeavour by the careful morality of my conduct to—I was going to write—deserve—but that is not the word, nor can I find a proper one.[340]

THURSDAY 5 Mrs. Todhunter is better. Mr. Webber, her brother called on us, he is afflicted with rhumatism—came to invite Blanch to accompany his sister to a rehearsal of the grand Opera—she went. (April 5. 1838 Thursday—in continuation) Painted on my copy of Sir Joshua's "Strawberry Girl" until 3—called at Bridge-water House and left my letter to be forwarded to Lord F. Egerton. This being a drawing-room day, there was a great concourse of people before the Palace and in St. James' Street. Miss Bates was presented today. Saw Mr. Murray at his door; Mitchel called, have engaged to visit him at Camberwell on Sunday week—gave him the last note received from the Baroness Lehzen, which he requested for a lady in Scotland. At 5 went to Todhunter's, sat with Mrs. T. until the visitors to the opera returned—dined with them. After tea Mr. Westcoate [*sic* for Westmacott][341] and Capt. Neeth stepped in, and stayed to supper.

FRIDAY 6TH We got home last night before 12, and before the rain which has continued. At 12 Mr. Brett and his sister called and we accompanied them to Pickersgill's. Received us cheerfully and showed us many of his works. His son was at work in the exhibition room, on one of his father's pictures. A daughter of the Duke of Hamilton was copying a whole length of her father in water colors.[342] She kept at her task intently, regardless of everything around her. Pickersgill seems full of employment; many whole lengths and other large pictures were in the room. His daughter[343] paints very well in miniature and on paper, she

340. See Sully's letter to his "Dear Friends" (his family), April 3, 1838, and Blanch's to her mother, April 5, 1838 (WL).
341. Sir Richard Westmacott (1775–1856), English sculptor.
342. Lady Susan Harriet Katherine, Duchess of Newcastle, daughter of Alexander Hamilton, tenth Duke of Hamilton, copying Pickersgill's portrait of the Duke of Hamilton (location unknown).
343. Mary Ann Pickersgill (1806–1893), English miniaturist.

showed us many of her works. Miss Tunno, her brother, sister, and another lady called. Invited us to Taplow lodge, and to his residence in Brook St (upper) no.19. They were very kind and affable. Miss Bradley, member of our landlord's family, stepped in before tea. Finished my dead-colouring of "Strawberry Girl."

SATURDAY 7 At 10 went to the Palace; got all ready by 11—but the Queen did not sit until 12 and but three quarters of an hour. She is to go immediately to Windsor, and cannot give another sitting until about the 27th. One, *long sitting* I would make do, but I dare say I shall take 2 more. The Baroness Lehzen, Miss Lisson and another lady were present. The Queen spoke of the size and shape of the intended crown making for the Coronation, and used the same opinion of its being small as might be, that I gave her when she asked my opinion on the subject at her last sitting. On my way home called on Chalon for the sketching Club's book of laws. On my first visit to Chantreys, I paused in front of a colossal statue on which an artist was chiseling a likeness from a model; size of nature, but in the statue, all small detail was left out, and nothing more attempted than the broad, general character. Called on Stevenson, met Mr. Carter, who was to sail to N York tomorrow. Mr. R. Rush was there and his son, also Mr. Livingston,[344] Mr. Vaux[345] of Philadelphia. Rev'd Lowel, wife and daughter, of Boston spent the evening. They are to leave this place for the Continent next Wednesday.[346]

SUNDAY 8 It was a bright moon lit night when Blanch and I left Stevenson's last night—but it changed to rain, and still continues Yesterday received a note from Mrs. Rawle, requesting my escort for herself and daughter to Paris—replied accordingly—Mr. Chalon sent me the Minute book and laws of the "Sketching Club." Which I made extracts from, for Neagle. Mr. Todhunter called, also P. Vaughan. At 6, the weather having become fine, we went to Price's. Met Dr. Blood and lady, Mr. & Mrs. Sinclair—David Roberts, the artist and Mrs. Cook. At Mrs. Blood's request, Mr. Price lent the portrait of his wife to the exhibition; and Mr. Roberts promised to send his man for it tomorrow. Got home at 2 o'-clock!!!

344. A member of the Livingston family from Clermont, New York; in her letter to her mother, April 8, 1838, Blanch identifies Mr. Livingston as a gentleman from the North [Hudson] River, New York (WL).
345. Possibly William Sansom Vaux (1811–1882), American mineralogist.
346. See Sully's letter to his "Dear Friends" (his family), April 7, 1838, and Blanch's to her mother, April 8, 1838 (WL).

MONDAY 9 Wrote to T. Howard, Sec'y Royal Academy, and sent it enclosed to Roberts. Blanch and I took an omnibus to Wilkie's. He was engaged; but we saw his sister and left with her, Carey's letter. He is always engaged until 2 o'clock. Miss Wilkie let us out through the garden door, and we walked home through Kensington and Hyde Parks. Choose a pair of bronze ornaments for Mr. Ned Carey[347]—20£. In looking for some sticking plaster in my shaving case, I discovered three U.S bank notes I had placed there when in Philadelphia. Called on Osgood. Returned to Chalon the book he lent me. Messrs Hodgson and Greaves called to learn how I got on with her Majesty's portrait. Mrs. Jaudon called for Blanch to dine with her—Mrs. Humphries and her sister, Miss Hoppy, were in the carriage with her. I joined them at 6 and Mr. J. at 7 when we had dinner. Got home at 11 and found that Mr. and Mrs. Hillard had called.

TUESDAY 10TH, Clear and cool. Mrs. Humphries desires her and her sister's portrait, but I decline engaging more business; as it would interfere with my visit to Paris. Went to Rogers after breakfast. He had Reynolds "Strawberry Girl" removed from the wall, that I might find it more convenient to copy from. I painted until I was tired, and then, by way of relaxation, I tried to make a written description of Rubens' palette for flesh, (April 10th, 1838 Tuesday in continuation) according to a picture of that master, which hung on the wall.—for which refer to my other book. [Again I inspected the palette of Rubens in the picture which Mr. Rogers owns; the fairest flesh is almost Naples yellow and white—going off into shadow by mixing it with neutral tint composed of black, Indian red and white: then the next degree of shadow is of the neutral and Venetian red, and the darkest shadow of burnt Umber and vermillion—over these are broken tints of blue and white. The olive and white in the half shadow, and the same with burnt Terra de Sienna, here and there. The Venetian red and white, broken here and there over the flesh, gave a very true effect. An arm had in the finishing some blue and white scumbled over the light, and whilst wet, some Venetian and white was broken into it, as on the elbow, wrist and fingers. The next degree of darker flesh, had the broad light Venetian and white, going into shade by use of the olive tint and white—this last tint strengthened with Venetian, for the half shade. The extreme dark burnt umber and vermillion—the first shade, olive and white, corrected with a neutral tint and white. Very dark flesh was a brown ochre burnt,

347. Edward Carey, Jr. (see note 1).

151

with white. Brown ochre and white for the highest lights. The half shade was the olive tint, and the very dark, of burnt umber and Indian red.]

WEDNESDAY 11TH Clear and warmer, Painted on my copy notwithstanding a pain in my face from a cold. Mr. Rand called—I cannot get reconciled to his vanity and jealousy of other painters. Mrs. Fitzhue and her daughter[348] called at dear Mrs. Buttler's request—I like them much. At 7 took dinner at Mrs. Bates; Leslie and wife, Chalon and sister, Dr. Boot, Dixwell and Mr. Vaux met us. After dinner we found in the withdrawing room, Mr. & Mrs. Osgood. Jaudon—Humphries, Hoppy and others. We had some good singing from a professional lady—a Miss Windham. Received Jane's 11th letter.

THURSDAY 12, I finished my 14th letter yesterday. Todhunter sent me a letter of Sill's from Philadelphia, to read, from which I make the following extract: "We are all delighted here that he (Mr. Sully) has received permission from the young Queen to paint her. And since I have received your letter. I have called upon the officers of the society, to cheerfully consent to allow Mr. Sully to exhibit the picture in the Royal Academy, or whereever he chooses, and that they only wish it to be understood that the *original* picture is to be painted for them, and that they wish to be put in possession of it previous to their annual meeting in April 1839. It is the opinion of Mr. Toppan and other friends of Mr. Sully here, that he can make for himself advantageous arrangements with the engravers, who will be very glad to share the profits with him; and I am authorized to say that Mr. Sully has free permission to have it engraved for his own benefit." A letter from E. Carey countermanding the purchase of Constable's picture, and also the commission to Landseer and Wilkie—if not too late—gave the letter to Leslie. Painted on my copy, altho in much pain from a cold. Blanch went to Todhunter's. Borrowed from Mr. Chalon the Minute book of the Sketching club, from which I made extracts. The Misses Pattersons called, and at Devonshire House 10. Mrs. Fitzhue and daughter called for Blanch, and took her to Whitehall to see a festival. Returned the book to Chalon.[349]

FRIDAY 13 The pain in my face is easier this morning. Miss Rogers left her card yesterday for Blanch, and this morning sent us an invitation to breakfast

348. Emily Fitzhugh; Mrs. Fitzhugh was a close friend of Sarah Kemble Siddons.
349. See Blanch's letter to her mother, April 13, 1838, especially on her opinion of Whitehall (WL).

with her, at 10 next Tuesday. A note also from Miss Fitzhue—will call for Blanch tomorrow to visit the Mint, and other places. Blanch has finished her 13th letter, which, with mine I send to Mr. Vaughan to be forwarded; but Mr. Hillard having called, we gave them to his care. An invitation from Leslie, and one from Fitzhue, and one from the Count Survilliers—all accepted. Doughty visited us at 8 a.m.

SATURDAY 14 This morning received a letter from Rosalie,[350] one from Mr. Rockhill, and a newspaper from Barnet by the packet of March 20th. At 8 we took tea with Mrs. Fitzhue and met Mr. F., his daughter; Miss Hamilton, the sister of Mrs. F. and of Mr. H.[351] who had charge of the Elgin Marbles from Athens. Mr. & Mrs. Wilson,[352] A professor of the Sanscrit tongue—and above all Mrs. Jameson,[353] who is as delightful in manners and conversation as she is in her writings. Returned home at 12. (Orchard St. 12)

SUNDAY 15 Wrote until ½ 11; when we took coach to Mitchel's. As the family were at church on our arrival we walked onward to a beautiful little village called Peckham or Peckwell. The snug little cottages, built in the Elizabethan taste, occupied entire streets. On our return to Mitchel's, we found the family returned. Took luncheon with them and then set off for a long walk, through the fields, and returned home through Dulwitch. Took an cheerful dinner with our excellent friends; and returned home by the coach at 9.

MONDAY 16 At 10 Miss Emily Fitzhue called for us, and we visited an artist by the name of Evans,[354] who is a pupil of the late Lawrence. He has fame for being a good copyist—but I saw no evidence of it in the pictures he showed us—one from Raphael was badly drawn and so was the large copy from Corregio. His having been six years with Lawrence, he was able to explain to me, that Lawrence always in portraiture, drew the head on the canvas very carefully with chalks, black, and relieved with white, *and painted his dead coloring over the drawing.* But it sometime happened, that after the first drawing was finished; he was struck with a more favorable view of the head. When that case occurred he would begin

350. Rosalie Kemble Sully (1818–1847), the artist's daughter, a miniaturist.
351. William Richard Hamilton (1777–1859), former secretary to Lord Elgin.
352. Horace Hayman Wilson (1786–1860), English Orientalist.
353. Anna Jameson (1794–1860), English author.
354. Richard Evans (1784–1871), English copyist and portraitist.

a fresh portrait, the first drawing has however been preserved for the sake of the likeness and has led to the belief of his making drawings of the subject to paint from. In returning home through Oxford Street we found much (April 10, 1838 in continuation) difficulty in pushing our way across Oxford St. as the street was filled by a procession of the "Trades' Unions"—Arrived at the door of our lodgings, we took Mrs. Fitzhue's carriage and drove through a storm of hail and snow to the gallery of the late Sir Soane;[355] but as it was not the regular day for admission, we were not allowed to enter. In the evening we called on Mrs. Jameson—7 Mortimer St. On Bates, on Audubon, Hillard, Misses Pattersons, Mr. Wiggin. An invitation from Miss Chalon for next May. Mrs. Rawle and daughter called. Blanch much afflicted with pain in the face.

TUESDAY 17 Blanch still unwell, and not able to accompany me to breakfast with Miss Rogers.—at the door met John Oldmixon—Osgood and wife coming up, I bade him farewell and we entered the house of Miss R. together. There are some exquisite pictures here. Two are by Reynolds—a Titian—and others of *note*; but the best were by humbler names—Stoddart, Watteau, Wilson, Gainsborough—Leslie's "Sancho with the Dutchess", a Wilkie. Turner, an excellent Rubens—sweet little Parmigianno—some fine bronze figures, vases and relics of art from Pompeii and Thebes. [I again examined those pictures in her collection that I had seen but slightly. A study by Reynolds of one of the figures in his 'Infant Academy' was a daub; nor would find houseroom if it had not a great name—another, 'a studious Girl' or a girl drawing, was much better, but by no means worthy of his fame. The expression was admirable—attitude not quite easy, nor was it *well* drawn—colouring so-so. And the execution most slovenly. The few pictures of Stoddard are very good. An exquisite sketch by Wilkie. Several good landscapes by Wilson. A fine Gainsborough. Leslie's capital picture 'Sancho and the Duchess'—a clever sketch by Turner. I again looked carefully at the Nativity by Titian. Neither in color or composition can I praise it—the tone is good but nothing else. 'Battle of the Amazons' by Rubens, a masterly sketch. There are many other pictures of more or less merit—and taken altogether is a collection of much attraction.] There breakfasted with us, Miss Martineau, Mrs. Read—two other ladies, Mrs. Rogers, Jr., the nephew—and after breakfast Mr. W. Vaughan and niece came. I must not forget a drawing by Lawrence of Mr. S. Rogers, done in black and white chalks on a middle tint ground on canvas 30 x

355. Sir John Soane (1753–1837), English architect and collector.

25. Miss R. showed us some clever sketches by the Princess Victoria, when the pupil of Westall,[356] who presented them to Miss R. also we were shown some correct drawings in lithography copied from originals done by Miss R. Mr. Vaughan engaged Blanch and me to dinner next Tuesday at 6. At ½ 12 I got away. Called on Robinson and ordered the bronze figures for Carey to be cased up and taken to Longman and Co.,[357] to whom I gave a letter requesting acknowledgement of their receipt. Mrs. Jameson called on us. And at 8, in spite of the heavy rain I visited her at tea; Blanch was too unwell to go. Mr. & Mrs. Kemble were there and we had a very agreeable time of it. Mrs. Jameson's sister and her husband[358]—I observed that she has a sketch which I gave Fanny Butler, hung up in a frame—it is prudent to withhold rough sketches, or any work you do not approve, as they are produced as a test of your skill. At 11 o'clock I returned home; and with a more agreeable impression of Mrs. Charles Kemble.

WEDNESDAY 18 Painted on my copy of Reynolds until four. At one Blanch went to Todhunter's, just in time to escape the rain and hail. At 7 I went to dine at the Count Survillier's. Met Mr. Jaudon at the door, and we entered together. Dr. Hamilton,[359] Mr. Philips, and some other friends of the Count. After dinner we ascended to the drawing rooms, and was particularly introduced by the Count to his brother Lucian[360]—who had his daughter or some near relative with him; and her son; a fine boy of 7. Lucian is larger than the Count and like him, speaks English indifferently. There was on the Mantle piece an exquisite ancient bust of Sapho, taken from Pompeii when the Count was King of Italy. It has the exact markings of a true portrait and nearer to Nature than any antique bust I have seen. [(It) is the most exquisite thing of the kind I have ever seen; it has all the marks of individual character and the Count has every reason to believe it to be an original portrait.] A group of Bacchus and a Young Figure, but I did not ascertain who—is also from Pompeii, but I did not think it of equal excellence with the Sapho. A Leonardo da Vinci; two children clutching a lamb—this picture excites raptures in the mouths of the connoisseurs; but I thought it an insignificant work. [a piece of dough in my estimation.] But it is the name that

356. Richard Westall (1765–1836), English narrative painter.
357. Longman, Orme, Brown, Green & Longman, booksellers, 39 Paternoster Row.
358. Robert Jameson, English attorney.
359. William John Hamilton (1805–1867), English geologist, president of the Royal Geographical Society for 1837.
360. Lucien Bonaparte (1775–1840), prince of Canino.

gives value to such puerile things: had a modern painter done the thing he would have been passed by. I am determined for my part to like merit for itself; nor shall the sanction of any name, recommend a bad work to my approbation. Called for Blanch, and got home by 11, and escaped the rain.

THURSDAY 19 A snow storm, and very cold—painted on my copy until ½ 4— it continues light until 8. Miss Jones, the artist, called, and Mrs. Osgood. A note from Mrs. Jameson of invitation.

FRIDAY 20 A clear morning. Comforting reflexion, that in 100 days more, we may embark for home. Painted diligently all the morning, and finished the copy of Reynolds "Strawberry Girl." Mrs. Hillard called, but as the weather had changed to snow and rain, Blanch declined walking out. Staid at home all day.

SATURDAY Cloudy and cold. At 10 went to Mr. Rogers to begin my 3rd copy after Reynolds. Mr. R. had left town, and his people were cleaning house. But I was accommodated with a comfortable room to which the picture was removed. The day becoming clear, I was enabled to look closely into the method Reynolds had followed in this picture—for an account of which, see my "Account of Pictures."[361] Painted until 5, returned home to dress and accompanied Blanch to dine at Miss Jones. (April 21st 1838 Saturday, in continuation) The only stranger to us was Miss Rush of Chelsea. Miss Jones showed us many of her pictures— some copies of the old Masters done in Germany and other parts of the Continent; by which I perceived her to be a more skillful painter than I had before supposed. We were much pleased with her, and Miss Rush—home at 11.

SUNDAY 22ND Rain, wind and cold. Miss Fitzhue called. At 5 we dined at Todhunter's, and passed a social day; at 11, home.

MONDAY 23 Gloomy and cold. At ½ 2, visited Fitzhue and rode to Westmacotes' Gallery of Sculpture. An artist of accomplished talent—but not in the highest branch of art—he and Chantry are just the sort of artists the mass of English like, and they are excellent in their way; poor Flaxman was beyond the understanding and taste of the multitude and was but indifferently encouraged. From

·

361. Sully's description of Reynolds's technique does not appear in his Memorandum Book, nor has it been located in his other papers.

thence to C. Woodburn's[362] to look at the late Lawrence's drawings by the Old Masters.[363] The prices asked for some of these, astonished me! I really consider this matter a sort of biblomania. [Some were very good—some curious—some I thought of little merit.] Spent the evening at Leslie's, with Landseer, his brother, and three sisters—Powel, Dr. Herring. Mr. & Mrs. De Charms, Mrs. Leslie's two sisters and Humphreys. Some laughable imitations were given of parts of operas—public singers—artists—and even animals; in which Landseer, Powel and particularly Dr. Herring showed great humour. We got home at near one, quite fatigued with excitement.

Tuesday 24 Audubon and son Victor called. At 5 we took an omnibus on our way and was set down at Grace Church Street from whence a short walk brought us to Mr. Vaughan's. At dinner we met Joseph Cooledge,[364] of Boston, who had just arrived. Memorandum to call on him at Fenton's Hotel, 63 St. James—Osgood—a Mrs. Carey and her stepson Mr. Dickinson. We walked home at 10.

Wednesday 25 Mrs. Pattersons of Philadelphia called. They gave me a direction to see the Gipsies at Norwood. Capt. Levy called; it seems that he kindly assisted Lewis, the publisher of the Indian Portraits and Biographies to return to Philadelphia. At 4 Blanch accompanied me in a walk to Fleet Street and other parts of the City. Passed our evening at home.

Thursday 26 Washington Smith, No. 3 Grecian Cottage, Norwood, Surry. Letter, 12th from Jane, Sarah, and Sally. One from King at Washington. Mr. Riviere, artist, called. Also Miss Fitzhue, who left flowers for Blanch, who had gone out. Mrs. Langley called. Invitations from Miss Rogers for Friday—obliged to decline. Accepted an invite to dine at Tunno's for 9th of May—one from Bates for the same day—declined acceptance. At 9 visited Mrs. Jameson—her regular soiree. C. Kemble read part of Shakespeare's Hamlet—a most intellectual feast, and never to be forgotten.

Friday 27 My 15th letter finished—and an envelope nearly filled for home—wrote also to Carey, Sill, King, and Mr. Rockhill. At 5 we dined at Todhunter's,

362. Samuel and Allen Woodburn, picture dealers, 112 St. Martin's Lane.
363. Lawrence acquired ten Italian drawings from Sir Thomas Baring; these were purchased by the Woodburns at the sale of Lawrence's studio contents. See Waagen, *Works of Art*, 2:168–78.
364. Joseph Coolidge, Jr. (c. 1798–1879), American in the China trade, art collector.

where I left Blanch and taking an omnibus, reached Uwins, Paddington Green, just before the sketching club assembled. Met Havel, the landscape painter, who was with the embassy to China, under Lord Amherst. All the members of the club were present—subject given to design, certain passages from Rogers' "Pleasures of Childhood"[365]—I designed the Youth leaving his native Vale—made rather a lucky hit—at least they were kind enough to compliment it. Other members of the evening took different points of incident; and some were very successful. Leslie's the best "A Father recounting to his Children." Chalons next "The Swing" Stanfield—subject like mine. [A young man from a hill looking back to his native home, which he is leaving.] Edwin [*sic* for Alfred] Chalon "Children spreading crumbs for Birds." Havel—"The Swing"—much landscape introduced. Bone *contended* with the "Sexton." Stump patronized the "Beggar." Partridge "The Gipsy Fortune Teller" and slight sketches of the rest—Uwins made an excellent composition of the "Fortune Teller"—Memorandum: Leslie's anecdote of Wilkie and Constable and the Cocked-hat, when at Lawrence's funeral. We had supper at the usual hour and according to rule and returned home at ½ 12.

SATURDAY 28 Quite cold, so that winter clothing and an overcoat are indispensable. Blanch took a long walk with Miss Fitzhue and attend the morning concert at Hanover Square Rooms. I painted all day on my copy after Reynolds. Mr. Nichols called. After dinner Blanch & I called to know how Mrs. Audubon was; and happy to find her better. Called on Brett—drank tea at home, and remained.

APRIL 29, 1838 SUNDAY Clear sky but cold. Todhunter called at one. I had busied myself all the morning in preparing a packet for home, consisting of letters, notes, cards &c. At 2 Blanch and I called on Fitzhue, and rode with them to their cousin Hamilton to the residence of Mr. Hamilton, brother of Mrs. F. and the gentleman who was intrusted by Lord Elgin to remove the marbles taken from the Temple of Minerva at Athens to the Museum in London. His residence is beautifully fixed at Chelsea, nearly opposite to the house once occupied by the famous Nell Gwynn. Mr. H. is an antiquarian and his house is filled with specimens of vertu. The frieze of his principal room is a plaster copy of that which came off the cell of the Parthenon. Medals, busts, statues and pictures abound— and it would take weeks of leisure to examine them. I was much pleased with a colossal bust of the Duke of Wellington, cut by Pestruci [*sic* for Pistrucci][366]

365. Sully refers to Rogers's *The Pleasures of Memory* (London, 1792).
366. Benedetto Pistrucci (1784–1855), Italian sculptor.

from a block of marble taken from the Parthenon. The works of the dead has so entirely put the faces of the living out of my mind that I can only recollect being introduced to a Mrs. Hamilton[367] and daughter. At 5 we returned home. Found that Mitchel had called during our absence. After dinner we went to Todhunters and spent the evening. Presented Mrs. T. with the copy of Lewis' Indian Biography.

MONDAY 30 Raw weather. Sent Blanch's 14th letter to Mr. Vaughan to be forwarded to Philadelphia. I am almost out of patience in waiting to hear from the Palace. Called on Dr. Macauley—but he has gone to Rotterdam. Left card for Cooledge. Rain drove us home. C. Mitchell called. Leslie called—also Miss Webber and Mr. Hodgson. The rain set in with vigor.

TUESDAY MAY 1ST Rain continues. Blanch is obliged to decline the picnic at Mitchel's. At 2 Miss Fitzhue called for us on their way to the Museum. Mr. Hamilton was there to receive us, and showed us several rooms, particularly that in which the Elgin Marbles are arranged—appointed with me a day to see the rest of the building. These wonderful remains of ancient art, deserve all the extravagant praise that has been written about them—I am thankful to have the perception to feel their merit. At 6 we accompanied Mr. & Mrs. Hillard, Mr. & Mrs. Osgood, to the Hay-Market Theatre—on our way there through Golden Square, we saw the Chimney Sweeps celebrating the first of May, dressed like Tom-fools and dancing to wretched music for the amusement of the mob, from who they collected half pence! Tis time this stupid mummery, a relic of a barbarous age, was done with. Home before 12—tea, and to bed.

WEDNESDAY 2ND Finished the copy from Reynolds "Girl and Bird" and retouched that of the "Sleeping Girl." Blanch went to Todhunter's. At 6 I went to dine at Hodgson and Greaves, 6 Pall Mall. The Guests—15 were principally artists; amongst which were Stanfield, Allan Cunningham the writer, Maclise, Harding,[368] Knight,[369] Burnet,[370] C. Landseer, Cozens, and Uwins. Burnet told me that Lawrence frequently varnished his pictures, leaving untouched the sky and flesh.—and of course the picture would be put out of tone—I should say it was a bad practice. At past 10 I called for Blanch and returned home.

367. Juliana Udny, wife of William Richard Hamilton.
368. James Duffield Harding (1798–1863), English painter.
369. John Prescott Knight (1803–1881), English painter.
370. John Burnet (1784–1868), Scottish painter, engraver, and author.

THURSDAY 3 Retouched, and entirely finished my three copies. Mr. Healy, who had just returned from Paris, called to see me. The weather is quite warm. Mrs. B. Todhunter called to invite Blanch to spend a few days with them in the Country. We called on Miss Rogers. Left cards for Mrs. Gordon, Mrs. Jaudon and Mrs. Rawle. J. Audubon called. At 8 after dinner, I went to the palace and left a card for the Baroness Lehzen. Passed the evening home.

FRIDAY 4 Cloudy, but mild weather. Remained at home and wrote until past 12. Visited the British Institution. Received from the keeper, Mr. Bernard, three tickets for the evening exhibition. Passed some time in the gallery. Turner's pictures grew upon me; there is much mind in his pictures. But Landseer's works enchanted me. His expression, composition, coloring (May 4 1838 Friday in continuation) and his management of his materials is exquisite. Bold and free, yet highly finished; much detail, and working with small pencils, and yet great breadth of effect. Vandyke brown seems to be a favourite color with him, which he uses in finishing, in the same flowing manner as is practised in water colors. His glazings are exactly suited to the quality and texture of objects—in some passages his half tint-shadows are put in opaque. He does not make it a point to load the color, but there is no stint of it in the proper place, and in some places the ground of the canvas is seen. The whole work has that flowing look as tho' he oiled out the surface. How would the boldness of Reynolds' manner unite with the care of Landseers?

SATURDAY MAY 5 Yesterday on my way home—examined some mathematical instruments to send to Alfred at West Point. Letter from Copperthwaite. Note from Mrs. Keeley. Cards from Mr. & Mrs. Dunlop. Blanch and I called on Doughty, and Captain Levy—neither at home. Spent the evening at home. It is too warm for fire. The rain kept us at home during much of the day Miss Fitzhue called to see us; and report progress about the Queen's portrait. It seems that her friend, Miss Pitt, who is intimate with one of the ladies in waiting has been taken ill—so there my business halts—Patience!!! Drank tea at Audubon's—Mrs. A. is still unwell. Left cards at Hillard's. Heard that Doughty will not leave England these two months, so I wrote a note to Levy to get him to take charge of my parcel to Philadelphia. Miss Fitzhue sent us some sea-kale. Note from Leslie to meet the club at the residence of Mr. Partridge on the 18th.

SUNDAY 6 Sealed my 15th letter for home—Blanch handed me her 15th; inclosed them in a parcel for Capt Levy. Called on Doughty, who is not yet ready to

go to New York. Blanch rode out with Mr. Keeley, and saw many places about London. Called on Todhunter—his wife a little better. At 5 went to dine at Keeley's. Met there Charles Landseer—Mr. Prentice, and Michael Nugent, reporter to the Times—a dry, sarcastic man, but of a benevolent character. Home at 11.

MONDAY 7 Gave my tickets of admission to the night exhibition of the British Institution, to my host, Mr. Atherston. Miss Fitzhue called, and it being clear, bright weather, took Blanch to ride. Capt. Levy called to say he would take charge of my parcel but will not sail until the 16th from Liverpool. Called at Mr. Todhunter's on my way to find out Perkin's.[371] His workshop is at 6 Francis St., Regent Square, where I found him and proposed to him Mr. Tucker's request which he promised to refer to Mr. Bacon, who now carries on that branch of the business. Mr. Perkins Sen'r, with his daughter came in, and we recognized each other. His loss of sight (being almost blind) and old age, has caused him to relinquish all concern in business. Called on Healy—his wife is ill with bilious fever. Blanch walked with me down Oxford Street after dinner. Brett and his sister called in the evening.

TUESDAY 8 A warm clear day. Blanch went to Todhunter's. For amusement I began sketch of the rooms we occupy, to send home. At 3 went to the Museum to meet Mr. Hamilton—introduced to Mr. Beekford. Mr. H. took us through that part of the establishment I had not seen before, and made me acquainted with the superintendents. After a slight investigation, we rode to the Mint and was introduced to Pestruci who is making the Coronation medal for Victoria. He is an artist of ability, but not educated, or used to the sort of work he has undertaken. I did not get back to Mr. Todhunter's until long past their dinner hour—but they had kept some by the fire for me. Sorry Mrs. T. is yet indisposed. Find that Mrs. Keeley is quite well. Home at past 10.

WEDNESDAY 9 Warm and bright day. Blanch accompanied Miss Atherston to the rehearsal of the opera for Don Givonni. Kemble called. Left our cards at Jaudons. Blanch saw Mrs. Rawle at her sister's Mrs. Bulkley—they were just setting off for Windsor. Walked to the Palace through Hyde Park and St. James. Left a note for the Baroness Lehzen. Visited the Suffolk Street Exhibition and returned to dine. Found a prompt answer to my note, and that (May 9 1838.

371. Angier March Perkins, engineer, 6 Francis Street, Regent Square, Grays Inn Road.

Wednesday in continuation) on Saturday next Her Majesty would send me notice when she can give me another sitting. Day-light continues at this season until ½ 8. At 9 o'clock we went to Chalon's, and had a very pleasant evening in lively chat and good music. Several members of the orchestra of the opera were there; we had a fine quintett composed by Richa. A solo on the harp by Barré—Chalon played the clarionett, in a concerted piece. Wilkie, Leslie, Landseer, Stanfield, and Sir M. Shee were there—I avoided the last named, as I am not pleased with the little attention he has shewn me since my first visit to him. Dunlop's, Miss Gamble and many others whom we knew were present. Returned home by ½ 1.

THURSDAY 10TH Bright and fair, wind eastwardly. Wrote, and drew all the morning. Mr. Stiles of Philadelphia called with letters for us. He lives 24 Manchester St., at Mrs. Richardson's.[372] At 7 we rode to Tunno's, upper Brook Street, to dine. Met Miss Tunno, and also Sir. Martin Archer Shee. Home at 12.

FRIDAY 11TH Still fair, but cold. At ½ 9 we went to breakfast with Miss Martineau. Miss I. Pilkinton and Mr. Fontblanque, a gentleman appointed Consul to Philadelphia. At 12 we visited the water color exhibition. Met there George and John Oldmixon. [I saw effects of color, light and shadow that rivalled oil painting. There were some in distemper by French Artists and others—but that method has not so much force of effect—it has a mealy look.] Amongst the wonders of the exhibition, I would particularly remark on the excellence of Taylor[373] and Mr. Harding. [This artist has so much skill in using opaque colors to make out detail in the front ground. His method is to paint the exact form of the object to be detached from its back-ground by light to paint it in pure white and then glaze it with the required color. Sponging out lights, and scratching out sharp lights is also practised. I am persuaded that it would be a useful practise in oil painting in order to obtain decision and freshness, to copy from water colored paintings.] I cannot say, however that I approve the union of two materials so opposite in their texture as transparent and opaque water colors—these gentlemen use them in the same picture with much skill, and yet they are not in appearance homogenous. Miss Tunno called on us. Mr. Doughty—Mr. Nichols. Koecker called with some friends; a lady who would wish to have a portrait, but I cannot undertake more than I have engaged now to paint, as it might detain me too long

372. Wife of Charles James Richardson, architect and surveyor, 24 Manchester Street, Manchester Square.
373. Probably John Frederick Tayler (1802–1889), English watercolorist.

from home. Left a parcel for home, of letters etc., at Captain Levy's lodgings, with a note for him at ½ 9 we went to Miss Rogers and spent a pleasant evening; and met there Mr. Rogers—his nephew. Dunlop and family. Philips, the painters, Eastlake, Copley Fielding.[374] Bates and family. Vaux. Home at 12.

MAY 12, SATURDAY Clear, bright day. Finished the colored sketch of our room to send home. Mr. Stiles called and Blanch took him off to see the lions. She dined with Miss Frompton; I stayed at home, and was closely employed, that luncheon time and dinner time passed unheeded. Had a visit from Fontblanque, of 3 Somerset St., Mr. J. D. Lewis. At 9 I found Blanch. The brother of Miss Frompton had just arrived.

SUNDAY 13 Showery. We intended to visit Mitchel's family at their house, in Camberwell, but the weather prevented us. Called on Mr. Audubon. After dinner at home, we visited Todhunter and took tea.

MONDAY 14 Received a short notice and was at the palace by eleven. While I was setting my palette, Lord Conyngham was shown into my room to wait upon the Queen. Her Majesty gave me a very long sitting, which has enabled me to finish the head. Persons present and in attendance were the Baroness Lehzen, Marchioness of Tavistock,[375] and other ladies. The likeness was much commended by all. The Queen quite approved the style I had adopted, and said: "It was a nice picture." After putting away my paints, etc., I loitered in the audience-room to look at the collection, which is worthy of the place it occupies. On my way home I called upon Hodgson & Greaves to report progress. Tickets for a Concert sent by Mr. Nichols. Cards from Mrs. Jameson. Note from Carpetmaker who I called upon, saw my carpet and ordered it to be packed up. Invitation from Mrs. B. Todhunter from the country. Called on Smith and directed the pictures of E. Carey to be packed up. We drank tea with Mrs. Audubon. On our way home through the rain we encountered a crowd of Catholic School Children, celebrating something.

TUESDAY 15 Bright, clear and cold. At 10 I called a hack and rode to the Palace with Blanch, the Queen having arranged that she should sit with the

374. Anthony Van Dyke Copley Fielding (1787–1855), English landscape painter.
375. Marchioness of Tavistock, Lady of the Bedchamber.

crown jewels instead of herself. The Baroness Lehzen received us; and fixed the trappings on Blanch. The Queen sent to ask leave to visit us—on condition that she might not interrupt business—but of course, on her entrance, Blanch paid her respects. She was very affable, asked many questions, smiled at the appearance of Blanch decorated with her jewels and, orders—but she observed, "I am interrupting business" courtesey'd & left the room. I reminded the Baroness that she promised to give me the exact measurement of the Queen's height, and as a remembrance, her Majesty's autograph, this which was presently brought by her.[376] She said, on giving me the tape, measuring her height: "The Queen (May 15 1838 Tuesday in continuation) says if you show this measurement when you return to America; they will say, what a little Queen the English have got." On taking my leave, the Baroness took a kind farewell with polite wishes for my welfare—I shall ever feel a grateful recollection of the treatment I have met with at the Palace. After putting away my things to be conveyed home, Blanch and I sauntered through the picture gallery, until the preparations for an audience warned us to be gone. After returning home we paid some visits. In the evening called on Doughty and left with him the letter 16 of Blanch, and my 10th with the drawing of our rooms, to be taken to Philadelphia. Passed the evening at Dunlop's. Met Leslie and wife. Chalons and sister. Bates and others. We had excellent music on the harp from a Mr. Barré.

WEDNESDAY 16 At 9 visited the Exhibition of Royal Academy after enjoying many of the excellent works by artists whom I personally know, I was curious to judge of the effect of my portrait of Mrs. Price and found it weak and smoky in effect—my leading error is the want of force. By the way, I think one of the advantages of an annual exhibition, is to expose one's faults in order to amendment. Landseer has all the qualities of an accomplished painter. Wilkie does not gain reputation by the works he has sent on this occassion. And the great Turner is extravagant beyond bounds. On returning home was pleasantly greeted by two long letters from Jane, her Nos. 14 and 13—but 11 is yet due. Hodgson and Greaves called upon me and bespoke a half length portrait of the Queen for which they are to pay me 200£—I was reluctant to undertake this order as it will detain me too long in London. Visited Hunter[377] in Maddox Street, the Queen's Robe-maker, that I might examine their quality, the Baronness Lehzen having given me an order on Mr. H. to use them. We dined at Todhunter's. Home at 11.

376. See figs. 31–32.
377. John Hunter, robe-maker and tailor to the Queen, 16 Great Maddox Street, Hanover Square.

THURSDAY 17 I spent the morning in preparing a design for the half-length. Called at Lord Dacre and left cards—on Miss Jones. On Cruckshanks [*sic* for Cruikshank] the miniature painter[378] with John Audubon. Looked at an Orchestrina for Darley. In the evening Todhunter, Miss Webber, Blanch and myself paraded the streets to look at the illumination which was to celebrate the Queen's birth-day, she being arrived at her 19th year.

FRIDAY 18 At 9 took Blanch to the Exhibition. At 12 we walked to Coventgarden-Market, met Mr. Fontblanque on our return. Received a letter from Miss Fitzhue. Paid my bill to Watkins the tailor; walked to Willis' Rooms[379] to hear a concert by the Destin family—but we were disappointed. At ½ 6 met the Sketching Club at Partridge's; all were splendid but Stanfield, and this was the last night of the season, and accordingly appropriated to a review of all the drawings executed during the last term—Stanfield's budget was sent. For a regular account of the business of the meeting, see Book on Account of Pictures. [According to their rules, the drawings of the past season were brought together and inspected. Mr. Stanfield was not present, but he sent his portion. After tea, the daylight being shut out, lamps were lit, a table was placed close to the wall, and an easel close beside it. A large frame 24 by 18 inches was placed on the easel to contain the inspected drawings—and for that purpose a cut was made in the paper stretched on the aforementioned frame, so as to form supports for the drawings. The first set shown was those belonging to the member at whose house the first meeting of the season was held—and then continued in regular succession until the eight collections were examined. To make the examination a regular one, each member should arrange his collection in the order they were formed. As the drawings were placed for inspection by Partridge, Uwins read from the minute book the evening and subject, and after examination, they were laid on the table by the easel. No criticisms were allowed as it would take up too much time. In conclusion, the minutes of the last meeting were read, which was from the pen of Leslie, Pres't., and Secretary pro. tem., in which he lamented that at their last meeting, when the exhibition of the Academy should have been discussed, so little interest on the subject was evinced. When we adjourned to supper, during which the placed to be visited on the 21st—their annual holiday—was arranged. Many toasts were drank after supper, complimentary at the Sketching Club that I had promised to endeavor to get established in Philadelphia. On this

378. Isaac Robert Cruikshank (1789–1856), English miniaturist and caricaturist.
379. Isaac Willis & Co., Musical Library, 75 Lower Grosvenor Street.

occasion, the supper was more varied: we had ham, fowls, various vegetables, dessert and wine.]

SATURDAY 19 Employed the day in making outlines of Chalon's and Hater's whole length of Victoria, as memorandums of the dress.[380] The Misses Patterson called on us. They intend to embark for New York next June. They have lodgings in Great Castle Street, 32, near Regent. Mr. Rush and son called. Mrs. Rawle and sister—Mrs. Bulkley. Mr. Hodgson. After dinner left a note for Mrs. Bulkley. Drank tea at Mrs. Hillard's. Thatcher and Mrs. Osgood were there.

SUNDAY 20 The rain this morning prevented our visit to the Zoological Gardens. Mr. Chalon, and Stump called; they approved the likeness I showed them of the Queen. Expressed also a desire to be in correspondence with the Sketching Club proposed to be formed in Philadelphia. Mr. B. West came to see us; and we have promised to call upon him. Mr. Stiles called Mr. Hillard and Coates. Mrs. Elwyn with a Mr. Seymour. Mr. Dixwell and Cooledge. At 9 we rode to Miss Rogers. Introduced to Lady Holland[381]—a large party were assembled, amongst which Mr. & Mrs. Stevenson, Mrs. Marsett, Mr. & Mrs. Carr, Lord Holland.[382] T. Moore, Marquis of Landsdowne. & etc. I took some pains to examine the most conspicious pictures, the Titian—"Visit of the Rich Men to the Birth Place of our Savior" except the *tone* of this picture, I could not admire it—t'is insipid as a composition, the most prominent object, a white horse, is badly formed.[383] The picture is full of gross faults that would not be tolerated in the works of a modern painter. The Rubens—Study for the Battle of the Amazons, is excellent. A small Parmegino, exquisite. A fine Guerino—others I could not so well see—except a girl drawing on a tablet, by Reynolds, by no means worthy of his great reputation. But celebrated names, and dead artists works are wonders!!

MAY 21, 1838 MONDAY In the morning visited the shop of Hodgson and Graves, borrowed some engravings. In the evening we went, by the orders of Mr. Fontblanque to Covent Garden Theatre, to see McCready's personation of Cardinal Wolsey, and were delighted. But I cannot say much for the rest.

380. The location of Sully's outlines is not known.

381. Saba Smith Holland (d. 1866).

382. Sir Henry Holland (1788–1873), English physician.

383. Titian, *Adoration of the Kings*, c. 1566 (Cleveland Museum of Art).

MAY 22, 1838 TUESDAY Rain, took Blanch to Mr. Hunter, Robe-maker, and by an order from the Baroness Lehzen we were allowed the use of the dress. Blanch put on the Kertle from which I made a drawing, and also other portions of the dress. Yesterday we received letters from home—and not being able to paint—I wrote much. Sent an apology to Sir R. Peel for not attending his polite invitation last Saturday. Called on Smith[384] of Bond St., and left directions that he should store the case containing Carey's pictures, until called for. Called on the Orchestrina man, and was so pleased with the flagolet organ, that I shall buy it for Darley. At 7 Blanch went with me to Hodgson and Greaves in order to accompany them to the Opera, was introduced to Mrs. Hodgson. At ½ 7 we were fixed in our places and I had leisure to inspect this immense place; there are six tiers of boxes and before the overture began they were filled, as well as the Pitt and Stalls. As we were early in attendance Mr. H. took us through some parts of the interior. In the painting room, we found some persons still at work, it being yet day light; the place is so arranged that the scenes are painted lying on the floor; the painters' brush has a very long handle. We were introduced to the principal, Mr. Greeves. The opera for the night was the Sonambula, *Signora Parasienna* performed and sung divinely—indeed the best Italian force was displayed in the cast of characters. We had a ballet and one act of Norma, in which the unrivalled Grisi[385] performed. The Orchestra had seventy persons—amongst which were Dragonetti, Lindley, Morié and other great players. The chorus singers were about seventy. The Queen entered her box late, accompanied by the Dutchess of Kent,[386] and Sutherland, and others. The annual expense of the Theatre is 50,000£. We got home before one o'clock.

WEDNESDAY 23 Took Blanch to Hunter's. She was equiped in the State Robes of the Queen, and I made drawings for my whole length. Rained hard—and I am paying the usual tax for my last night's indulgence—inflamed eyes, occasioned by the glare of light, and pains in my limbs. On my return home, drew all the morning—Stiles called. Blanch went out. Dined at ½ 5 with Todhunter. Mrs. T. better. Home past 11.

384. John M. and Samuel M. Smith, carvers and gilders, picture dealers, general dealers in works of art, 137 New Bond Street.
385. Giulia Grisi (1811–1869), Italian soprano.
386. Marie Louise Victorie, Duchess of Kent (1786–1861), Queen Victoria's mother.

THURSDAY 24 Rain. Finished my design. Ordered a Bishop's half-length cloth. At ½ 7 we went to Greaves at his invitation to see the opera of Puritani from his box. The Cenerentola and a pas de deux. As we had Grisi, Tamburini,[387] La Blache[388] and other great talent, it was worthy of all praise.

FRIDAY 25 Began a half length portrait of the Queen for Hodgson and Greaves. A Mr. Lancaster called with letters from home, from Mr. Earle, and newspapers. Also Mr. Ord,[389] who came by the "Great Western" called and brought us letters and papers. He took charge of my letters to put in the letter bag at the New England Coffee House where he puts up. It was my letter to Carey and Blanch's 17th. Called on Strickland, Wiggin and Dixwell. Met young Provost. Dined at Todhunter's with Mr. Pedre, or Petrie.[390] At 9 took a cab and rode with Blanch to Mr. Coates, who gave a little party to his married friends— met there Osgood, Hillard, and their wives—walk home with them at 12.

SATURDAY 26 Dead colored the face and neck. The niece of Mr. Uwins called, Miss Elwin; Blanch had gone out. Lord F. Egerton called. Mrs. Jaudon brought Blanch home at 7, when we dined. At 8 called on the carpet maker and I paid him. Met Reviere the painter, of 12 Bath place, New Road. Went to look at a Celestina—price 50£.

SUNDAY 27 At 3 we assembled at Hillard's—Coates and Peabody and visited the Zoological Gardens—the grounds are extensive and seem well arranged for the purpose. The three living giraffs astonished and pleased me most. There was a throng of visitors. Met Mr. Bell, my acquaintance of Baltimore—encountered Todhunter and sister—accompanied them home to dine.

MONDAY 28 Closed my 17th letter and Blanch her 18th and gave them to Coates to be sent by the "Great Western." Completed the dead-color of the half-length. Called on Hodgson and Greaves. Brett came to see us. Audubon. Stiles, Mr. Mattheas, Mrs. Leishman, No. 6 Clarence Place, Clapton Square, Hackney. Leadyer, our laundress, is to be found at 2 Parsons Green Lane, Fulham.

387. Antonio Tamburini (1800–1876), Italian baritone.
388. Luigi Lablache (1794–1858), Italian bass.
389. George Ord (1781–1866), American naturalist.
390. Possibly Henry Petrie (1768–1842), English antiquarian.

TUESDAY 29 Painted on the half-length until past 4; Hodgson and Greaves called, and paid me the usual half in advance (100£) Blanch and I called on Miss Elwyn, and on Miss Tunno. In the evening we went to Audubon's, met Mr. Harris. Bespoke some linen for my expected voyage home.

WEDNESDAY 30 Rode to the City with Blanch and put her in to an omnibus for Hackney where she is to visit Mrs. Leishman and Mrs. B. Todhunter. Cashed the cheque for the 100£. Visited the House of Lords with Hodgson, to make a drawing of the Queen's Throne and chair of state, which I accomplished to my mind while seated on the Lord Chancellors "Wool-sack." From thence we went to the opera house to select some drapery that might assist me in the half-length. Purchased a travelling trunk. Dined with Coolege of Boston, at Fenton's. Mr. Gray of Boston[391] with us.

THURSDAY 31 Yesterday Maywood arrived and left a parcel letters and papers from home; and one for Leslie, which I sent to him by the two penny post. Maywood is at 18 Leicester Square—B. West at 26 Mornington Place. At Hogdson's suggestion I altered the arrangement of my composition of the half-length—and perhaps for the better in such size picture—but these publishers are hypercritical. Walked with Blanch, who had returned from the country at 12. Mr. Grey of Boston called. Left letter and parcel for Strickland. Evening at Mrs. Jameson's, met Leslie; Rev'd Gannet [*sic* for Gannett],[392] Cunningham, Dr. Herring—Lover, G. Hater and others.

JUNE 1, 1838 FRIDAY Blanch went to Todhunter's and as it came on to rain returned in a cab. Mr. Hodgson sent our letters 18 and 19 by the "Great Western." The evening at Stevenson's; met Tichnor[393] and wife, Cox and two daughters, Cooledge, Grey, Vaux, Rodgers and sister, Hanse, Baylie and wife and others.

SATURDAY 2 Painted on the half-length. Mrs. Leslie called and I gave her the *parcel* brought by Maywood. Stevenson and wife called. Mr. Rush called; note from Mr. Vaughan. After tea we walked to Mrs. Jaudon's, where we left a note. Bought articles on our way back.

391. Probably Francis Calley Gray (1790–1856), Boston civic benefactor.
392. Reverend Ezra Stiles Gannett (1801–1871), American clergyman.
393. William Davis Tichnor (1810–1864), American publisher.

SUNDAY 3RD Our Rosalie's birth-day. Went to Divine Service at White Hall. But we could not distinctly hear the preacher, and the little we did hear was not instructive. The music, so-so. But I had some interest in looking at the ceiling painted by Rubens which may have been fine, when fresh from his hand—but now the colors are sunk into a brown hue, as thó toned down with burnt umber; the composition does not redeem the dark hue into which the colors have sunk, and the drawing, which is masterly is very gross—to make matters worse, they have done up the gilding around it so new and bright, that your eyes are pained to look up to it. There is over the door a Bust of Poor Charles the 1st, which I am told was there when the room was a banquetting Hall and the window, from which the scaffold erected for his execution is built up a sort of clerical skreen or pulpit to contain 6 persons is placed before it. I think the room might be 90 by 50 feet and more than 40 feet high. Mid-way is a gallery, on 3 sides where servants in livery and menial persons are accommodated with seats. We called on Dr. Warren and family, of Boston,[394] at Sackville's Hotel. Mr. Rush called; Petty Vaughan and sister—Koecker and two sons and Mr. Pickersgill. At 5 we dined at Todhunter's and returned home before 11.

MONDAY 4 Visited Royal Academy's exhibition. I perceive that Landseer uses Vandyke brown in finishing. Called on Tupman and ordered a clock for our mantelpiece. Painted until 3 o'clock. After dinner called and left cards at Fontblanque, Jaudon's and Patterson's.

TUESDAY 5 Oldmixons called. J. Audubon. Healy and Debonshal [*sic* for Dubourjal].[395] Blanch went to hear the celebration of the Charity Schools at St. Paul's. After dinner I left Blanch at Audubon's, while I called on Healey to borrow a lay-figure. Found it in use, and he not at home. Went to Hodgson and left message on the subject. On returning home from Audubon's we found letter from Emily Fitzhue, with tickets of admission to St. Paul's.

WEDNESDAY 6 More tickets this morning for St. Paul's from Miss Hamilton. Mr. Tupman called—paid him for the clock and took receipt—he is to make me a watch for 22£; to be finished on my return from Paris. Mr. Hodgson brought Wagstaff,[396] the engraver, to see the portrait of the Queen, which he is to en-

394. John Collins Warren (1778–1856), American surgeon.
395. Savinien Edmé Dubourjal (1795–1865), French miniaturist.
396. Charles Edward Wagstaff (b. 1808), English engraver.

grave—am glad to believe they approve my portrait. Painted on it until 4. Blanch being at Todhunter's—at 5 joined them. Dined at 7 owing to Blanch and Miss Webber being out. Home at ½ 11.

THURSDAY 7 Finished 19th letter and left it with a parcel at the Misses Pattersons. Sent my draperies to Jackson and Graham's to be packed up with my carpets. Left my sketching Box at Winsor's[397] to be filled with moist water colors for Jane. Bought articles to take to my family. We called on Miss Martineau. At ½ 9 went to Allenson's. Met Dr. Pattieson, Mr. Ogden from Liverpool, Mr. Rush, Stiles and his friend Ryan and several other Americans. Home at 12 o'clock.

FRIDAY 8 Strickland is to leave Liverpool to day; he has my letter No.18 and I think one by Blanch—Miss Patterson has my 10. Painted until I went out to procure a lay-figure of Osgood—he has none. Blanch accompanied me to Hogson's, who promises to get me one. Walked to Picadilly and took an omnibus to Kensington. Saw Wilkie who will undertake to paint a picture for Carey. He took us into his painting room where he was executing a portrait by reflected light, obtained from a mirror. He says that all his firelight or torch light effects in his pictures are obtained in that manner. [A mirror (is) placed below the face of the sitter and threw the light upwards—a screen was placed before that part of the window that would light up the sitter's face; so that no light reach it except the reflected light from the mirror.] In speaking of resemblance in portraits, that it was well to add to the completion and youth of the face because it compensated in a degree for the want of life and motion. [There is a pervading drab tone in his pictures (particularly in his portraits) that injures the effect.] In walking home we passed through the magnificent Kensington Gardens. Walked to Convent Garden Market and bought some oranges. Miss Jones called and Mr. Maywood. After dinner Hodgson brought me the Regal Robes, and took home the volume of Vandyke's portraits, also Chalon's print and a roll of prints. Tea home.

SATURDAY 9 Painted on the drapery, but could not get on for want of a lay-figure. Called on Winsor and Newton to pay for some palette knives he had neglected to charge. Called on Reviere, but he had no manikin. Called on C. Landseer, 8 Buckingham Street, Fitzroy Sq. He cheerfully lent me his lay figure. And I got Hodgson to have it brought to me. On my way home I bought a knife for

397. Winsor & Newton, color manufacturers, 38 Rathbone Place.

Alfred. Hoppy of Providence and Mr. Maywood had called. Received letter by two penny post from Wilkie with Carey's letter; which I intend to leave with E. Landseer that he may be induced to undertake a picture for Carey also. After tea we strolled down Oxford Street and bought a dress for the lay-figure.

SUNDAY 10 Went to the Palace Chapel at St. James' at past 10 with Todhunter. Excessive crowd before the door—he and the ladies got in but not succeeding myself, I turned into the Park—encountered the Queen in an open carriage on her way—she bowed as though she remembered me. Went home, and was lucky in meeting Miss St. Ledger,[398] the friend of F. Buttler who had called to see us. I detained her until Blanch returned. Todhunter and sister went home, where we joined them after Miss St. Ledger left us—on our way we left a card for Maywood. It rained all the evening. Home 11.

MONDAY 11TH My picture was not returned from Wagstaffs until past 1. So I employed myself in making a colored sketch from a reduced whole length after Lawrence. Mr. Maywood called. A note from Ann Mitchel to invite Blanch to spend a week with her. Mr. Fonblanque called. Kept house all day on account of rain. Blanch finished her 20th letter.

TUESDAY 12 Storm of rain, hail, thunder and lightning in the midst of which Peter Mitchel and Sister called. Also Maywood. Two gentlemen called to see Carey's pictures I brought for exhibition. Made some progress in the picture. News-paper from Barnet of N York by the packet of the 20th.

WEDNESDAY 13 Sent Blanch's 20th letter to Mr. Vaughan to be forwarded to Philadelphia. Yesterday at ½ 9 went to tea with Mrs. Bates, met there Dr. Warren, Lady and two daughters, Mr. Cabot and lady of Boston also. Cox of Philadelphia and two daughters and others. Painted until 4. Brett called and lent me a picture of Reynolds. Says he can send me at Philadelphia the whole length of Lady Montague by Reynolds for the sum of 300£ to be paid by instalments of 100£ per annum. He also sent me a sketch by Cipriani[399] after Reynolds. Dr. Warren called. Went to see Hodgson. Left a note for Stevenson.

398. Harriet St. Leger, Irish gentlewoman.
399. Galgano Cipriani (1775–1857), Sienese engraver.

THURSDAY 14 Mr. Audubon called to take leave; he is going to Edinburgh. Painted until 4. Blanch went to Todhunter's. Heard that Sill had arrived and was at his mothers near Manchester, where our letters will remain until he can get to London. Hodgson, wife, and sister called. A circular from Sir R. Peel to admit Blanch and self to see his pictures next Sunday. Dr. Herring, Prevost, and Keely called. Brett drank tea with us.

FRIDAY 15, Worked on the drapery of my half- length. Received a note from the Marchoness Lansdown[400] for 29th of June. At which time I hope to be on my way to Paris. Maywood called, left me his wife's address in Paris—and a copy of the engraving after Tom's portrait of him—Dr. Macauley called, 4 Bennet St., St. James. Mr. Hodgson called and left me some gold lace. At ½ 5 I took a cab and carried the Queen's portrait with me to show poor Mrs. Todhunter, and I shall leave it with her until Sunday. Dined there with Mr. and Mrs. Parkman,[401] he has a distressing cough. Got home at 11.

SATURDAY 16 Has been raining all night—worked closely. Hodgson called and brought me some materials. Blanch accompanied me to Brett's where I left her to be taken to see the Horticultural Exhibition. Called on Kemble to borrow a collar of the St. George Order, left a note for him. Called on Koecker. On my way home saw a balloon ascension. Mrs. Jaudon has called in our absence. Blanch did not return until 7. At ½ 9 went to Stevenson's. A large party, and principally Americans. Leslie and wife. Introduced to Lady Shelburne—who Mrs. L. said was the "Great Gun" of the evening. Was agreeably surprised to meet Col. Biddle[402] and Mr. McIlvaine of Burlington,[403] just from Philadelphia. Macauley.

SUNDAY 17 At ½ 2 we visited the collection of Sir R. Peele.[404] The hall of entrance is well furnished with original drawing by Rubens and a few by Vandyke; these were once belonging to Lawrence. Sir Robert introduced himself and fa-

400. Louisa Emma Fox-Strangways, Marchioness Lansdowne and Lady Shelburne, Principal Lady of the Queen's Bedchamber.
401. Francis Parkman (1788–1852), clergyman.
402. James Biddle (1783–1848), American naval officer.
403. C. P. McIlvaine (1799–1873), American bishop.
404. On Peel's collection see Waagen, *Works of Art*, 2:2–27, and Jameson, *Companion*, 341–80.

miliarly taking charge of Blanch, he pointed out to her what he thought might interest and then led her upstairs, where Lady Peel[405] and daughter accosted her in a kind and affable style. Meantime several artists had arrived. Chalon and others. [The Last Judgment is Rubens great work. The studies and sketches for the picture are done of water-colors and tinted in a masterly style. Sir Robert said the sketch (about 4 feet high) was the size of the original painting at Munich.] The collection of pictures is particularly rich from the Dutch school, amongst which De Hooge pleased me most. [The celebrated Chapeau de Paille, by Rubens[406] (Chapeau d'Espagne) is here.[407] It is very fair, light, and yet forcible. The effect is given chiefly by the opposition of drapery, the flesh being but little disturbed by strong shadows.] One apartment is filled with fine portraits by Lawrence, also shows to great advantage. [It is a great treat to the portrait painter for some of his best pictures are amongst them—Duke Wellington, Lord Londonderry, Canning and several others.[408] Dignity, elegance and taste are the elements of his style—it may be a little too much of conventional taste, bordering on theatrical strut; but there is always vice in the excess of excellence. Van Dyke's simple dignity is allied to insipidity. Reynolds' breath and boldness degenerates often into a mysterious boldness—I feel the beauties and excellent qualities of all these great men, but if I were forced to choose between Lawrence and Reynolds, I should prefer Lawrence. I find in his later work more striving after color. There is a greater flow of broken tints in his colors.] Another room has pictures by Reynolds. The portrait of Dr. Johnson[409] pleased me most. [—excellent, but very simple as to color. Lady and Child, so so. Robinette with a bird on her shoulder, disappointed me.] In this room we met Mrs. Jameson and sister and got into conversation with Mr. Drummond.[410] Wilkie. [Wilkie's exquisite picture of 'John Knox Preaching' is advantageously fixed on the stairway[411]—and opposite is Lawrence's Kemble, as

405. Julia Floyd (d. 1859).

406. Rubens, *Le Chapeau de Paille*, c. 1622–25 (National Gallery, London).

407. In a 1859 postscript to his memoirs (1851), Sully explained: "Sir Robert Peale owned the famous picture by Rubens, called the Chapeau d'paille. It is a misnomer; the hat is beaver. It should be called the Chapeau d'espagne."

408. Lawrence, *Arthur Wellesley, First Duke of Wellington*, 1825 (Wellington College, Berkshire, England); *Charles William Stewart, Third Marquess of Londonderry*, c. 1813 (private collection); *George Canning*, 1825–26 (National Portrait Gallery, London).

409. Reynolds, *Samuel Johnson*, 1772–78 (Tate Gallery, London).

410. Samuel Drummond (1765–1844), English portraitist.

411. Wilkie, *The Preaching of Knox Before the Lords of the Congregation*, 1832 (Tate Gallery, London).

Rollo[412]—did not like it.] Leslie, Lane,[413] Turner, Uwins, Maclise and others. Long may Sir R. Peele live to enjoy his well merited wealth. His abilities are a public blessing—the excellent Police of England sprung from him and his riches make others happy. His superb dwelling is situated on the Banks of the Thames, the garden descends by terraces, to the edge of the river. From his parlour windows you have an extensive view of the river. Leslie accompanied us to Oxford Street. Dined at Todhunter's. Rode with him and Mr. T. in Kensington Park. Returned home at 11 with the Queen's portrait.

MONDAY 18TH JUNE 1838 Painted until four. Blanch walked out with me—left note for Marchioness Landsdowne. Cards for Rawle. After dinner went to Mrs. Audubon's. Left Blanch and went to see Reviere to see a half size lay figure made by the direction of Chantry. I agreed to purchase that and a small one for 11 Guineas and ordered it sent to me. Got home at 11.

TUESDAY 19 Hodgson and Greaves called. Too much disposed to cavil and find fault. Miss Jones called and made a judicious remark on the picture by which I have been enabled to improve it. Finished with the manikin, which was much in our way. Called on Stevenson, Bates, Jaudon and Cox.[414] Bought a basket for Blanch at the Pantheon. After dinner went to Todhunter; on the way we stepped into a German toy shop where I met Morse[415] of NYork—lives at 14 Bedford Place, Russel Sq. Mr. T. gone to Gravesend. Expect Sill next Sunday.

WEDNESDAY 20TH, WEDNESDAY Finished the half-length of the Queen. Riviere sent the box containing the manikins. Hodgson and Graves called, and gave me plenty of hyper criticism. Paid Riviere 11£. Hodgson and Greaves sent for the portrait and borrowed Blanch's autograph of the Queen's. Spent the evening at Mrs. Jamesons, where we met Carlisle [*sic* for Carlyle] and Lady[416]—a Polish Prince whose name I forget, dropt in, and we had the pleasure of listening to some interesting discussion. Carslile spoke of the value of *original* observation from writers, no matter how humble the acquirement of the individual.

412. Lawrence, *Charles Kemble as Rollo*, 1800 (Nelson-Atkins Museum, Kansas City, Missouri).
413. John Bryant Lane (1788–1868), English history and portrait painter.
414. John Cox (1788–1864), American merchant and president of the Lehigh Coal and Navigation Company.
415. Samuel F. B. Morse (1791–1872), American artist and inventor.
416. Thomas Carlyle (1795–1881), English essayist and historian; his wife Jane Baillie Welsh.

THURSDAY 21 It has rained all night and still continues. Received Jane's letter of May 30th and newspapers. Went to Hodgson and Greaves, where by appointment I met Burnet, who was kind enough to confer with me on the treatment of the portrait, and proved to me where the *effect* might be mended; as the likeness was quite satisfactory, I readily consented to work on the picture again, which is to be sent to my lodgings for that purpose-but I will do no more at the suggestion of Messrs. Hodgson & Greaves, whose *notions* on the subject do not suit me. Osgood called on me. Blanch and I took a cab from Whitehall and reached Camberwell at ½ 1. Peter Mitchel accompanied us to the Dulwitch Gallery[417]—we were caught in the rain—I found but a few really good works of the high sounding name which is the great eclat given to this collection—but fine names do not make fine pictures—Reynolds has no very good specimen here.[418] But one by Rubens is pretty good—some few landscapes, particularly of Claude. Some fine Murrillos—but none equal to one I saw in New York brought from England by Abrahams [*sic* for Abraham].[419] "The Jacob's Dream" by Rembrandt,[420] I should prefer to any picture in the collection. There were two or three young men copying either in water colors or pencils for oil colors are not allowed to be used. After dinner we had some agreeable music—a teacher Mr. Benfield and niece were there. We returned to town at 12 o'clock.

FRIDAY 22 Re-painted the back-ground and chair of the half-length. Worked until 5. Dr. Warren called. I am glad to find that Mr. Brett has sold the whole-length by Reynolds, together with the bulk of his collection to Lord Francis Egerton for 1900£. Blanch and I walked to Miss Rogers and left our cards to take leave, as we are now making our calls before going to France. Called on Lewis.

SATURDAY 23 Mr. McIlvaine and Col. Biddle called. Also Hodgson and Greaves—wrote to the Baroness Lehzen on their request. We went with Todhunter

417. Dulwich Picture Gallery, Dulwich College. On the paintings Sully would have seen, see Waagen, *Works of Art*, 2:378–90.

418. In an 1859 postscript to his Memoirs, Sully had the following comment on Reynolds's *Mrs. Siddons as the Tragic Muse*, 1789 (Dulwich Picture Gallery): "It is a poor painting, and is an insult to the ability of that great painter. I saw the original in the collection of the Marquis of Westminister."

419. Richard Abraham, English entrepreneur and art dealer, brought to New York in 1830 Murillo's *Grupo Familiar* (Kimbell Art Museum, Fort Worth, Texas).

420. Arent de Gelder, *Jacob's Dream* (Dulwich Picture Gallery). The picture was revered as a Rembrandt until 1946, when a cleaning revealed de Gelder's signature.

to the Opera and sat in the pit where we had the delight of seeing Taglioni danc-
ing a ballet.

SUNDAY 24 Have entirely finished the half length. Mrs. Rawle, Mrs. Bulkley
and Miss Rawle called to arrange with us about going to Paris. At past 5 went to
Todhunter's—they had taken Blanch out to ride. At 7 I accompanied T. to the Bir-
mingham Railroad Depot, in expectation of Sill's arrival. Returned home past 11.

MONDAY 25 Took Blanch's 21st letter to Miller. Sill and Todhunter called
with letters and papers from home. Sent the picture to Hodgson and Greaves.
Note from Peabody inviting us to view the Coronation procession from his win-
dows at Hatchet's Hotel; but we had promised to be at Hodgson and Greaves,
we had to decline. Dined with Todhunter. Returned the velvet borrowed from
Hunter. Received an answer from Miss Tunno at her place near Winsor, Taplan
Lodge, Maidenhead. Took leave of the Marchioness and Marquis of Lansdown.
Of Lady and Lord Francis Egerton. Called at Devonshire House to take leave.
Procured Passports for Paris at the French office in Poland Street. Called on
Macauley, returned Landseer's manikin. And the balance of things borrowed
from Hodgson. Called on Brett. Packed up my easels and paints; returned Shel-
burne's easel and paid the hire of it.

TUESDAY 26 Spent the day in preparations for our trip to France.

WEDNESDAY 27 Took my letter 20th for home, together with notes, cards etc.
and made into a parcel, to Mr. Vaughan to be forwarded. Called on Rawle, who
with her daughter, is to meet us at about 9 o'clock next Sunday, at the Iron-Gate
Stairs off which lies the steamer that goes to Havre. I called at the office and paid
all our passage money. Mr. McHenry of Philadelphia, called. Also Sill. Took
leave of Miss Martineau. Of Fontblanque. After dinner took a cab (June 27th
1838 Wednesday. In continuation) to Healy's and returned his copy of Reynolds,
and the book which he lent to Blanch. I saw Deboujal, who has promised that he
and Healy will make me some written directions for Paris. Spent the evening at
Jameson's and returned book.

THURSDAY 28 Day of the Coronation; and London seems teeming with life.
At ½ 7 we won our way to Hodgson and Greaves and having obtained places, we
waited patiently for the expected Pageant. The day was overcast, with now and
then a slight sprinkling of rain, but it was notwithstanding very favourable. At 11

the georgeous carriage containing the youthful Victoria passed, greeted by shouts of the people, and waving kerchiefs. In another carriage, followed her mother, the Dutchess of Kent, who was warmly greeted—so was the Duke of Sussex,[421] and particularly the French Ambassador—his fine appointment and attendence tickled the people. At 4 the procession returned. The Queen wore the regal crown; and carried the Orb and Sceptre. After partaking of a hearty Luncheon; we reached Todhunter's at 7 where we took a light dinner. Mr. Langley, wife and sister, called for Mr. & Mrs. Sill. Todhunter, Miss Webber and Blanch—we nearly filled the omnibus. A leisure drive through different parts of London showed us the illumination to advantage, altho the streets were much crowded. We finally gained the park where was to be splendid fireworks—here we were completely jammed until about 1 o'clock—Blanch and I became surfeited with the show, tired and sick. We left the coach and by much perseverance got home. Dr. McHenry had called.

FRIDAY JUNE 29, Letter from Maywood at Paris, dated 26th. His daughter has given up the plan of going to Philadelphia with us. My landlord, Mr. Atherston, has agreed to retain my rooms until my return from France, by paying him for the time of absence, one half of the amount for rent. Mr. Stiles thinks of going with us. Mrs. Jameson called for us to visit the artist Mr. Briggs.[422] His house is well arranged for his business—more so than any other I have seen in London. His sitting and family rooms are furnished with studies from the Old Masters. Briggs is bold, effective, but rather coarse in his style; but he holds rank with the best *portrait* painters in England. [Mr. Briggs is a portrait painter of knowledge and skill; he also composes history pictures—somewhat in the style of Opie.] We met Mrs. Opie,[423] who is his connection, and resides for a time with his family. She uses the address of a Quaker; seems very cheerful. It is difficult to credit the idea that the short portly, jolly looking Mrs. Opie was at one time of her life handsome, but I have seen greater changes in my time. Briggs has skilled as a composer in the manner of Opie—his coloring too is of a true cast—but there is somewhat of vulgarity in his works. Called on Mrs. Bates. And left cards. Took our dinner at an eating house in Oxford, to avoid the rain—and to avoid giving trouble to our poor servant Jane, who is ill. Marquis Lansdown left his Card,

421. Augustus Frederick, Duke of Sussex (1773–1843), Queen Victoria's uncle, president of the Royal Society of Arts.

422. Henry Perronet Briggs (1793–1844), English portrait painter.

423. Amelia Alderson Opie, Mrs. John Opie (1769–1853), English novelist and poet.

with a request I would be at Lady L.'s party. Visited Bates—left cards at Lord Dacre, Tunno, Audubon, Shee, Beechey, Mr. McHenry left letter and papers. Hodgson called and drank tea with us.

SATURDAY 30 Mr. Hodgson left me the note of the Baroness Lehzen, which I have answered—I also wrote to the Robemaker, Hunter. Healy and Doubjal called. We took leave of Uwins, Leslie. Mrs. Leslie took us to Landseer's—chatted with his sister and left for him Carey's letter, the which he has since returned and in a friendly note has accepted the commission to paint Carey a picture. Left cards at Dunlop's, at Langley's, Allensons, Price. Saw Todhunter and handed Sill Blanch's 22nd letter to send home. We dined at a confectioner's in Oxford St. Called on Audubon's family. Settled my account with Atherston.

SUNDAY JULY 1ST Took a cab at 20 minuets past seven and reached the wharf and got on board the steamer lying in the stream at 8 o'clock—and was much amused by the many, and exhorbitant demands made on your purse for assistance that was intrusive and troublesome. Mr. Stiles came on board as fellow passenger. Mrs. Rawle and daughter arrived at the key immediately after, but not being sure of my arrival, they lingered a long time before joining us. We felt much pleasure in having the company of Stiles on our trip; he proved of great use to us. At 9 we got under weigh—but proceeded slowly. It began to rain during the morning and was quite cool, so that we could well bear to be crowded in a small cabin with a great number of passengers—not less than 80 persons—and births for 20!! In fact at bed-time, sofas, tables, stools, and even the water-closet was occupied by sleepers. In our passage down the Thames, we had a glimpse of Greenwitch [*sic* for Greenwich] and many pretty towns on the river.

MONDAY 2ND At 5 I was glad to get on deck. We were now in the Channel, driving through the long waves, and the boat quivering under the effects of the propelling steam. A fine morning, and in the distance we discried the Coast of France. The difficulties and inconvenience of the past night was the theme of joke—but we should not choose such another, altho we found such amusement in the varieties of snoring. (July 2nd 1838 Monday—in continuation) Dined at the first table at 3 o'clock—but those who dined at the second table at 5 o'clock had better fare, with a dessert etc., that was withheld from the vulgar, 3 o'clock-ers. As we neared Havre, the tide left us and we had to land in boats that came off for us—of course an additional expense. But to petty charges through the whole trip, there was no ceasing. The Custom House boats took possession of the lug-

gage—we gave ourselves up to the directions of a conductor who was attached to the hotel, we had decided to stop at; and he caused us to give our passports up to the police officer who demanded them on our landing. They returned Mrs. Rawle's; kept Stiles'; but mine being in my trunk which was taken to the Custom House—I was allowed to proceed. We halted at the hotel of Mrs. Wheeler; which had at least cleanliness to recommend it. The commissionaire, or conductor, promised to attend to all our custom house business. So after bespeaking dinner, and engaging our passage to Rouen, we strolled about the town—everything here was novel to us. Such tall and singularly built houses, narrow streets. Washer women at their work by the fountains which are in many places—or they were busy on the edge of the river, beating with a short wooden paddle, instead of washing the clothes. Innumerable birds in cages—to sell; Parrots the greater number—the argument, screeching. In the market place we were entertained by the quarrel of two coarse women who bandied epithets for the amusement of the mob, until one of the belligerents silenced her antagonist by the use of some select phrase, beyond our comprehension, but occasioned a shout of triumphant applause from the crowd. The Houses are put together with timber frame work and filled in with mortar and covered with slate, sides and roof—this seems the general mode of construction. After going through and partly round this singular and I may add pretty town, we returned to the hotel just in time to hurry to the Custom House to see our trunks examined; and such a scene of noise and confusion I have seldom seen. We had also to repair to the police office to have our passports examined. They were retained to be sent to Paris and they gave us in their stead a sort of substitute, for which each person paid three francs—but not having the French coin they took shillings (a still greater imposition). These affairs kept us so long that we had but little time for dinner, but were hurried to the boat—in all this business Stiles was our best help. When on board I discovered that my trunk was left—the effect of trusting too much to our conductor. I hurried back to the Custom House, after telling Blanch that I would follow in the next conveyance. Waited at the Customs the examination of my trunk, and got back in time to save my place in the boat. At this place I was appointed by our party the paymaster. Our steamer was rapid and we shot from the wharf in fine style. Plenty of spectators, and on board a gay company, with a German band of musicians, who played charmingly. Our boat (the Seine) soon entered the river Seine; passed Honfleur, and the scenery began to assume its character, I should say of a sort between that of our North River and the Schuylkill. Veinport, a highly romantic spot, it was a cluster of low thatched cottages, built on the border of the stream, and extended and buried in the woods around. Sometimes we

passed close to an ancient French Chateau, with its artificial groves, cut into ar-
chitectural form, very stiff, but from old association, very interesting—it was so
much like the scenes that Watteau loved to paint, that one might almost expect to
see a bevy of long waisted, hooped petticoated, ladies issue from some recess or
alcove. Close to the lordly house and ground was situate a clustered village as
tho' seeking protection from its power. I thought, with dear Fanny Buttler, how
much more one enjoys such scenes in company with *silent* spectators. We were
much pleased with the manners of a free, noble looking young Englishman who
was communicative and civil. One fellow-passenger, a Frenchman, had a parrot
and a pet-dog; the least I had ever seen, I carressed it, and he took occasion to
comment on its extraordinary qualities—its great intelligence, sweetness—! It
had, he said, no unpleasant odour of breath or body like other Dogs!—nay! its
very excrement was without smell!!—he swore to it! Before you reach Rouen, the
Seine becomes narrow as the Schuylkill. We arrived at that place by 10 o'clock. I
had leisure and amusement in resisting the intended imposition of the porter
who carried our trunks to the hotel—travelers warn you that this is the land of
imposition. (July 2nd 1838 Monday in continuation—) We found comfortable
quarters at the Hotel Rouen, Madame Clark. Sitting room on the first floor and
three chambers, 18 francs per diem—clean beds—tiled floors but carpeted. We
retired at 11, well fatigued.

TUESDAY 3, Rose at 6—our rooms front the Seine, which gave us perpetual
variety until breakfast. I find a greater similitude in the French customs to Amer-
ica than the English, which I could not have expected—I am sorry to say that
spitting is one of them—but the ladies in America have not that abomination as
the French have. The men are more severe to their miserable horses, than are our
negroes; but they are very kind to pets and children—yet the ordinary women are
suffered to wheel barrows and carry on their heads, the heaviest burdens and do
the druggery which are left to men in America. How ridiculous seemed to me the
trappings of their cart-horses. Thó in the heat of Summer, they were so covered
with harness and skins from neck to tail, that little of the animal is to be seen.
The river must be deep at Rouen; I saw a ship of at least 400 tons lying at the
wharf. A great many poplar trees are planted here—I saw groves of them. Our
passports, or rather certificates were examined here. We had the good fortune to
procure an intelligent guide; or Valet de place—indeed we could not have seen
half that we accomplished without one. After breakfast we set off under his direc-
tion. We first visited the place where Joan of Arc was in prisoned—now a private
residence; 'tis called the Hotel du Bouteroup. In the Square where she was

burned is erected her statue and the ruins of the church, or place where the Duke of Bedford witnessed the cruel and disgraceful scene, this house is partly patched up and used by a carpenter, and is litterally tumbling to pieces. The hall, or palace of Justice is interesting. It has a curious oak ceiling, richly carved, and is yet in good repair. One of the most ancient remains and what was once a barrier gate, our guide said, was built by Rouen himself; he was a shepherd, and is so represented in a bas relief under the archway of the gate and his name was given to the new city. This structure has a curious old clock, and is called the "Old Clock Gate." This stands across a very narrow and dirty street and was built in 900 A.D. Nothing of the kind presents a greater contrast than this antiquated, dirty city, to the fresh and clean Philadelphia. The houses are piled up to a fearful height, in streets scarcely wide enough to allow carts to pass each other; no side walks or foot way. The gutter is placed in the center and is disgustingly dirty with all sorts of filth—one street was but 10 feet wide, with beams fixed from house to house to prop each other up. Some of these must have been 40 feet high. The Church of Notre Dame de Loretto, a Metropolitan church, is the most worthy of inspection. The principal spire which must have been upwards of 400 feet, was shattered by lightening, and it is now being replaced with one of iron. A poor substitute for the light tracery work of marble, that must have adorned the original. I doubt whether it had not been better to have left the ruins, than such hecterogeneous repairs. They are repairing the interior, and also the statues!! What patch work!! A tomb to the memory of an early Norman governor, the Duke Braisie, who hold sway under Lewis 12, has a figure recumbent in marble, and a masterly piece of sculpture it is.[424] There are about two or three good pictures amongst plenty of daubs. A modern picture by Poisson[425] recently painted, is excellent. The artist is now studying at Rome, and is about 31 years of age. Church of St. Maclou (I won't answer for my spelling) was built in 800 and is well worth visiting. The Cathedral of St. Ouen, is modern and not so lavishly ornamented with tracery, but is simple and beautiful. It is about 400 feet long, about 70 high. I was much pleased with a large organ, of dark oak, with pipes of lead, it accorded in appearance so well with the place, particularly with the circular window above it, of stained glass—these windows of stained glass, are admirable. (July 3rd 1838 Tuesday—in continuation) Specimens of painting on glass. We visited an exhibition of modern pictures. Amongst them were some

424. Attributed to Jean Goujon (d. 1567), tomb figure of Governor Brezé.
425. Pierre Poisson (1786–1848), French history and portrait painter. Sully is wrong about his age.

good efforts, particularly one by Rouqueplan,[426] representing a circumstance from the Massacre of St. Bartholomew. This artist is now studying at Rome—go into the Library of this building—not to see the backs of books, or an old illuminated manuscript Bible, which cost the artist 30 years to make; but to look from the windows at the magnificent view of Rouen. At past one we returned to our hotel, well tired, but well pleased with what we had seen. After luncheon, and a refreshing nap, Blanch accompanied me in a walk. We ascended to the top of Mount St. Catherine, which overlooks the whole country, and presents a view of enchanting beauty. It was really "La Belle France." The people we met were civil, and appeared to be happy—but we were shocked to see the women do the rough labour of seavengers and porters, they are turned into beasts of burden.

JULY 4TH WEDNESDAY. Breakfast at ½ 5; bill 218 francs. Arranged ourselves in the diligence for Paris, and had a charming ride through a picturesque country—at 12 we took breakfast on the road—I should call it dinner and at a quarter before six came in sight of Paris!! The Triumphal Arch being one of the principal objects in the great city. At 7 alighted at the Custom House, where we showed our permits and had our luggage slightly examined. Took a hack and drove to Madame Couzin, Hotel Mirabeau, Rue de la Paix, where up showing Douboujals letter of recommendation we were cheerfully received and accommodated. Her charge for apartments,—4 chambers and a sitting room on the 4th story, 10 franks per day. There is a table d'hote attached to the hotel where we may dine; and our breakfast and tea may be taken at home. After tea we walked to the Boulevards, entered the Garden of the Tuileries and mingled with the thousands that were taking the fresh air by moon light—and returning to our lodgings, felt persuaded that Paris must be the most magnificent of cities.

THURSDAY 5TH A bright and clear atmosphere. Our ride yesterday to Paris was very pleasant, thó our ladies had to put up with the interior, the 'coupe" being previously engaged—Stiles and I were perched in the 'Imperial'—where we should by choice have been; and as it proved to be pleasant weather, we enjoyed a continual feast of fine scenery. We coaxed Mrs. Rawle and Blanch to visit it. In Paris we find the women handsome, particularly in form, and dressed in good taste—so are the men. After breakfast we sauntered to the Boulevards. Mrs. Rawle and daughter having a visit to make, and we went on a search after the

426. Camille Joseph Etienne Roqueplan (1800–1855), French painter, called Rocoplan.

shoemaker that serves Mrs. Furness. But although we found his former residence we could not trace him; so we returned home. Went to visit Maywood, took some refreshment at a shop, and was cheated—What a pity it is that a stranger who may be disposed to like a place, should be disgusted and indignant at the conduct of treacherous dealers. The Maywoods seemed much pleased to meet us. Our return through the Boulevards Italian was quite entertaining. The noble shops, rivalling those of Regent's Street in London; the broad pavement thronged with people. Visited the Palais Royal and sauntered through its numerous arcades of shops, which are like the Bazaars in London. In the afternoon rambled through the Tuileries thronged with people who were walking for exercise, or seated under the trees, looking at the fountains and statues, or taking ices under the shades of a restaurants, Pavillion, and listening to the exquisite Military Band. The Palace thó ancient (and for that I like it better) is very imposing. The statues, fountains and careful improvements have done much for the place; but it falls far short of the vastness of the parks in London, where you do not feel any undue restriction from the police, which is offensively the case here, and by men armed. In London the few places from which the mob is restricted are inclosed; and their police mingle with the people as one of them; keeping peace mostly by their forbearance and kindness, and always ready to do you a service. We took tea at 9 and retired at 11.

FRIDAY 6. Stiles accompanied me to Gaglani [*sic* for Galignani][427] to whom I delivered Carey's letter. He was very civil and desired me to make use of him. Went to the American Consulate. He—Mr. Brent—advised me to get a commissionare (July 6, 1838 Friday—on continuation—) to transact my passport business. Called on Mr. Cox, Rue Louis le Grand—called at a shoemaker's and was measured for boots and shoes. Blanch and I visited La Madalene;[428] a beautiful Temple in the Corinthian order; 8 columns in front, and 16 on the perystile. I don't like the cutting up of the Cell into the appearance of square blocks of masonry; nor do I like the tympanum being so crowded with large figures. After one, took a hack and with Mrs. Rawle, daughter and Blanch, we drove to Pere La Chase.[429] As you approach within a quarter of a mile the ground gradually rises to the gate and then increases in steepness to the summit of the burial ground. It

427. M. Galignani, publisher of the newspaper of foreign items *Galignani's Messenger* and owner of Galignani's French, English, Italian, German, and Spanish Library, 18, rue Vivienne.

428. Eglise de l'Assomption or de la Madelaine, rue St. Honoré.

429. Cemetery of Mont Louis, or Père Lachaise.

is intersected by roads and paths, but the rest of the inclosure is well occupied with tombs and monuments; and in the greater part, is choked up with them. Here you have every variety of monumental taste; from the lofty pretentions of rank and wealth, to the humble and frivolous bad taste of childishness. Some few, however, were simple and beautiful—on the whole I left the place rather disappointed. The tomb of Abelard and Heloise had great interest for us. And the view of Paris from the summit of the grounds, was very grand and extensive. Oak floors are common here. Some are tiled in tasteful forms as mosaic, and other styles. Here are abundance of street vendors, with their musical cries. The fruit is excellent and cheap. The modern and principal streets have broad flagged pavements, some are coated with asphaltum. Place Vandome is a grand opening, with a lofty column in the center surmounted with a statue of Napoleon. The Boulevards Italien, an elegant street, very extensive, and much frequented. The handsome shops that line it are second only to those of Regent's Street. I find the climate in summer more like that of Philadelphia, than of London—yet not quite so warm. It has rained but once since we arrived, and that happened in the night. My boot-maker lives A la Teté d'or, Rue St. Honoré, No. 249, 3d. floor, Bottier.

JULY 7, SATURDAY Our companions not being early risers, we did not finish breakfast until past 9. At 10 I went alone to the Gallery of the Louvre; inquired my way until I overtook a person with some paint brushes in hand, him I followed close and passed into the Gallery unquestioned. Took a rapid glance at the two first rooms, and on entering the stupendous long gallery, filled with pictures, terminating in a distance my eye could not reach; while preparing to begin my hasty inspection, Hubbard, the artist, accosted me, and kindly accompanied me throughout. We walked leisurely down, looking slightly at everything, and halting where I saw any particular attraction. There were many men and women copying. In general the lady artists were the best. In this superficial glance at the collection, the coloring of Rubens pleased me best for large works.[430] I invariably saw that in his flesh tints, his high lights were yellow—say Naples, white and Venetian. Next tint, Venetian and white, in different degrees of strength. Then a grey, perhaps composed of ultramarine Venetian and yellow. Then an olive half tint—perhaps of yellow, black and red. The dark shade of vermillion, black and yellow; the red predominating. This I took to be the modelling system of color; unless the flesh was *very* fair; in which case, the first yellowish tint, passed at

430. Sully probably refers to *Rubens' Poem*, the series of twenty-one immense paintings of the life of Marie de Medici, executed 1621–25 for the palace of Luxembourg and transferred to the Louvre in 1816.

once into gradations of lilac (vermillion, black and white) then to the olive shade, mixed with the formentioned and lastly to the dark red shade. While this preparation was fresh, it seems to have been improved with red tints—blue tints, and the warm, reflections of orange tints, and pure touches of vermillion, or orange in the shadows, especially in the separation of fingers, toes &c., or whatever reflection could add to warmth of shadow; I could no where perceive that he had toned his flesh like the practice of Titian. Veronese makes a good impression as it regards color; and so does Titian after you have looked into him. "The Marriage Feast" by Veronese[431] seemed crowded, confused, and not so rich as I had expected. The collection from the Spanish school,[432] disappointed me as to color. But the force of light and shade is great. The ceilings of many apartments are painted by modern French painters, and have great merit—perhaps a little too gaudy. There was a particularly fine one by Vernet, well composed, and in a masterly style. As our party had not yet joined me, according to agreement. I accompanied Hubbard to his lodgings across the Seine, in order to write an application to the Director of the Gallery for leave to copy in the Louvre, (July 7th 1838 Saturday, in continuation) without such authority, one is liable to be prevented by the attendant of the gallery. On returning to the Louvre, I found Stiles and our party. From thence we rode to the Luxemburg Palace where I saw the best works of the modern French School, and was most agreeably disappointed in their excellence. Horace Vernet,[433] considering the high walk of art he has chosen, is the best living painter whose works I have seen. His composition, expression, effect, coloring and handling are all exquisite. De la Roche is not so true but has much merit. We remained in the Palace until it was time to close the doors. We visited the apartments of Mary de Medici, which to be sure, were highly ornamented with paintings, marbles, gilding, mirrors and velvet. The paintings on the ceiling we were told by the guide, were done by Rubens; but I could not find in them the least trace of his manner.[434] We dined at a restaurant close to the palace and, in the evening walked leisurely home. At ½ 7 went to the Theatre Francaise,[435] and had the gratification of seeing the celebrated Madamoiselle Mars[436] perform;

431. Veronese, *The Marriage at Cana*, 1562–63 (Musée du Louvre, Paris).

432. Sully would have seen works by Velázquez, Ribera, and Murillo.

433. On the pictures in the Luxembourg, see M. Galignani, *Picture of Paris* (Paris, 1816).

434. The ceiling paintings, representing the signs of the zodiac, were painted by the Flemish artist Jacob Jordaens (1593–1678).

435. Theatre Français, rue de Richelieu.

436. Anne Françoise Boutet (1779–1847), called Mademoiselle Mars, French actress of the Comédie Française.

but as we could only understand the plot of the piece, we could not be capable of appreciating her powers; but I was persuaded from her very great simplicity of manner, that she must be excellent. Such performers as it is with great painters, like H. Vernet, belong to no *school*. The age of Mademoiselle Mars from the distance we saw her, seemed 35. A gentle rain obliged us to ride home. Had tea at 12 o'clock and retired.

SUNDAY 8TH At ½ 10 walked to the Cathedral of Notre Dame. Mr. Bonner, the friend of Styles accompanied us. The streets were as busy as in a week day; shops were open, labourers at work in building etc. etc-, in fact I thought there was rather an increased ardor in business than otherwise. As the evening came on, the shops were closed in order to allow the shop-folks to have their share of the holiday; So that all places of amusement and public resort were filled; in the streets were multitudes of well dressed folks, some seated before the doors of caffés or restaurants taking ices, or refreshments. I saw but little intoxication amongst the lower orders, althó it was very warm, and much drinking going on. This treatment of the Sabbath is to a stranger shocking. At Notre Dame, where some visitors like ourselves had been drawn thró curiosity, the service seemed more like a Pageant than worshipping. I must confess that I felt a reproach at our intrusion, and endeavoured to put on all possible respect and humility. This cathedral did not impress us as that of Rouen, althó I think it is larger. We visited other churches—saw at a distance La Morgue on the river. The bridge and statue of Henry 4th. Rested ourselves at a caffé, and then gained admission to the private apartments of the Palais Royal. The rooms are numerous and some of them quite regal; expecially the Throne room, although comparatively small. There were many modern paintings, but the best were by H. Vernet. One or two by Girard[437] were very hard, polished and elaborated. I believe this palace is the residence of the Duke de Nemours. In the evening we rambled through the Garden of the Tuilieries. There were multitudes of well dressed and well behaved people promenading. The fountains were in action—the basins of which must be about 100 feet in diameter, swans were gliding about in them. Continued past the Pyramid or rather Needle, to the Champs Eleyseé—which looked to me more like a beer-garden. It was completely a Fair, and filled with persons of the lowest order. All sorts of sports were going on; but gambling seemed the chief end of all—one visit to this place of a Sunday, is enough. We got home at 10 quite tired; had tea, and was glad to get to bed.

437. Pierre Girard (1806–1872), French landscape painter.

MONDAY 9TH Yesterday Mr. Cox and daughters called. Recommended me to apply to March and Arthur, No. 7, Rue Neuve, du Mont Thabor, for information respecting the packets to England. At past 10 we took a hack for 4 to the Garden of Plants,[438] where we found free admission without showing our pass ports. We saw much to admire. The animals were well kept, and have plenty of room; and the prospect of Paris from the Temple on the Hill is very extensive. Rode to the Sevres Porcelean Factory. Had to show cards of admission, which showed us to the establishment. They have wares from all parts of the world; and from the earliest period. But nothing that we saw equalled their own specimens. The painting on china is wonderful. Copies of Van Heysum's flower pieces—from animals—landscapes and history—portraits, size of life, kit kat size, are admirably done. On our return, near our hotel, we encountered Mr. Stiles removing his baggage to another lodging. After dinner, Mrs. Rawle and daughter rode out with Mrs. Morgan. Blanch and I rambled about the city. To the Tuilieries. Listened to the fine military band, composed of about 60 players. Took some ice in the open air as others do and at 10 returned home. Mrs. R. and daughter soon joined us, and we had tea. The french beds are remarkably clean. And altho the shopkeepers will overreach you, still there is not that extortion amongst the servants, porters, and such people as you experience in London.

JULY 10TH, 1838 TUESDAY After breakfast I went to the office of March and Arthur and arranged to take route homeward, by way of Boulogne. Paid an advance of 30 francs to secure places on the coupeé. Have arranged to send my dutiable articles in a separate case, which he will forward for me to the Custom House London to be reshipped, by which no duties are called for. Visited the Louvre with my permission to copy. Met young Healy and Hubbard who accompanied me to the best places to procure pencils, colors etc. Returned to the Louvre. Met Mr. Saul on the way. Sketched in the gallery until 4. Accompanied Hubbard to his lodgings and was much pleased with his improvement in painting. He told me much of the new mean tricks of Jones, alias Harris—he is known and much despised in Paris. Returned home in time for dinner. Stiles called in the evening. The American Consul left his card. Settled our account with Stiles, and paid him 64 sous. It has been excessively warm to-day; about the degree of heat we have in June in Philadelphia. The streets are not so well watered as in London, and in some of the narrow streets, where there is no pavement, the

438. Jardin Royale des Plantes, or Jardin du Roi, rue St. Victor and Quai St. Bernard.

walking is tiresome and inconvenient, and the stench bad enough—but I must confess not worse than it is in clean Philadelphia.

WEDNESDAY 11 Sent for an Emballeur, or packer of goods. At 10 we went to Mr. Brent's office, the American Consul. A new passport was made for Mrs. Rawle. Rode home. Walked on the Boulevards-Italien. Bought a nail-brush from a Huxter, I finding that I had overpaid her, returned me the overplus; a very agreeable contrast to the common practice of overreaching a stranger. I delivered the letter of introduction from Hodgson to Ritner and Gosnell, on the Boulevards Italien Mont Martre. Mrs. Morgan called for us in her Barouche and we visited the Gobelins Factory. A very extensive establishment and quite equal to my expectations. The carpet department alone is worth the trouble of a visit. But their masterly translation of pictures is really wonderful. I think their last works are their best. A Saint Stephen in the first room is excellent, and the copies they are now making from Raphael's cartoons very exact, as are also other copies now in progress. The most complicated mixture of tints is exactly rendered. Visited the church of Ste. Geneviève.[439] A handsome interior of Gothic architecture, but not old. It had *one* excellent picture of some royal personage, worshipping at an alter. The Pantheon is altogether the finest modern building I have seen; not so large as St. Paul's in London, but the interior is more grand and simple. We went through the vaults, where are placed the monuments of renowned men. The visit to one of which, would have satisfied me, but the guide went dogedly through the whole. There is a remarkable echo in these subteranean passages. The Invaledes[440] was the last building we visited today and in this our chief scrutiny was directed to the Church and dome. This part was elegantly disposed on four arches, that lead into, and make part of four other domes of lesser size, it is a happy thought and beautifully executed. If beauty of construction was the point, I should give this the preference over every modern church I have seen. We passed for the dozenth time the Hall of Deputies[441]—but not without a tribute of admiration. In the afternoon Mr. Morgan called and took Blanch and Miss Rawle to walk, and visit Tortoni's.[442] Mr. Saul called.

439. Church of St. Geneviève, or the Pantheon, rue St. Jacques.
440. Hotel Royal des Invalides.
441. Chambre des Députés au Palais Bourbon.
442. Café Tortoni, Boulevard des Italiens, a fashionable resort, particularly in summer; celebrated for its ices.

THURSDAY 12 Rose at ½ 4; wrote a note to Hubbard to tell him of a remittance received by the consul for him. Went to deliver it but not being able to find his hotel I put it in a two penny post close by. I had to go around the Tuilieries, as the gates were not yet opened, and I had forgotten to bring money to pass the most convenient bridge. At ½ 10 we set off for Versailles in an open barouche. Nothing but a desire to see a wonder could have made the ride sufferable, such heat and dust!! The thermometer above 80. There were many fine objects on the way to amuse us. If it were not for the absence of fences, or enclosures, the country would resemble Philadelphia's invirons. The approach to the Palace of Versailles through a large village, becomes every moment more imposing, and the palace itself is extensive and magnificent—in short I have seen nothing of the kind heretofore that has given me so exalted an opinion of a royal establishment. We stopped at the Reservoir hotel at about one o'clock, and after ordering dinner we procured a guide and set forth on our sight seeing. To our dismay we learned that the palace could not be visited (July 12 Thursday—in continuation)—the palace could not be shown to strangers without an express permission: so we had to content ourselves with a ramble through the grounds and some public buildings of the concern, this occupied all the time we had to spare, and well rewarded us for the trouble. Numerous avenues of clipt trees, gardens, wild groves, grottos, fountains and statues innumerable. Vanderlyn's panorama,[443] exhibited in N York, gave a lively idea of this place. We hastened to our hotel quite tired and hungry, made a hearty meal and got to town at 8 o'clock. Mr. Saul called on us.

FRIDAY 13 Another warm day. The weather has much like what we experience at this season in Philadelphia. Have begun to pack up. I am glad to be so near the time for embarkation for home. I certainly could find much to employ me for a length of time in this great reservoir of art. Sent my case intended for Philadelphia to March and Arthur to be forwarded. At ½ 1 Mr. Morgan called for Mrs. Rawle and myself (the young folks had gone out). We visited the diorama[444] and enjoyed a wonderful production of art and ingenuity. In the meantime Mr. Saul had taken the young ladies to see the interior of the Palace of the Tuilieries. Mr. Stiles called, and Healy who gave me a letter and some colors to take to his brother[445] in London. He assisted me in his experience while I paid my bill to

443. John Vanderlyn (1775–1858), *Panorama of the Palace and Gardens of Versailles*, 1816–18 (The Metropolitan Museum of Art, New York).

444. Paris Diorama, Boulevard St. Martin.

445. Thomas Cantwell Healy (1820–1873), American painter.

Mr. Couzens and the table d'hote etc. Before 11 Mr. Saul returned with our young girls who were much pleased with their visit to St. Germain[446]—at 12 our friends bid us farewell; and we retired after preparing our luggage.

SATURDAY 14 Left our lodgings early, put our luggage in a cart, ourselves in a hack, and were soon at the office of the diligence. Mr. Saul and Mr. Healy joined us there, and remained until we set off—in a half an hour we passed thró the Porte of St. Dennis, and were quite out of Paris. The approaching rain drove me from the Imperial to the interior. We passed thr ½ a country that much resembled the neighbourhood of Philadelphia. Dined At Clermont. Beggars around every where when you leave Paris and their importunity is distressing. Sometimes they offer for sale fruit, or flowers, and throwing the latter into your lap; trust to your generosity for payment. At ½ 9 gained the noted town of Amiens, where we found supper and good beds.

SUNDAY 15 Gentle rain. Breakfast and off at 7. It cleared up during the day, and the dust being hard, and the air cooled, our ride was delightful. The singular buildings, and queer old fashioned villages amused us. But there was poverty and filth to mar the pleasure. Dined at a beautiful town called Abbeville. The fortifications which surround the place give it an imposing appearance. The place seemed cleanly and thriving. There were but few symptoms of Sabbath, except the chyming of church bells. Arrived at Boulogne at ½ 6. Our passports were taken for examination and returned the next morning.

MONDAY 16 Left Boulogne at 5 in the steamer with plenty of passengers chiefly English. In the evening at ½ 6 we landed at the Custom House, and after a slight detension, were allowed to proceed. Mrs. Rawle took a coach, and we another. On our way left a card for Hebard at the N American Coffee House. Alighted at 46 Gt. Marlbr ½ at 8 o'clock. Found our lodgings ready and a new servant, as poor Jane had been sent to St. George's Hospital to be cured. Found a bundle of letters from home, which employed us delightfully until bedtime—11.

TUESDAY 17 Early this morning we arranged our baggage. After breakfast delivered letter and colors to Healy. Called at Tupman and left my watch to be repaired. Went to the Counting House of the agent of March and Arthur—Mr.

446. Church of St. Germain l'Auxerrois.

Christopher[447]—shewed him my order for the box from Paris. Visited the Quebec at the Catherine docks and looked at the writing left in the bottom of the Drawer in the state room I had engaged—recognized the hand writing of those at home. Left a letter for Hibard. Called on Hodgson & Greaves. He wants more done to the portrait—I am displeased with the pretense of this Hodgson, he grants that all are pleased with the picture, the subscription large, the Queen's name at the top of the list—and yet he wants more done. But I decidedly refused to be imposed upon. However we parted on civil terms, and he tried to smooth matters over. I hear that his subscription list is large. Left a card for Maywood and returned home. Jane got leave to visit us; she wishes much to go with us to Philadelphia and from my experience of her good qualities as a servant, I am inclined to take her. Visited Todhunter. Mrs. T. somewhat better.

LONDON JULY 18TH 1838 WEDNESDAY Blanch went with me to Dr. Herring, who took us to Lewis the engraver, who is likewise a clever landscape painter.[448] Met Couzins there. Went with Herring to see Miss Rolls, an amateur artist of much talent—from thence to Uwins whom we took final leave of. Then to Leslie's, who regretted there was not time left to paint my portrait. Returned home and found two letters, from Jane, and Ned Carey, with newspapers, by the Sirius. Read until it was time to go to Audubon's, where we dined and staid until 10.

THURSDAY 19 At ½ 10 called on Lord F. Egerton, who took a friendly leave of me. Left my card with servant for Lady E. Saw, at a shop window in St. James' Street a wonderful painting by Denner,[449] of an old head. Rode to St. George's Hospital and saw Jane Dodsworth, left her a proposition to take her with us to Philada as our servant—of course to bear her expenses and hire her as Cook in my family. Rode to Pall Mall called on Messrs Hodgson & Greaves—bid them farewell. Mr. Tutman has sent my clock. Keely called. Blanch walked with me to Devonshire House. Left cards for Prevost, Wiggin and Dixwell. Called at Hillard's. Wrote to Miss Tunno and Miss Leishman. Called on Maywood and left two letters to go home. Through the Pantheon. We called on Miller to thank him. Healy called. Went to Miss Jones, and left cards. Called on Todhunter.

447. Thomas & Joseph Christopher, customhouse agents, 13 Harp Lane, Tower Street.
448. Frederick Christian Lewis (1779–1856), English engraver and landscape painter.
449. Balthasar Denner (1685–1749), German portraitist.

FRIDAY 20 Have written an apology to Miss Tunno for not visiting Taplan Lodge. Bought several articles to take home. We visited St. Paul's and ascended to the "Golden Gallery" where I was in 1809. We halted at Birch's and took some Bunns.[450] Called on Mitchel and bid adieu. He took us through the Bank of England to show us the interior. Partook some strawberries and cold ice-cream. Called on Jaudon. On Willet & Co.[451] Met Prevost; who perhaps will go home in the same ship with us. Took an omnibus home at 4 dined at Todhunter's; his wife's sister, Mrs. Timbles and husband. Home at 8 to meet Healy and Doubajal. Went for Blanch at 11.

SATURDAY 21 Went to 52 New Broad St. Agency of B.U.S. Mr. Jaudon settled my account and paid me 209.6/6 which I checked in gold. Left Blanch's letter to be forwarded by the Mediator which vessel has been detained. Took a cab to the docks, but the streets were so blocked up that I had to leave it and walk. Paid Hubbard in advance for our passage; will sail on Sunday week. Went to the brokers for information how to ship baggage. Returned home. Jane called in my absence, and Blanch told me she had concluded to go with us. Blanch had gone to dine with Keeley—and I set off to pay visits. Ordered the flagolette piano for Darley to be packed up. Called and left card at Count Survilliers. Then to Cozens to whom I left a note, and to Mr. Wright, saying goodbye. Then to Stanfield who parted with much affection. To B. West; and to Humphrey my cards. Took an omnibus to Oxford. Took dinner at an eating house—got my watch from Tutman. Bought four manakins. At my lodgings found cards from Mrs. & Miss Rolls, and the music from Mitchel which we had left there. Healy called and agreed to let me have his copy of Titian for 30 Guineas. Blanch returned; had tea. Mr. Humphrey called.

SUNDAY 22 At 10 we rode to Hampstead Heath—you have on two sides an extensive view. The greater part of London is visible. The air fresh and much too cold for the season. Returned at ½ 1. Mr. Hillard called also Koecker and his son Leonard. At 3 I visited a German artist, Mr. Hanson,[452] in Golden Square. He has talent, but it is of the French and Italien School. Mrs. Jameson and Lady

450. Samuel Birch & Co., cooks and confectioners, 15 Cornhill.
451. Willett & Blanford, wholesale looking glass and picture frame mounding manufacturers, carvers, gilders, and oval turners, 29 Bouverie Street.
452. Christian Heinrich Johann Hanson (1790–1863), German painter.

Munsten [*sic* for Munster][453] came in—on returning called on Koecker and borrowed an English newspaper. He will not make a charge for the professional services he has rendered Blanch. At ½ 8 we drank tea with Mrs. Jameson, the sister and husband, Mr. Bates, a young artist from Dublin Mr. Crawley, and a lawyer of that place. At 10 Lady Munsten called for Mrs. Jameson to accompany Mr. Hansen, who had just before came in, to Lady Norton's—*we were not FLAT-TERED by the circumstance*. But we waited until, ½ 10 for Mrs. Jameson's return—and in vain—we took leave.

MONDAY 23 Packed up the manakins in one box. Jane will come to us next Thursday. Mrs. Jameson called to apologize for leaving us last night. Hodgson called and I rode home with him. He has had a change made in the arrangement of the hand of the portrait as I had consented—and it has much injured it. He returned me the Queen's autograph and presented me with others. Healy brought me the copy of Titian, paid him 31 £ & 10 shillings. Blanch went with me to Langley, Allenson, Price and Lough, the latter we found at home, and saw his atelier. In the evening to Jaudon's. Drank tea with Mrs. Rawle at Mrs. Bulkly's.

TUESDAY 24 Several things I had purchased were sent to me. Answered Marquis Lansdown's note to dine with him. Wrote to Lord Conygham for cards of permission at Windsor. Called on Brett. Procured gold for Mr. Hodgson's draft. Blanch went with me to the Quebec. Paid Hebard the passage of our servant Jane, 18£, 7/6. Arranged with Mr. Poole, who is the clerk of Tipladay, Kennedy & Co., to take charge of my luggage next Friday. Called on Christopher who has received the clock from Paris and will ship it. At home found a note from Mrs. Jameson with print to Mrs. Buttler. Note from Count Survilliers. We dined with Brett and with his brother. Rode to Richmond Hill Stopped at the Star and Garter; walked over the grounds and was gratified. Tea at Hillard's. Osgood and wife and Coates.

JULY 25TH, 1838 WEDNESDAY Accompanied Leslie to Holland House to breakfast. There at 10 which gave us time to ramble over the place. The mansion is of the time of Charles 2nd, and has many valuable recollections. It is said to have been designed by Inigo Jones; it is altogether a rare specimen of ancient grandeur. Some excellent pictures, particularly by Reynolds, whose portrait of

453. Mary Wyndham, wife of George Augustus Frederick Fitzclarence, Earl of Munster (1794–1842).

Sterne[454] pleased me much. [(It) is equal to any portrait I have seen by Sir Joshua; it has a remarkable broad effect, and except a trifling defect of the half shadow on the left hand being too brown, I could see nothing but excellence.] Miss Rogers was here on a visit and joined our walk. Was introduced to Mr. Allen, principal of Dulwitch College. Breakfast past 11. Present Lady and Lord Holland. After breakfast Lady H. sent for Leslie and I in her boudoir where we saw some precious gems, and works of art. She gave me a facsimile of the hand writing and snuff box presented to her by Napoleon. Was introduced to her son, received some compliments of my portrait of the Queen. Lord H. gave me a letter to the Marquis of Westminster[455] that I might see his pictures. On taking leave Lady Holland, with mock solemnity, adjured me not to sail from London on *Friday*; as I told I expected to do. Blanch has made some purchases in my absence. Cozens left me a proof to look at of Biddle's portrait. Mrs. Audubon sent us a cake to take home. Went out with Blanch to make purchases for home. It rained. At ½ 5 we dined with Mr. Vaughan, where we found Mr. & Mrs. Farnum of Philadelphia. Mr. & Mrs. Lough. Home at 11.

THURSDAY 26 Humphrey's has left me a print for Longacre.[456] Leslie two letters. Also some of his hair, and of Landseer for Jane Darley. Blanch went with me to take leave of Mrs. Hodgson and husband. Then to Murray's; they were all out but the son, of whom we took leave. Mr. Wright called; left card for Mrs. Tunno. We went to see the excellent collection of the Marquis Westminster.[457] [Marquis of Westminster has three of West's best compositions.[458] The original also of Mrs. Siddons as the Tragic Muse (that in Dulwich Gallery is a copy).[459] Some of the best works by Murillo, also capital pictures by Claude, Rubens, Hobbema, Rembrandt, Poussin and many others. A Family piece by Leslie of the Westminster family, is the worst picture of his that I have seen in London. But still there

454. Reynolds, *The Reverend Laurence Sterne*, 1760 (National Portrait Gallery, London).

455. Robert Grosvenor (1767–1845), first Marquess of Westminster.

456. James Barton Longacre (1794–1889), American painter and engraver.

457. On the Marquess of Westminister's collection, the Grosvenor Gallery, see Waagen, *Works of Art*, 2:301–19.

458. West, *The Battle of the Boyne*, (Collection of His Grace the Duke of Westminster); *The Battle of La Hogue*, c. 1775–80 (National Gallery of Art, Washington, D.C.); *The Death of General Wolfe*, 1770 (National Gallery of Canada, Ottawa).

459. Reynolds, *Mrs. Siddons as the Tragic Muse*, 1784 (The Huntington Library, Art Collections, and Botanical Gardens, San Marino, California).

was great brightness and truth in it.] Mrs. Jaudon called to say goodbye. The Marquis Landsdown sent me letters for Mrs. Buttler. At 3 Hodgson called with a gentleman of the Theatre, and took us to see Hope's fine collection[460]—rained. [Hope's collection is rich in relics of vases, urns and other furniture from Etruria—it is a princely establishment; is particularly rich in specimens of the Dutch school: a De Hooge, and two by Teniers, took my fancy the most. A fine Cuyp, Mieres and a G. Dow. He has one room fitted in the Egyptian style.] Took us to Wood, the portrait painter, who has made a copy of my original head of the Queen.[461] After dinner went to Audubons, where we took tea with Dr. Philips. A Spanish gentleman, Col. De Rigo called to be remembered to R. Sully and to Mr. Davis, the writer. The little rain that has, fallen has made the streets detestably muddy. I left with Audubon the pamphlet and other things lent me by Notti.

FRIDAY 27 Hillard called. Couzens called. Wrote my excuse and farewell to Lord Landsdown—had the balance of my baggage packed, and at 3 hired a van and took them to the Catherine Docks. Blanch accompanied me in a cab. Had our things put on board, and we returned. Blanch spent the evening at Hillard's, while I dined at Brett's, where I met Mr. Pickersgill and Mr. Pyne, the landscape painter.[462] Retired at 1.

SATURDAY 28 Couzens presented me with his whole length engraving of the Queen from Chalon, and two children after Landseer. Had them packed in a tin case. We took the coach to Hampton Court, according to the earnest injunction of Samuel Rogers, whom we bid farewell to yesterday. This is a fine old mansion. The grounds laid out on a grand scale and the approach to it through an ancient forrest is magnificent. A large Hall and Armoury—long suites of apartments, state beds and pictures—few good, thó high sounding names. Beauties of the Court of Charles the 2nd., so-so. [There is one room filled with pictures by West, that are bound with excellence. A vast variety of old pictures with great names attached to them, that serve to injure the names of the worthy dead.] The tempo paintings

460. Henry Philip Hope (d. 1839); on his collection, see *A Catalogue of the Collection of Pearls and Precious Stones formed by Henry Philip Hope* (London, 1839) and *The Hope Collection of Pictures of the Dutch and Flemish School* (London, 1898).

461. John Wood (1801–1870), English portraitist; see fig. 34.

462. James Baker Pyne (1800–1870), English landscape painter.

463. Thomas Holloway (1748–1827), English engraver.

464. The paintings by Lely, West, and Mantegna, and Raphael's cartoons remain at Hampton Court as part of the Royal Collection, London.

by Andrew Mantegna are nearly obliterated; cartoons of Raphael, are nothing in color or effect, 'tis interesting to see the work of so great a master, but the design, which is their great merit, may be relished in Halloway's [*sic* for Holloway's][463] engravings. [It is very interesting to dwell upon their high qualities and think of the precious hand that wrought them.[464]] We met in the park with Mr. Marras and his daughters and Mr. Hill, who had come out to seek us; they pressed us to dine with them at their house in the vicinity; but we begged off. Took a light dinner at the hotel. A Gipsey woman and her child attracted our notice, bought a basket and she told Blanch her fortune. Returned home at ½ 6; spent the evening at Osgood's. Coates, Peabody and others were there. Home at 11.

SUNDAY 29 Paid Atherston's bill, and arranged matters for our departure. Blanch and I called on Koecker and left the paper. To Audubon's and took charge of some letters. Blanch went to Todhunter's, and I went to take leave of Stuart whom I met. Called on Jenkins. On Stevenson and then joined Blanch at Todhunter's, whom we bid adieu. Took carriage at Tottenham C.R. and went home for Jane and our baggage; and then rode to the ship. At ½ 4 got clear of the docks, and by aid of steam boat passed down the Thames and anchored below Gravesend.

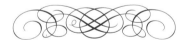

The Sullys reached New York City on September 11, 1838, and boarded a steamer upriver to the United States Military Academy at West Point, where Thomas's son Alfred was a cadet. Most of the immediate family had traveled there for the joyous reunion, and all arrived home in Philadelphia on September 15. Sully began his full-length portrait of Queen Victoria for the Society of the Sons of Saint George on September 30; he began a second version for his own use on October 2.

Further Reading

Erickson, Carolly. *Her Little Majesty: The Life of Queen Victoria.* New York: Simon and Schuster, 1997.
A well-researched biography, the most recent and thorough.

Fabian, Monroe H. *Mr. Sully, Portrait Painter: The Works of Thomas Sully (1783–1872).* Washington, D.C.: Smithsonian Institution Press for the National Portrait Gallery, 1983.
The definitive work on Sully's life and career to date.

Hibbert, Christopher. *Queen Victoria in Her Letters and Journals.* London: Sutton Publishing, 2000.
A rich selection of excerpts from Victoria's papers.

Stein, Richard L. *Victoria's Year: English Literature and Culture, 1837–38.* New York and Oxford: Oxford University Press, 1987.
A descriptive map of London in Victoria's coronation year.

Strachey, Lytton. *Queen Victoria.* 1921. Reprint, New York and London: Harcourt Brace Jovanovich, 1989.
A witty and irreverent biography of Victoria, written by one of the principal members of the Bloomsbury group.

Index

Coperthwait. *See* Cowperthwaite, Joseph

Corbit, Mr., 88, 106–8

Corporation of London, portrait commissioned by, 13, 97; *see also* Hayter, Sir George, *Queen Victoria*

Correggio (Antonio Allegri), 99, 153; Sully on painting of, 99

Cousins, Samuel, 104, 104n.173, 106, 159, 191–93, 195–96

Cowperthwaite, Joseph, 78, 78n.15, 87, 114, 122, 160

Cox, Dr., 120

Cox, John, 169, 172, 175, 175n.414, 184, 188

Cozens. *See* Cousins, Samuel

Crew. *See* Carew, John Edward

Cruikshank, Isaac Robert, 165, 165n.378

Cumberland, Frederica Caroline Sophia Alexandrina, Duchess of, 130, 130n.268

Cunningham, Allan, 107, 107n.181, 139, 159, 169

Cuyp (artist), 196

Dacres, Lady, 133, 136, 138

Dacres, Thomas Brand, twentieth Baron, 35, 130, 130n.267, 138, 165, 179

Dafrique, Felix, and Paul Lebas, after Sully, *Queen Victoria*, 55, fig. 43

Dance, Charles, 123, 123n.246

Darley, Francis T. S. (artist's grandson), 75

Darley, Jane Cooper Sully (artist's daughter), 118, 118n.218, 125, 135, 137, 143, 152, 157, 164, 171, 175, 192, 195

Darley, William Henry Westray (artist's son–in–law), 78, 78n.9, 118, 118n.218, 122, 129, 138, 165, 167, 193

Debonshal or Deboujal. *See* Dubourjal, Savinien Edmé

De Charm, Mr. and Mrs., 123, 156

De Hooge (Pieter de Hooch), 174, 196

De Silver, Antoinette, 78, 78n.10

Delaroche, Hippolyte (Paul), 127, 146, 146n.328, 186

Denner, Balthasar, 192, 192n.449

Denning, Stephen Poyntz: after Sully, *Queen Victoria*, 53, fig. 40; *Queen Victoria, Age Four*, 6, fig. 2

Dixwell, Mr., 108, 110, 113, 125, 132, 146, 152, 166, 168, 192

Dodsway or Dodsworth, Jane, 122, 178, 191–94, 197

Dolci, Carlo, 104

Doughty, Thomas, 26, 82, 82n.38, 84, 89, 95, 97, 101, 105–7, 110–11, 114–16, 119, 130, 138, 143, 145, 153, 160, 162, 164

Dow, G. (Gerrit Dou), 104, 196

Downing, Mary, 78, 78n.12

Dragonetti, Dominico, 102, 102n.161, 167

Drummond, Samuel, 174, 174n.410

Dubourjal, Savinien Edmé, 170, 170n.395, 177, 179, 183, 193

Dulwich Picture Gallery, 195; visited by Sully, 27, 176

Dunlop, Mr., 115–16, 118–19, 133, 160, 163–64, 179

Dunlop, Mrs., 116, 118–19, 123, 160, 163

Dyck, Anthony van, 122, 171; *Philip Herbert, Fourth Earl of Pembroke, and His Family*, 45, fig. 30; Sully on painting of, 174; works seen by Sully, 28, 118, 126, 134, 173

Earle, James S., 21, 78, 78n.16, 168

Eastlake, Sir Charles Lock, 126, 126n.253, 163

Egerton, Lady (Harriet Catherine Greville, Countess of Ellesmere), 114, 114n.204, 120, 126, 130, 131, 136, 177, 192

Egerton, Lord (Francis Egerton, first Earl of Ellesmere), 28, 30, 35, 121, 121n.231, 131, 135–36, 139–40, 147, 149, 168, 176–77, 192; party of, 130–31; collection, visited by Sully, 28, 126–28, 136

Elgin, Lord, 152n.351, 158

Elwin, Miss, 144, 168–69

Elwyn, Dr. Alfred Langdon, 146, 146n.329

Elwyn, Mrs., 166

Etty, William, 102, 102n.157

Evans, Richard, 153, 153n.354; Sully on work of, 153

Feodora, princess of Leiningen, 9

Fielding, Anthony Van Dyke Copley, 163, 163n.374

Finden, Edward Francis, 142, 142n.309

Finden, William, 133, 133n.283, 134, 138, 142–43; wife of, 142

Fitzhugh, Emily, 152, 152n.348, 153, 156–61, 165, 170

Fitzhugh, Mr., 153, 156

Fitzhugh, Mrs., 35, 152–54, 158

Flaxman, John, 93, 139, 156

Fontblanque, Mr., 163, 165–66, 170, 172, 177

Howard, T., 151
Hubbard, Captain. *See* Hebard, Captain
Hubbard, Richard William, 114, 114n.207,
 185–86, 188–90
Humphries, Mrs., 151
Humphrys, William, 81, 81n.27, 83, 107–8,
 122, 136, 138, 152, 157, 193, 195
Hunter, John, 164, 164n.377, 166–67, 177,
 179
Huntington, third Earl of, 89n.87
Hurlstone, Frederick Yeates, 128, 128n.257
Huysum, Jan van, 188

Inman, Charles, 129
Inman, Henry, 59; *Thomas Sully*, fig. 1

Jackson, Samuel, 84, 84n.58; Sully on
 paintings of, 84, 90
Jameson, Mrs. Robert (Anna), 35, 36, 153,
 153n.353, 154–57, 163, 169, 174–75,
 177–78, 193–94; sister of, 155, 174, 194
Jameson, Robert, 35, 155, 155n.358, 194
Jarvis, John Wesley, 102, 102n.158
Jaudon, Samuel, 77, 77n.7, 78, 87, 90, 92, 98,
 105, 114, 119, 129, 133, 139, 148, 152, 155,
 161, 169–70, 173, 175, 193–94; brother of,
 92, 108, 133; daughter of, 87; Sully por-
 trait of, 105–6, 113–16, 118, 122, 130
Jaudon, Mrs. Samuel, 90, 92, 107, 120, 130,
 133–34, 138–39, 151, 160, 168, 196
Jaudon of the *Literary Gazette. See* Jerdan,
 William
Jenkins, Mr., 110, 112, 122–23, 136, 197
Jenkins, Mrs., 87, 90, 100, 122
Jenkins, Mr. (artist), 6
Jerdan, William, 89, 89n.86, 142
Johnson, Frank, 100
Jones, alias Harris, 188
Jones, Charlotte, 144, 144n.315, 156, 165, 171,
 175, 192
Jones, Edward or Henry (color merchant),
 123, 123n.245
Jones, George, 147, 147n.334
Jones, Inigo, 194
Jones, Mr. (at Price's), 117, 133
Jones, Mr. (neighbor), 110
Jordaens, Jacob, 186n.434
Jourdan. *See* Jerdan, William

Kane, John Kintzing, 58, 77, 77n.6, 78
Keeley, Mrs. Robert (Mary Goward), 81–83,

87–88, 90, 92, 96–98, 110, 112, 133,
 160–61, 193; sister of, 115
Keeley, Robert, 81, 81n.33, 82, 88–89, 97,
 103, 106, 115, 161, 173, 192
Kemble, Adelaide, 34–35, 69n.54, 101,
 101n.153, 102, 105, 110
Kemble, Charles, 32, 34, 96, 96n.131,
 100–101, 113, 123, 155, 157, 161, 173
Kemble, Frances "Fanny." *See* Butler, Mrs.
 Pierce
Kemble, Mrs. Charles, 155
Kent, Edward Augustus, Duke of (father of
 Victoria), 7–8
Kent, Marie Louise Victoire, Duchess of
 (mother of Victoria), 5–10, 37, 167, 178;
 double portraits with Victoria, 7, 9
King, Charles Bird, 91, 91n.107, 102, 105, 157
King, Mr., and nephew, 119
King, Mr., and son, 96–97
King, Mr. (a dandy), 146
King, Mr. (sending money), 115–16, 126
Knight, John Prescott, 159, 159n.369
Knowles, James Sheridan, 90, 90n.95
Koecker, Leonard, 90, 90n.100, 95, 97, 101,
 103, 105, 113, 116, 121, 124, 145, 162, 170,
 173, 193–94, 197; son of (Leonard), 101,
 121, 131, 193
Koecker, Mrs., 101

Lablache, Luigi, 168, 168n.388
Lamont, D. G., copy after Sully, 55
Landseer, Charles, 82, 82n.43, 83, 92, 98,
 137, 159, 161–62, 171, 177
Landseer, Edwin, 62–65, 92, 92n.108, 92,
 106, 116, 120, 136–38, 157, 195–96;
 commission from Carey, 138, 152, 172,
 179; portraits of Victoria's dogs, 18;
 portraits of Victoria, 18; *Queen Victoria*,
 62, fig. 50; *The Return from Hawking*,
 130–31; Sully on painting of, 117, 127–29,
 160, 164, 170
Lane, John Bryant, 175, 175n.412
Lane, Richard James, 18; portraits of Victo-
 ria, 6–7, 15, fig. 8
Langley, Mr., 88, 102, 111, 115, 131, 136–37,
 178–79, 194
Langley, Mrs., 88, 101, 106, 111, 115, 118,
 131–32, 144, 157, 178
Lansdowne, Louisa Emma Fox-Strangways,
 Marchioness, 35, 125, 173, 173n.400, 175,
 177–78

Lansdowne, Henry Petty-Fitzmaurice, third
Marquis of, 30, 35, 53, 114, 114n.205,
120, 122, 166, 177–78, 194, 196; and
access to Victoria, 29–30, 125–26; collec-
tion visited by Sully, 28, 121, 126–28, 146;
party of, 30, 124–26
Latrobe, Benjamin Henry, 133, 133n.282
Laurie, Sir Peter, 83, 86, 86n.71
Lawrence, Sir Thomas, 21, 25, 86, 95,
95n.124, 121, 153, 156, 157n.363, 158,
172–74; *Arthur Wellesley, First Duke of
Wellington,* 174; *Charles Kemble as Rollo,*
174–75; *Charles William Stewart, Third
Marquess of Londonderry,* 174; *George
Canning,* 174; *Mrs. Francis Robertson,*
100; and Sarah Siddons, 31; *Sir Thomas
Baring and Members of His Family,* 132;
Sully on painting of, 100, 119, 132,
153–54, 159, 174
Lebas, Paul, and Felix Dafrique, after Sully,
Queen Victoria, 55, fig. 43
Lee, William, 92, 92n.109, 98
Légaré, Joseph, 59; after Sully, *Queen Victo-
ria,* 60, figs. 47–48
Lehzen, Louise, Baroness, 6, 14, 140–42,
144–50, 160–61, 163–64, 167, 176, 179
Leishman, Miss, 192
Leishman, Mrs., 169
Lely, Sir Peter, 120
Leonardo da Vinci, Sully on painting of, 155
Leopold, king of the Belgians, 5–6, 16, 18
Leslie, Charles Robert, 5, 26, 80, 80n.25,
81–83, 85–88, 91, 93, 95–98, 104, 107,
110–11, 115, 120–21, 123, 134–35, 137, 139,
144, 152–53, 156–58, 160–62, 164–65,
169, 173–75, 179, 192, 194–96; *Musidora
Bathing,* 41; *Sancho with the Dutchess,*
154; sister of, 135, 157; son (Robert), 85
Leslie, Mrs. Charles (Harriet Stone), 81, 91,
96, 107, 110, 112, 123–24, 134, 152, 157,
164, 169, 173, 179
Leuchtlein, J., after Sully, *Queen Victoria,*
53, fig. 38
Levy, Captain, 96, 106, 124, 157, 160–61,
163
Lewis, Frederick Christian, 192, 192n.448
Lewis, John Delaware, 84, 84n.60, 88, 90,
106, 108, 110, 128, 143, 163, 176
Lewis, Reeve, 119, 119n.224
Lewis, Samuel, 143, 143n.313, 157, 159
Lindley, Robert, 102, 102n.162, 167

Lingen, Mrs. George (Maria Oldmixon), 78,
78n.11
Linwood, Mary, 129, 129n.263
Lister, Miss, 147, 147n.337, 149
Liston, Robert, 111, 111n.193
Little, Mr., 122, 135
Livingston, Mr., 150, 150n.344
Lockhart, John Gibson, 144, 144n.319, 145
Longacre, James Barton, 195, 195n.456
Longman, Thomas Norton, 85, 85n.62
Lonsdale, James, 100, 100n.152
Lough, John Graham, 96, 96n.132, 104, 110,
112, 124, 146, 194–95
Lough, Mrs. John Graham, 104, 195; sisters
of, 104
Lounsdale. *See* Lonsdale, James
Louvre, Musée du, 185–86, 188
Lover, Samuel, 98n.138, 169
Lowel, Dr., 113, 115; wife of, 113
Lowel, Rev., 150; wife and daughter of, 150
Lowell, Mr., 107
Lyndhurst, John Singleton Copley Jr.,
Baron, 98, 98n.140

Macauley, Dr., 135, 139, 143, 145, 159, 173,
177
Maclise, Daniel, 98, 98n.139, 159, 175
MacReady, William Charles, 110n.188
Maitland, William Fuller, 97, 97n.135
Mantegna, Andrea, 196–97
Marsh, Stephen Hale Alonzo, 112, 112n.196
Martineau, Harriet, 82, 82n.40, 85, 88–89,
92, 102, 105, 134, 137, 154, 162, 171, 177;
mother of, 85
Maywood, Mr., 169, 171–73, 178, 184, 192;
wife of, 173, 183
McCready, Mr., 166
McHenry, Mr., 177–79
McIlvaine, C. P., 173, 173n.403, 176
McMurtrie, James, 124, 124n.248, 126;
nephew (Mr. Tilghman), 124
Meigh, Charles, 55
Melbourne, William Lamb, Lord, 6, 14, 18,
29–30, 35, 37, 105, 105n.177, 121, 139–40,
148
Michelangelo Buonarotti, 111
Mieres, Frans I van, 196
Miller, John, 84, 89, 98, 105, 108, 114, 124,
136, 177, 192
Mitchell, Mr. (of New Haven), 58
Mitchell, Ann, 91, 97, 105, 172

Smith, Mrs. Henry Middleton (Elizabeth Sully), 91, 91n.105, 138

Smith, James, 120, 120n.227

Smith, John M. and Samuel M., 36, 104, 104n.172, 106, 108, 112, 163, 167, 167n.384

Smith, Washington, 157

Soane, Sir John, 154n.355; collection visited by Sully, 27, 154

Society of the Sons of Saint George, 3, 197; commission for Victoria portrait, 3, 20, 29–30, 37, 49, 60, 89, 152; lawsuit against Sully, 58–59, 71n.94

Stanfield, Clarkson, 89, 89n.88, 117, 135, 138, 142, 158–59, 162, 165, 193; *Scenes at Home and Abroad,* 110, 110n.188

Stanhope, Lincoln, 89, 89n.87

Steell, Sir John, *Queen Victoria,* 17, fig. 10

Steen, Jan, 28

Stevenson, Andrew, 58, 87, 87n.74, 88, 90, 95, 107, 122, 128–29, 139, 148, 150, 166, 169, 172–73, 175, 197; and Sully's commission, 20, 29–30, 35, 88–89, 97, 105, 121, 125, 128, 131, 139, 142

Stevenson, Mrs. Andrew (Sarah Coles), 55–58, 91, 91n.104, 98, 107, 120, 122, 166, 169

Stevenson, Mr. (railroad contractor), 119

Stewart, John, 81, 81n.29, 84–86, 88, 97, 101, 106, 115–16, 119

Stiles, Mr., 162–63, 166–68, 171, 178–80, 183–84, 186–88, 190

Stothard, Thomas, 132n.279; Sully on painting of, 132, 154

Strickland, William, 114, 114n.201, 115, 118–19, 168–69, 171; daughter Elizabeth, 114

Stuart, Gilbert, 21

Stump, Samuel John, 135, 135n.291, 137, 158, 166

Sully, Alfred (artist's son), 77, 77n.2, 160, 172, 197

Sully, Blanch (artist's daughter), 3, fig. 33; on Fanny Butler, 35, 69n.54; on Fanny Butler and Victoria, 36–37; letters home, 81, 89, 96, 104–5, 108, 114–15, 121, 129, 131, 136, 143, 153, 159, 160, 164, 168, 171–72, 177, 179; sitting in for Miss Bates, 101; sitting in for Victoria, 47–48, 163–64, 167; trip to England, 19–20, 26, 75–197; on Victoria sitting, 29

Sully, Ellen Oldmixon (artist's daughter), 114

Sully, Lawrence (artist's brother), 20–21

Sully, Matthew (artist's father), 20

Sully, R. (debtor for frames), 143

Sully, Rosalie Kemble (artist's daughter), 153, 153n.350, 170, 196

Sully, Sarah Annis (artist's wife), 19, 20, 28, 32, 75, 78, 105, 114, 124–25, 143, 157; letters to, 26–28, 30, 96, 116–17, 120, 123–24, 129, 131, 143, 152–53, 168, 171; portraits by Sully, 31; and stipend from Carey, 19, 77

Sully, Sarah Chester (artist's mother), 20

Sully, Thomas: apartment at Howland St., 26, 80–81, 90; apartment at Marlborough St., 26–27, 35, 68n.34, 87, 90, 90n.97, 161, 163–64, figs. 15–16; children of, 20–21; early life of, 20–21; *Hints to Young Painters,* 75, 137; Journal of, 28, 31, 75–197; Memorandum Book of, 28, 75, 94, 128, 134n.286, 137, 151, 156, 165; on Hayter's portrait of Victoria, 37–38; as portraitist, 20–25, 149; portraits of actors in character, 21, 31–32; portraits of women, 25, 33; Register of, 21, 28, 75; subject paintings for Carey, 19, 26, 28, 77; trip to Paris, 50, 146, 150–51, 170, 173, 177, 179–91; Waste Book of, 75

Sully, Thomas, portrait of Victoria: access to Victoria for, 20, 29–30, 35, 88–89, 105, 124–25, 128, 131, 138–40; as American portrait, 18, 62; copies by other artists, 53, 55–59, figs. 39–41, 43–44, 46–48; copies by Sully, 49–53, 55, 58, 197, figs. 35, 42; copy sent on tour, 58–62, 197; costume for, 37–38, 47–48, 141–42, 164–67, 171–72; crown jewels in, 47–48, 142, 147–48, 150, 163–64; and *Fanny Kemble as Beatrice,* 36–45; and Fanny Kemble Butler, 35; pose for, 41–45, 48, 65, 141; prints after, 49–53, 58, 62, 150, 152, figs. 36–38; protocol for, 29, 108–9, 116, 139–40; reception of, 50–55, 59–65, 149; sitting sessions for, 18, 20, 38, 41–47, 50, 140–50, 163–64; portrait and related works: autograph of Queen Victoria, 45, 164, 175, 194, fig. 32; *Diagram of Colors Used to Paint Queen Victoria,* 58, fig. 45; *Queen Victoria,* frontispiece; *Queen Victoria* (half-length, engraver's version),

Photography Credits

Designed by Diane Gottardi

Typeset in Monotype Bulmer with Shelley Allegro and Copperplate display
by Jo Yandle

Printed on Gardapatt 135 gsm paper and bound with Brillianta and Nettuno 140 gsm paper
by Arnoldo Mondadori Editore, S.p.A, Verona